D1593801

Maternity,
Mortality,
and the
Literature
of Madness

Maternity, Mortality, and the Literature of Madness

Marilyn Yalom

THE PENNSYLVANIA STATE UNIVERSITY PRESS
UNIVERSITY PARK AND LONDON

Library of Congress Cataloging in Publication Data

Yalom, Marilyn.
 Maternity, mortality, and the literature of madness.

 Includes bibliography and index.
 1. Mental illness in literature. 2. Mothers in
literature. 3. Literature, Modern—20th century—
History and criticism. 4. Literature—Women authors—
History and criticism. I. Title.
PN56.M45Y3 1985 809'.93353 84–43061
ISBN 0–271–00398–7

Acknowledgment is gratefully made as follows for permission to reprint copyrighted material.

Quotations from *All My Pretty Ones* by Anne Sexton. Copyright © 1962 by Anne Sexton. Reprinted by permission of Houghton Mifflin Company.

Quotations from *To Bedlam and Part Way Back* by Anne Sexton. Copyright © 1960 by Anne Sexton. Reprinted by permission of Houghton Mifflin Company.

Les Mots pour le dire, by Marie Cardinal, used by permission of Éditions Bernard Grasset.

La Souricière, by Marie Cardinal, used by permission of Éditions Julliard and Presses Pocket.

Surfacing, by Margaret Atwood. Copyright © 1972 by Margaret Atwood. Reprinted by permission of Simon & Schuster, Inc.

The Woman Warrior: Memoirs of a Girlhood Among Ghosts, by Maxine Hong Kingston. Copyright © 1975/76 by Maxine Hong Kingston. Reprinted by permission of Alfred A. Knopf, Inc.

A section of chapter 4 appeared in "They Remember 'Maman': Attachment and Separation in Leduc, de Beauvoir, Sand and Cardinal," *Essays in Literature* 8, no. 1 (Spring 1981). A different version of chapter 2 appears in *Coming to Light: American Women Poets in the Twentieth Century,* ed. Diane Middlebrook and Marilyn Yalom, University of Michigan Press (in press).

Contents

Acknowledgments

I would not have written this particular book were it not for the life I have shared with the psychiatrist Irvin Yalom. Nor would I have written it without a background in French literature dating from a time when existential thought dominated my education in this country and in France.

I am particularly indebted to my colleagues at the Center for Research on Women and Stanford University, who have undertaken or encouraged new forms of scholarship which challenge traditional assumptions about gender. Among these persons I wish to thank Mary and John Felstiner, Myra Strober, Diane Middlebrook, Barbara Gelpi, and Maclin and Albert Guerard. A very special sense of gratitude is felt toward Estela Estrada, whose work at the Center has made mine possible. I also wish to thank Dr. Mildred Ash for her insightful reading of the manuscript, Dr. David Spiegel for valuable psychiatric observations, Lillian Robinson for careful editorial counsel, and Winfried Weiss for ongoing critical and moral support.

Lastly, I am grateful to my daughter, Eve Yalom, through whose life I first became a mother and later a feminist, and my three sons—Reid, Victor, and Benjamin—who, like their sister, have had dual-career parents since their birth and have not complained unduly.

"*What the person out of Belsen—physical or psychological—wants is nobody saying the birdies still go tweet-tweet, but the full knowledge that somebody else has been there and knows the* worst. . . ."

Sylvia Plath, Letters Home

"*I thought every house had to have its crazy woman or crazy girl, every village its idiot. Who would It be in our house? Probably me. . . .*"

Maxine Hong Kingston, The Woman Warrior: Memoir of a Girlhood Among Ghosts

1
Introduction: Feminist and Existential Considerations

It is now possible to speak of a subgenre of fiction devoted to the topos of madness and created, to a large extent, by female authors. Increasingly since the turn of the century, women writers who have endured a psychosis have drawn from their personal histories the raw material for works of art. Anne Sexton, Sylvia Plath, Joanne Greenberg, Maxine Hong Kingston, the French writers Violette Leduc, Marie Cardinal, and Emma Santos have left us frankly autobiographical accounts of mental breakdown, while Virginia Woolf, Anaïs Nin, Jean Rhys, Doris Lessing, Margaret Atwood, Margaret Drabble, and Marge Piercy have presented in their fiction visionary versions of derangement.

The theme of madness has never been absent from Western literary history, as Lillian Feder adeptly demonstrates in her recent book *Madness in Literature*.[1] The greatest of writers—Aeschylus, Sophocles, Shakespeare, Dostoevsky, Nietzsche, Kafka,—and their somewhat less celebrated brothers—E.T.A. Hoffman, Gérard de Nerval, Rimbaud, Trakl, Lautréamont, Artaud, Salinger, Roethke—have explored that underworld where unconscious processes run amuck and created characters who often express profound human truths that lie beyond the threshold of reason. Yet it is obvious to any sensitive contemporary observer that the tradition of madness in literature, like most literary conventions in the past, was predominantly male-authored and male-centered and therefore subject to the critique that its archetypes do not apply equally to women and men.

By the mid-twentieth century, a large body of psychoanalytic, psychological, and literary theory had developed around these authors in the wake of Freud's use of literary examples to illuminate psychodynamic questions.[2] Theories constructed by male analysts (for example, Ernest Jones, Theodore Lidz, Norman H. Holland) focused on male characters

(such as Oedipus and Hamlet) who had been created by male writers (for example, Sophocles and Shakespeare). Obviously, this masculine hegemony tended to represent only half the human race; the other half was not only neglected but often forced to distort itself by conforming to misdirected theoretical models. Women's internal experience, as recorded by women themselves, was simply not considered very important by those who formulated the basic theories of psychoanalysis, despite the fact that by the nineteenth century a few exceptional women had already begun to break the male monopoly on literary madness. Charlotte Brontë led the intruding female ranks, which, according to Gilbert and Gubar in their impressive work, *The Madwoman in the Attic,* included no lesser figures than Jane Austen, Mary Shelley, Emily Brontë, George Eliot, and Emily Dickinson.[3] It was not until our own century, however, that works on madness written by women began to rival, both in quality and quantity, those written by men. This burgeoning body of literature provides an opportunity for today's theoreticians to explore pathology from the perspective of the "other half"; it offers a fresh avenue of approach into the underworld of mental disorder and a vista on basic anxieties that may be common to all Western women.

Twentieth-century women writers have appropriated literary insanity for their own ends and have endowed it with specifically female parameters. Many have emphasized the gender-related aspects of mental illness and, in some instances, have shown how the metaphor of madness could pertain only to a woman: for example, the interminable menstruation in Marie Cardinal's *Les Mots pour le dire*[4] and the ritual childbirth in Margaret Atwood's *Surfacing.*[5]

The best of these works possess a symbolic structure beyond the narrative line, with levels of meaning that elucidate the female situation in particular and the human condition in general. Thus, Sylvia Plath's story of her breakdown and recovery in *The Bell Jar*[6] is simultaneously a pre-feminist exposé of the adverse effects of sexist culture on American women in the 1950s and, as Judith Kroll has demonstrated, a pan-human myth of death and rebirth.[7] Similarly, Marge Piercy's hallucinatory vision of a woman's life in and out of the asylum in *Woman on the Edge of Time*[8] presents both a heavy-handed feminist critique of society and a highly original utopia.

Several of these works pay special attention to the process of psychotherapy through which the protagonist is or is not brought back to sanity. Various modes of therapy are described, from rest, cures and electric shock to Freudian and other dynamic approaches, and differing evaluations of professional healers are presented. Some writers see doctors as clearly inimical, particularly to women, as in Charlotte Perkins Gilman's

turn-of-the-century story *The Yellow Wallpaper,*[9] which presents insanity as flight from marriage and motherhood within a male-dominated social system, and, more recently, Helene Cixous's rewriting of Freud's case history of Dora from a French feminist perspective[10] and Emma Santos' various books detailing her personal struggle in France during the 1970s to maintain a sense of willful autonomy against a psychiatric system that would drug and "castrate" her.[11] Others, like Joanne Greenberg in *I Never Promised You a Rose Garden*[12] (whose "Dr. Fried" was none other than the celebrated analyst Frieda Fromm-Reichman) and Marie Cardinal in *Les Mots pour le dire* (whose unnamed analyst is the highly regarded Michel de M'Uzan), offer sympathetic visions of therapists who helped the narrators return to sanity. Still others, like Anaïs Nin, Doris Lessing, and Margaret Atwood, eschewing psychiatric professionalism in their fiction, have created their own versions of autotherapy within complex systems of psychic disintegration and reintegration.

Yet scholarly attention to these works has thus far been notably thin. As Elaine Martin points out in an insightful article on *The Bell Jar* and *Les Mots pour le dire,* "little research has been done on the combined subject of women, madness and literature,"[13] and those who are at the vanguard of psycho-literary criticism in our country—for example, Leo Bersani, Shoshana Felman, and Meredith Anne Skura[14]—have not yet taken up the challenge of female-authored texts. Some recent attempts to understand the significance of this literature have come from feminist psychologists, sociologists, and literary critics who conceptualize madness in terms of sexual politics and focus largely on culture and society as causal agents in women's mental disease. These writers have indicated patriarchal oppression as the primary culprit in the etiology of female mental disorders. Gilbert and Gubar, for example, in *The Madwoman in the Attic,* argue that "patriarchal socialization literally makes women sick, both physically and mentally,"[15] and Annis Pratt in *Archetypal Patterns in Women's Fiction* understands insanity, "whether literary or clinical," as "a mirror of the feminine persona's place within society, an image of the enclosure and of its victims. . . ."[16] The psychologist Phyllis Chesler in *Women and Madness*[17] takes the position that women, incorporating into their self-images the negative "feminine" qualities that men assign them, act out behaviors that would be considered "abnormal" or "mad" if they were acted out by a man. "When and if they are hospitalized, it is for predominantly female behaviors such as 'depression,' 'suicide attempts,' 'anxiety neuroses,' 'paranoia,' or 'promiscuity.' "[18] Those women, however, who reject traditional sex-roles—such as lesbians or ambitious professional women—fare no better in traditional psychiatric circles where they are treated with a view toward curing their "deviancy." Chesler's work has been highly influential

in calling attention to sexist straight jackets that cause psychological disequilibrium.

Some of the scholarship that is most relevant to the subject of women and madness has been produced by feminist thinkers investigating the broad arena of motherhood. The work of Nancy Chodorow, Dorothy Dinnerstein, and Adrienne Rich[19] has brought us new perspectives on the roles mothers play in their daughters' mental lives, as well as an appreciation of motherhood as a socially constructed institution which, in its present form, often undermines the mother's mental health and produces children who are essentially ambivalent about their own mothers.

Chodorow has underscored the important Freudian concept of identification, noting that girls normally maintain an identification with their mothers far longer than do boys. The mother's shortcomings, as well as her strengths, become those of the daughter in a way that is more intense than it is for sons, who normally make a "phallic" and "oedipal" switch toward their fathers and dissociate from being like their mothers. It is this strong identification between the female child and her same-sex parent that may make the development of a strong, independent selfhood harder for girls than for boys.

Dinnerstein's *The Mermaid and the Minotaur,* subtitled *Sexual Arrangements and Human Malaise,* argues that the malaise of both sexes derives primarily from the fact that "women remain almost universally in charge of infant and early child care" (p. 26) and that this predominantly female care results in both man's basic fear of and alienation from women and, ironically, woman's own complicity in perpetuating the kinds of gender arrangements that make for global insanity. Dinnerstein's analysis of woman as the "dirty goddess," the scapegoat for our ambivalent attitudes toward carnality and mortality, is predicated upon the belief that this situation could change if men were equally in charge of the rearing of children. With characteristic decisiveness, she writes: "Woman is now the focus of our ambivalence to the flesh not because she gives birth to it but because she is in charge of it after it is born" (p. 155). Without discounting the plausibility of Dinnerstein's thesis, I approach the psychological implications of maternity and motherhood from a different vantage point: What about woman's ambivalence to her own flesh? What about the ambivalence that derives not from the fact that she is born of woman but that she gives birth? Where is the subjectivity of the mother in our investigation of the crazy-making potential of motherhood?

Most feminist scholarship has examined motherhood as a social construct subject to change, indeed in dire need of change, so that women contemplating or experiencing motherhood will not be brought to breakdown. The emphasis has been on what psychiatrists would call primary

prevention—that is, prevention (rather than treatment) of madness by removing or altering conditions inimical to women as a "target population."[20] Less attention has been paid by feminist scholars to the biological and existential aspects of motherhood, which may also contribute to mental unbalance. Admittedly, these "givens" are less amenable to change than socially constructed realities and therefore are less palatable for many of us to contemplate. Nonetheless, when we examine the writings of women looking inward to the vortex of their distress—women who "know" madness from experience as opposed to scholars who "know about" madness—it becomes impossible to ignore the biological and existential dimensions of their obsession with maternity, over and above the societal structure in which motherhood is anchored.

One of the central questions I raise in this book is the extent to which maternity, as option or experience, serves as a catalyst for mental breakdown. A corollary of this question concerns the distinction between *maternity* and *motherhood*: to what extent is maternity (conception, pregnancy, parturition, lactation, and the nurturing of infants) a fixed biological, existentially loaded reality, and to what extent is motherhood (the daily care of children and the ensuing lifelong lien on the mother) a mutable social construct? How do maternity and motherhood in our society form a springboard toward madness?

A second set of questions, intricately related to the first, concerns the experience of madness as both a pan-human and a gender-specific phenomenon. My work assumes that certain existential facts of life, the most obvious of which are aging and death, are born into each individual, regardless of sex. These facts of life also include the philosophical constructs of isolation, freedom, and responsibility. Such existential givens often lie dormant within an individual until they are evoked by a boundary experience, such as sickness or war or childbirth. Both men and women confront the same existential facts of life, although the boundary experiences through which they are brought to conscious awareness are sometimes different for men and for women.

Of course, one may argue that not even existential realities are gender-blind, that freedom, responsibility, isolation, aging, and even death are experienced differently by men and women. Existential givens become contaminated by gender so early in life that it is often difficult to isolate the "human-specific" experience from the "gender-specific" experience. Still, existence conceptualized by Heidegger and Sartre and other existential thinkers entails certain ultimate concerns around which all human beings constitute their lives. And while it is true that these existential concerns are always experienced in life as relative to a thousand social, economic, biological, and political factors, it is also true that they are

absolute in a philosophical sense. Every human being, even the most enslaved, has some measure of freedom, if only that of resisting, if only that of imagining how things could be different. Every human being is separate from all others, no matter how one strives toward fusion or solidarity. Every human being ages and ultimately dies, no matter how many face lifts or transplants one may purchase so as to delay the process.

Given the assumption, then, that existential realities are intrinsic to every human being, I ask the questions: How are these realities affected by one's sex? What boundary experiences specific to women force them to confront these realities? How do women come to terms with this confrontation in both adaptive and maladaptive ways, including escape into madness? What manifestations of madness are specific to women?

A third set of questions concerns the etiology of mental illness and, in particular, the role of parental presence and absence, sickness and death in the development of a daughter's mental instability. In examining texts that elucidate both existential and gender issues, I investigate certain experiences in childhood that result in developmental deficiencies, leaving some individuals highly vulnerable to decompensation in young adulthood. What are these experiences? How do mothers and fathers, individually and collectively, contribute to a complex cluster of attitudes toward life and death and to an ability to cope with living and dying? Without falling into a "blame-the-parents" mode, I speculate upon the existential meanings of "mother" and "father" for women who undergo mental breakdown.

A final set of questions concerns the relationship of creative women to madness. Although we look to the works of writers because they best communicate the raw feel of subjective experience, we must not forget that these works are, indeed, written by artists, who as a group have a higher incidence of mental disease;[21] and, if the artist is a woman, we have reason to believe that the relationship between creative genius and madness is doubly problematic. These works reflect, among other things, the conflict between art and life keenly experienced by both aspiring and proven women writers. How does this conflict exacerbate mental illness? What strategies have been found to be effective in staying or alleviating its course? To what extent are the tensions experienced by highly creative women paradigmatic for all women?

These questions are linked to certain theories about maternity, mortality, creativity, and their relationship to madness that are presented in depth at various points throughout the book and that I shall outline only briefly at this time. Unlike some feminist scholars, I do not hold the view that women are driven mad primarily by patriarchal society, although the psychic insults generated by sexism (as well as by racism and classism)

can contribute significantly to mental distress. All women (like all blacks) suffer some form of discrimination, but not all women (nor all blacks) suffer psychotic episodes. Most of our sociological theories of psychosis simply do not fit current psychiatric evidence, which argues strongly in favor of some biological basis for many forms of mental disease. Madness— an imprecise, nonmedical term for a variety of abnormal mental states characterized by major impairment of personality functions, loss of reality testing, and marked disorders of mood—derives from sources that are complexly bio-psycho-social and pertain to both women and to men. For example, both men and women may be born with a genetic predisposition toward mental disorders; both may be exposed to parents or primary caretakers whose own problems in living are so severe that they are unable to provide for their children the necessary safety and guidance; both pass through the vicissitudes of difficult developmental tasks. Both women and men are born with the same existential givens that take on meaning, for better or for worse, in a social context.

But if the experience of madness derives fundamentally from similar sources for the two sexes, the triggering agencies are often different. Take, for example, the triggering agencies of war and childbirth. We know from medical history that men sometimes go crazy in battle—that if they don't die under the bombs and shells, they may return shell-shocked, or, to use current terminology, with a crippling posttraumatic stress disorder. This has not been the boundary situation through which women have traditionally been driven insane (though modern warfare is beginning to obliterate such distinctions).

Women are, however, faced with a uniquely frightening ordeal in the form of childbirth. Because it is so common and because its casualties are often difficult to assess, we tend to underestimate the impact of childbirth upon the mother's mental health. The writers studied in this book make it abundantly clear that childbirth constitutes an alarming episode in their lives and a key factor in their mental illnesses. Their accounts of childbirth demonstrate the extent to which it can be perceived by women as a form of torture, defying all learned standards of behavior; a unique encounter with existential aloneness, akin to mental breakdown and dying; an experience comprehensible only to the birthing mother, effecting, at its worse, total disintegration, postpartum depression, and attempted suicide, and at its best, a transition into psychological and social maturity. The female body as proving ground for the adult woman is one of the central themes of this book.

Similarly, the claim of motherhood is understood as a central fact to be reckoned with for all women, even those who choose not to have children. Women are born into bodies that are fashioned to carry other human

bodies. This biological given throws multiple seeds of anxiety deep into the girl-child's psyche, where they germinate for the major part of a lifetime, regardless of whether the male seed finds its way to the female egg or not. Added to this basic existential source of anxiety are further layers of anxiety produced by social pressures for women to reproduce, and under circumstances that are often detrimental to the mother and the child as well. Regardless of one's political position on this matter, it is difficult to deny that procreation is of far greater significance for women than for men and that it plays a more critical role in the fashioning of a female sense of identity.

The relationship between parenthood and madness seems to have no parallel in the lives of men. How many men experience postpartum depression or a mid-life crisis issuing from the empty-nest syndrome? For males, parenthood can take on the threatening aspect of being supplanted by a son, but the theme of paternity simply does not loom very large in the annals of their mental illnesses; their psychic crises center in other issues, most notably around the need to achieve an adult male identity through worldly success. They too must imitate the same-sex parent in growing up and growing toward death, but men do not have in their life course the burden and the refuge of maternity.

A fundamental biological difference between males and females is found not only in the fact that women may carry other human beings in their bodies, but also in the fact that the childbearing option is limited to the premenopausal years, whereas men are, in theory, able to procreate throughout the full adult life cycle. Regardless of the value that we assign to this difference (would a woman of sixty consider it an asset to become pregnant?), we recognize from a purely existential stance that the longer procreative time-span offers men greater freedom. They may choose to defer parenting or may sire children in the middle or later years. The phenomenon of the man of forty or fifty or sixty who starts a new family unit is common enough in our time.[22] A woman simply does not have that generative possibility. Because her childbearing years are limited, she often feels pressured to produce offspring exactly at the worst time for other life opportunities. We have scarcely begun to consider the full ramifications for women of the "time bomb" built into their reproductive system.[23] Surely the knowledge that the most auspicious years for having babies span barely two decades adds to the anxiety women experience around the already problematic questions of mating, maternity, and motherhood.

Another area of theory informing this book concerns the relationship between mortality and madness as found in the works of certain existentially oriented psychological thinkers, namely Rollo May, Ernest Becker,

and Irvin Yalom.[24] Following their approach to mental illness, I focus on the discovery of death in childhood, the development of death anxiety, and the importance of parental death, especially when it occurs early in the child's life. Unlike Freudian theory, which translates death anxiety into the fear of abandonment by a parental figure, existential theory posits that the fear of one's own death is a primal source of anxiety, and that the loss of a family member, especially a parent, may set in motion a lifelong inability to deal with one's own mortality except in neurotic or psychotic terms. In the case of individuals who have not developed appropriate psychological mechanisms for containing death anxiety, certain life passages, such as the choice of a career or the experience of childbirth, may have the paradoxical effect of reactivating and intensifying the fear of death, "freezing" that person in psychotic time—which is one way of refusing to grow toward death. For several of the writers in question, maternity will be analyzed along this line.

Finally, in raising the subject of the relationship of female creativity to madness, I have been inspired by the important body of feminist literary criticism produced in the past decade by Adrienne Rich, Elaine Showalter, Ellen Moers, Tillie Olsen, Sandra Gilbert, Susan Gubar, and others.[25] Their work has made us aware of the deeply rooted conflict between creation and procreation experienced by women in patriarchal societies. Rethinking women's literature from the vantage of this highly evident yet newly found truth, we have come to appreciate more fully the remarkable achievement of women writing at all—their sacrifices and triumphs—and to begin to understand the turmoil involved in the process of creating when one is beset by injunctives to reproduce one's biological rather than one's imaginative self. The prejudice against the woman writer, that "singular anomaly,"[26] as against most other forms of female creativity except motherhood, is by now well documented. Yet, in spite of the unique obstacles women authors face, my work also focuses on the benefits derived from writing. Writing as therapy emerges as a significant, mind-preserving strategy for many of the authors under consideration, even for those whose lives ultimately ended in suicide.

Selecting the authors who would exemplify these broad concerns and elucidate the questions raised turned out to be easier than I anticipated, once I had decided to accept the limitation of remaining within those literary traditions I know best—North American and French—with less attention to the British scene, although it too has produced a body of literature informed by a psychiatric world view. Of the American and French writers who have in recent years produced psychiatric novels based on their own experiences, Sylvia Plath and Marie Cardinal are clearly the most important; their fictional accounts of a personal truth constitute

aesthetically successful and psychologically credible works of literature. Moreover, their inner afflictions, while idiosyncratic to the individual, her time and place, give expression to universal female anxieties. Those of us who have moved at the margins of mental illness (and which adult, at some time or another, has not?) may be vicariously drawn into its center through the sequence of suffering narrated by the Plath and Cardinal personae.

The decision to devote a chapter to the Canadian author Margaret Atwood grew out of my realization that valuable literary visions of mental breakdown are not necessarily grounded in clinical reality; indeed, the allegorical journey recounted in *Surfacing* leads away from the purely psychological into the mystical, and gives rise to questions about the relationship between abnormal mental states and the religious experience.

Plath, Atwood, and Cardinal are three of the most prominent women in American, Canadian, and French literature who have, in less than two decades, helped create the subgenre of the psychiatric novel and given it a distinctly female cast. Plath's 1963 publication of *The Bell Jar* and her suicide in the same year cast her into the posthumous role of an avatar of mental breakdown. Atwood's work, a decade later, draws from the dual springs of personal and ecological alienation. Cardinal, whose writing spans two decades though she has only recently been translated into English, has acquired the aura of a French prophetess proclaiming the secrets of lunacy and therapy.

While the scope of this study is largely restricted to the novels of these three authors, it also attends to the work of others, such as Maxine Hong Kingston, Anne Sexton, and Virginia Woolf, whose writings are particularly valuable for our understanding of mental breakdown in the lives of highly gifted women. Certainly many other writers might have been included. If I have chosen to limit this book to a few illustrative authors, I do so with the knowledge that this is not a closed system and that other literary scholars will focus, with profit, on other aspects of women's mental illness.

In discussing Plath, Cardinal, Atwood, Kingston, and their fictitional counterparts, I do not mean to imply that author and protagonist are exactly one and the same. As René Girard wrote years ago, one must be wary of equating author and protagonist, especially when they resemble each other.[27] The presence of the author within a work of fiction, even a frankly autobiographical one, is a vexing problem for the literary critic and one that I do not pretend to address explicitly in this study.[28] Suffice it to say that the writer of fiction never aims for reproducing her life with total verisimilitude; she invariably invents, transposes, conceals, combines, and creates a personal myth. But to the extent that author and protagonist

share the same *psychological* reality, it would be a mistake not to perceive the isometric relationship between the writer's particular psychological concerns and his or her fictional representative. In the successful autobiographical novel whose subject is the passage through madness, the dynamics of the author's inner world are propelling forces, spawning the milt of primitive obsessions that are to be hatched into consciously crafted literary works.

We, then, will approach literary personae *as if* they were living people, attending to what is said and what is not said, and gleaning from the experiences of author, narrator, and protagonist truths that have meaning for real women. Whenever possible, I shall differentiate between the "author *of* the text and the author *in* the text," to use Paul De Man's formulation;[29] however, since writers often blur these distinctions, particularly in intentionally autobiographical works like Cardinal's *Les Mots pour le dire*, I shall have to be guided by the contours of an inner landscape shared by the author and her persona. Such an approach is primarily psychological, although it will also draw upon ancillary concepts from philosophy, sociology, and anthropology, as they emerge from or seem relevant to close textual analysis.

There is always the temptation to reduce psychiatric fiction and poetry to their clinical contents. This is a dangerous direction for a critic because, even if one has the requisite understanding of psychodynamic theories, a work of literature is always more than an individual case study or even the expression of universal unconscious forces. As Jean-Michel Rey reminds us in his study of "Freud's Writing on Writing," although Freud introduced a form of literary interpretation that privileged thematic content and established a correspondence between literature and dreams, fantasies, and myths, he was also the first to caution that "all genuinely creative writings . . . are the product of more than a single motive . . . and are open to more than a single interpretation."[30] Thus, at the very moment when Freud was producing dogmatic psycho-literary interpretations, he was warning against reductionism. What Freud and many of his followers failed to appreciate is, in Rey's words, "the formal work of which literature is capable, the power that a fictional text can deploy for representation, the syntactic and semantic transformations of which fiction is the locus,"[31] or, more simply put, the structural, stylistic, and linguistic elements of writing that shape the final product at least as much as the author's conscious and unconscious motives. We must look to the madwoman-author as *communicator* of her internal experience, as one whose formulation of an appropriate literary discourse compounds, veils, and often enlarges the historical record.

To write about a mental condition that is, by definition, a state of derangement presents an almost irresolvable paradox: how to present

through language and in an aesthetically viable form the inarticulate and inchoate ground of mental disease—how to communicate the uncommunicable. Somehow by dint of self-examination, self-analysis, self-torture, and an overriding desire to exorcise once and for all the demons of the mind, these writers take on the challenge and find, as in the title of Cardinal's book *Les Mots pour le dire,* "the words to say it." They recreate worlds of suffering where no one who has been there would go again by choice, worlds glimpsed only in nightmares by the rest of womankind. As artists, they unlock the madwoman within and give her voice, so that she speaks our hidden torments, our social indignations, our apocalyptic visions. Paradoxically, it is by assuming the mad persona in her female form that these writers refuse to be victims of mental disease and clinical labeling. Instead they transcend patienthood and transform pathology into art. As A. Alvarez has written of Sylvia Plath, she who emerges from the wreck with a verbal treasure may attain to oracular stature, "salvaging from all those horrors something rather marvelous."[32]

2
Sylvia Plath: *The Bell Jar*

Within the cluster of twentieth-century works of fiction that constitute a literature of madness, *The Bell Jar*, Plath's first and only novel, has attained the status of a minor classic.[1] It has become a touchstone for any author who would dare to write another work of psychiatric fiction. It is especially significant for women writers who recognize their own situation in Esther Greenwood's struggle to withstand the conflicting pressures of an artistic vocation, the surge toward sexuality, and the exigencies of marriage and maternity.

Critics of various theoretical schools have seen in *The Bell Jar* reflections of their own concerns and evidence for the truth of their particular ideologies. For example, certain psycho-political thinkers in the radical psychiatric camp have focused upon the interplay between "our schizoid civilization" and "the schizoid individual." Following R.D. Laing, they have assumed, like the English psychologist David Holbrook in his perceptive study of Sylvia Plath, that "schizophrenia is the inevitable result" of contemporary society.[2] Holbrook's book recalls the earlier work of A. R. Jones, who, in a short piece on Plath's poem "Daddy," stated that "the tortured mind of the heroine reflects the tortured mind of our age."[3] One of the failings of these psycho-political writers is that they do not take sufficiently into account the gender-specific strands of mental disease. In the case of Plath, they do not take seriously enough her fundamental bitterness and rage against a life situation in which she found that being female and being fully human were mutually exclusive. This is the core meaning of the statement found in her journals that "Being born a woman is my awful tragedy."[4]

Feminist critics, on the other hand, tend to see in *The Bell Jar* nothing but its gender-charged aspects. They read it as the work of a prefeminist

consciousness at odds with and crushed by a world of masculine male-
volence, "a world where"—as Plath averred—"in spite of all the roses and
kisses and restaurant dinners a man showered on a woman before he
married her, what he secretly wanted when the wedding service ended
was to flatten her out underneath his feet like Mrs. Willard's kitchen mat"
(p. 69). Certainly a feminist reading of *The Bell Jar* rightly underscores
its political significance as a form of protest against male power and social
conditions that dominate and deform the "second sex." The most com-
prehensive piece of feminist scholarship on *The Bell Jar* is, to my mind,
found in Lynda K. Bundtzen's book, *Plath's Incarnations: Woman and the
Creative Process*. Bundtzen reads *The Bell Jar* as "an allegory . . . about
femininity, and more specifically, three aspects of femininity: the woman's
place in society; her special creative powers; and finally, her psychological
experience of femininity,"[5] and she brings to her study a good understand-
ing of Freudian psychoanalysis as reinterpreted by feminist revisionists.
My major quarrel with Bundtzen is her sometime tendency to follow
Freudian theory and language too slavishly (for example, "Esther Green-
wood, alter ego for Sylvia Plath . . . wished her father dead as a rival for
her mother's affections . . ."); still, *Plath's Incarnations* is a valuable source
for any serious Plath reader.

While acknowledging my debt to both of these theoretical schools, and
especially to recent feminist scholarship, this book has been equally influ-
enced by other sources. It draws its insights from psychoanalytic and
existential theoreticians, although they are not always in agreement with
each other. My basic assumption is that the experience of madness, for
women as well as for men, often derives from fundamental existential
realities, but at the same time, the *forms* of madness that women undergo
have specifically female parameters.

The Bell Jar is constructed upon the bedrock of significant existential
experiences: the protracted illness and early death of the author/heroine's
father that filled her with lifelong anxiety; the rite of passage into adulthood
necessitating choice and forcing a discovery of her own aging process; and
the escape into madness as a reaction to intolerable internal and external
stress. But it also bears witness to female specificity, most notably in the
recurrent images of decaying figs, dead babies, jarred foetuses, and other
forms of aborted maternity that are objective correlatives of the protago-
nist's inner state of terror.

To illustrate the first—the broadly human and deeply existential sub-
structure of *The Bell Jar*—and the second—the gendered expression of
mental disease—let us examine the parable of the fig tree offered by the
narrator, Esther Greenwood, early in the book as a condensed represen-
tation of her sense of being-in-the-world. In the parable, each fig on the

tree represents a different possibility for self-realization, both in the private domain mediated through husband, children, and lovers, and in the public world where the narrator might become a professor, an editor, or a world traveler. The fig tree is grafted upon other legendary biblical trees—the tree of life, the tree of knowledge, the tree of Jesse. The tragic irony of Plath's vision is that she conjures up a twentieth-century nightmare, a Kafkaesque paralysis of starving to death before, indeed within, the tree of life.

> I saw my life branching out before me like the green fig tree in the story.
>
> From the tip of every branch, like a fat purple fig, a wonderful future beckoned and winked. One fig was a husband and a happy home and children, and another fig was a brilliant professor, and another fig was Ee Gee, the amazing editor, and another fig was Europe and Africa and South America, and another fig was Constantin and Socrates and Attila and a pack of other lovers with queer names and offbeat professions, and another fig was an Olympic lady crew champion, and beyond and above these figs were many more figs I couldn't quite make out.
>
> I saw myself sitting in the crotch of this fig tree, starving to death, just because I couldn't make up my mind which of the figs I would choose. I wanted each and every one of them, but choosing one meant losing all the rest, and, as I sat there, unable to decide, the figs began to wrinkle and go black, and, one by one, they plopped to the ground at my feet. (pp. 62–63)

The figs initially describe as "fat" and "purple" are traditional symbols of female fecundity. Esther is not only within reach of these figs—she is sitting *in* the fig tree, in its "crotch." Both "crotch" and "fig," though ostensibly attributes of the tree, are even more suggestive of the person within the tree, and specifically of the female organ, denoting generative powers that wither and die for want of being exercised.

Lest we have any doubts about the meaning of this parable, the author provides a textual interpretation within the text: the narrator is "starving to death" because she cannot decide which of the figs to choose, since "choosing one meant losing all the rest"

Never was the existential dilemma of choice presented more graphically, nor the neurotic personality's inability to choose and thus to live. The reasons for this inability are also clearly stated: any choice implies the exclusion of another choice. Choosing means that certain possibilities will be closed off forever: it brings us closer to an awareness of death, which

Heidegger defined as the "impossibility of further possibility." It means moving inexorably with the stream of life, and inevitably toward one's end. Refusing to choose is a way of freezing time, of keeping alive the illusion of the availability of all possibilities.

Why is the narrator so fearful of choice? Why is she so terrified of growing toward death that anything, even madness, is preferable? The problematic of choice incarnated in the fig tree, already difficult enough for a male facing adult career decisions, is exacerbated for the female by the conflict she experiences between her options as a woman and her options as a human being. The traditionally female option of "a husband and a happy home and children" is presented as separate from all the other options—those of becoming "a brilliant professor," traveling to "Europe and Africa and South America," having "a pack of . . . lovers," and even becoming an "amazing editor," like her female role model Ee Gee, or "an Olympic lady crew champion." Assuming the roles of wife and mother is seen as one choice among many, but one which precludes the possibility of realizing the others. Many American women of Plath's generation and class, accepting the post-World War II separation of spheres for men and women, contented themselves with that first choice, but the protagonist of *The Bell Jar*, like Plath herself, is unable to exclude from her life those options which would fulfill her humanity in other than domestic circles.

We must remember that although *The Bell Jar* is about a young woman of twenty facing her postcollege future, the novel was written by a woman almost ten years older than her protagonist, a woman who had already lived the antagonisms between wifehood, motherhood, and her career as a writer. Plath knew from hard experience that it was possible to be both wife and professor, mother and writer, and she knew too at what expense. When she recreated retrospectively the dilemma of choice, for the person she had been before her breakdown, she undoubtedly had greater conscious awareness of the deeply conflictual nature of the wife-mother-artist combination than she had had as a younger woman.

It is not only the dilemma of choice, with both its pan-human and gender-specific attributes, that the fig tree parable represents, but also the state of paralysis-unto-death experienced by the protagonist in the face of choice. A hint of the source of her inability to deal with the mounting pressures of young adulthood is offered a few pages before the parable of the fig tree. There the narrator refers back to the death of her father when she was about nine years old. She tells us that she was only "purely happy" before she was nine and that she "had never been really happy again" (pp. 60–61). She recognizes that this key loss in childhood (drawn from the author's personal history, like almost everything else in the book) is

somehow linked to the crisis of identity and late adolescent psychosis experienced in her twentieth year.

Several of Plath's poems written between February 1961 and her death two years later perseverate around these two tragedies of childhood and early adulthood. In "Face Lift" (137) and "Lady Lazarus" (198),[6] the "I" of the poem recalls her ninth and twentieth years as landmarks in a personal history of sickness, death, and renewal. In both instances Plath departs substantially from the facts of life, allowing the poet imaginative liberties that the novelist does not enjoy. The most direct connection to *The Bell Jar*, both linguistically and connotatively, is found in lines from "Face Lift" that suggest the death of the old self, discarded in the aftermath of a face lift or successful psychotherapy. "They've trapped her in some laboratory jar. Let her die there"

In "Daddy" (183) the poet refers again to the crucial ninth and twentieth years, although nine is now changed to ten in order to achieve a more symmetrical structure of cyclical rebirth every decade.

> I was ten when they buried you.
> At twenty I tried to die.
> And get back, back, back to
> you.

Written in the wake of her separation from Ted Hughes in October 1962, which liberated Plath's negative feelings toward the male imago, "Daddy" gives us access to some of the violent emotions she continued to harbor toward her long-dead father. Here Plath's persona views her earlier suicide attempt as a desire for union with the father, and her ill-fated marriage to the poet Ted Hughes as a later endeavor to replace the lost father figure with a husband made in his image. Freudian thought, which had penetrated all levels of American culture in the 1950s and 1960s, had given Plath a theoretical framework by which she was able to comprehend her father's lasting importance in her psychic life. As early as 1958 when she was in therapy in Boston with Dr. Ruth Beuscher, she had begun to try to untangle the web of turbulent emotions she experienced for the parent who had "deserted" her at an intolerably early age, and the other—the Mother—whom she irrationally blamed for her father's death.[7]

In *The Bell Jar*, Plath bracketed out her negative feelings for her father; she remembers him only with the nonjudgmental love of a small child, forgetting the morbid tyranny of his long-term illness,[8] suppressing the rage that found release in her late poetry, and reconstituting her past so as to create an idealized version of daughterly solicitude.

Without entering into traditional psychoanalytic theories about the father-daughter relationship (which Bundtzen does, pertinently, in her study of Plath),[9] I wish to suggest an additional line of approach—that the death of a parent of either sex, especially when the child is at an early age, is a traumatic event of massive proportions. As the psychiatrist I. Yalom has written, "The loss of a parent brings us in touch with our own vulnerability; if our parents could not save themselves, who will save us?"[10] The recognition of the finitude of life, difficult enough to assimilate when one is an adult, may prove intolerable when confronted prematurely. Thus, the child's loss of a parent leads to intimations of its own mortality, generating a fund of anxiety that may be crucial in the shaping of character structure. Despite the fact that death anxiety goes underground—that is, it is repressed and remains subterranean in one's later years—the child's dread of death, especially if one has been exposed to it too early and too intimately, as happened to Sylvia Plath, continues to produce internal stress throughout one's life. When combined with the external stress of such a major life transition as Plath experienced on the brink of adulthood, the two forces were of such intensity as to render her helpless, out of control, and ultimately mad.

Why should a life transition involving choice and decision, like that which most human beings experience on the threshold of adulthood, evoke in Plath's case such debilitating anxiety? The insights offered in the parable of the fig tree and in I. Yalom's analysis support each other and offer a reasonable explanation. "Individuals in their late teens and early twenties are often acutely anxious about death."[11] Faced with apparently irreversible decisions, they become anxious, paralyzed, even psychotic precisely because these decisions exclude other possibilities and confront the individual with the "impossibility of further possibility." Passage into adulthood, necessitating momentous decisions concerning one's professional and personal life, may simultaneously unleash unconscious fears of growth toward death; if these fears come to dominate an individual's psychic life, they may precipitate what appears to be entirely irrational behavior.

As Bruno Bettelheim pointed out some twenty years ago in an insightful article entitled "Growing Up Female," breakdowns experienced by college men and women have significant differences according to one's gender. A "boy" is more likely to resolve his " 'crisis of identity' . . . through serious academic work. A girl may undergo a parallel experience, only to discover that her new dedication to scholarship may rule her out of the marriage market. Fearing that her single-minded absorption will allow her chances to slip by, she stops dead in her tracks; or worse, she cannot make up her mind about what she wants, and she may suffer a college-girl 'breakdown.' "[12] Bettelheim's analysis of the "college-girl breakdown,"

if slightly dated for today's female students, has obvious relevance to the mental paralysis experienced by Esther Greenwood.

The Bell Jar tells the story of a young woman facing the rite of passage into adulthood signified by the last year of college. Outwardly, she has all the conventional earmarks of an individual destined for success—an outstanding college record, several career options, even a conventional boyfriend. Inwardly, however, she is terrified of the future and of any decision that implies growth toward maturity and the autonomy of becoming one's own parent. One way of avoiding growth is to become imprisoned in neurotic indecision. This is what the narrator diagnoses as she tells Buddy Willard that she wants to live in both the country and the city:

> "I *am* neurotic. I could never settle down in either the country *or* the city. . . . If neurotic is wanting two mutually exclusive things at one and the same time, then I'm neurotic as hell. I'll be flying back and forth between one mutually exclusive thing and another for the rest of my days." (p. 76)

A feminist interpretation of this passage reminds us of the mutually exclusive demands of marriage and career, and of the double bind experienced by women today caught between a "feminine" and a "feminist" mystique.[13] Like many women then and now, Plath's autobiographical heroine was caught in the squeeze between societal expectations that she herself had incorporated and attempts at self-determination that would have allowed a more authentic self to emerge. If we ask ourselves whether Plath/Greenwood would have been "saved" had she been born a generation later and come to maturity in a more favorable climate for women, what can we answer? I am inclined to believe that her life would have been easier, that she would have felt less alone, but I am hard put to convince myself that she would have avoided the experience of madness after her junior year of college. By the time the author/narrator of *The Bell Jar* had reached her twentieth year, her inner anguish before death and her fear of life bore little resemblance to the cheerful façade she presented to the outside world. The outside world, feminist or otherwise, would probably have been at a loss to comprehend, much less alter, the self-destructive forces at play in the process of her psychotic break.

Yet it is because feminist concerns have sharpened our perception of female specificity that we now fully appreciate the gendered dimensions of the author/narrator's breakdown and partial recovery. In the following pages, I shall consider three major manifestations of gender-specificity in *The Bell Jar*: first, Esther's phobic attitude toward babies, which constitutes a distinctly female form of apprehension; then, her suicide attempt

from the perspective of the influence of paternal and maternal figures; and lastly, male and female imagos who play key roles in the protagonist's therapy.

The narrator's obsessive maternal fears—her "infantophobia"—can hardly go unnoticed. Esther is haunted by visions of babies in various stages of existence: "bald babies, chocolate-colored babies, Eisenhower-faced babies" (p. 181), "big glass bottles full of babies that had died before they were born" (p. 51), babies in the process of coming into the world, cadaverous babies strung throughout her consciousness like a dance of death. At one point she observes outright: "If I had to wait on a baby all day, I would go mad" (p. 182). Her ubiquitous horror at babies exists on different levels of the mind, reflecting both the fears of maternity and the fears of motherhood—those centered on pregnancy, the foetus, and childbirth, and those connected with being a mother in the life-program sense. These two sets of fears are, of course, often intertwined.

It is important to recognize that although Esther's infantophobia may spring largely from personal pathology, it leads to visionary insight. With foresight into the feminist politics of a later generation, the narrator knows that marriage and children constitute for some women, like herself, the ultimate entrapment, and that even the experience of childbirth is structured by male doctors to take control away from the birthing mother— to make her forget her "terrible pain" and send her home with a mind to "start another baby" (p. 53). Thus we must understand Esther's obsessive maternal fears *both* as a symptom of her personal mental illness and as a reasonable reaction to the genuine threat that maternity and motherhood entail for many women.

The scene in *The Bell Jar* in which Esther, under the tutelage of her medical school boyfriend, witnesses a woman giving birth is a remarkable testimony to the feminist critical faculties Plath exercised ahead of her time. She seems to have learned from her own experiences with English midwives who assisted at the births of Frieda and Nicholas in 1960 and 1962 what others turned into a social movement a decade later—that the birthing process, as directed by the medical profession, often places the mother in the role of a passive, suffering observer. Since the suffering of childbirth was, according to Plath, inevitable (and all but a very few mothers would agree), she concluded that "the most important thing . . . was actually seeing the baby come out of you yourself. . . . If you had to have all that pain anyway you might just as well stay awake." The narrator silently asks herself the question women have by now learned to ask: were there "other ways to have babies" (p. 54)?

From Esther's perspective, parturition has been turned to the purposes of a communal male plot against women. She is warned by another medical

student, "You oughtn't to see this. . . . You'll never want to have a baby if you do. They oughtn't let women watch. It'll be the end of the human race" (pp. 52–53). What she does see confirms this ominous forecast: the excrutiating agony of some poor woman on an "awful torture table" (p. 54), a woman-turned-animal, turned-object, thoroughly dehumanized by nature and nurture alike. Mrs. Tomolillo, the birthing mother, "a good girl" (p. 53) in the words of her doctor, blindly follows the instructions of those who would make of her and her countless counterparts nothing but mindless receptacles for the perpetuation of the human race.

Throughout the book women who embrace maternity are depicted as dupes of male treachery, unaware of what they abandon in the process. Esther is acutely aware of the danger that motherhood presents to her creative self. Her boyfriend's naive comment that after she became a mother, she "wouldn't want to write poems anymore" leads her to reflect that having children "was like being brainwashed, and afterward you went about numb as a slave in some private, totalitarian state" (p. 69).

The prime example of maternal mindlessness is Dodo Conway, the mother of six, on the verge of a seventh, who parades her baby carriage up and down the street before Esther's home. Esther's reactions to Dodo are highly revealing.

> Dodo interested me in spite of myself.
> .
> I watched Dodo wheel the youngest Conway up and down. She seemed to be doing it for my benefit.
> Children make me sick. (pp. 95–96)

On the one hand, Dodo incarnates the bovine immanence of woman as flesh, acquiescing to the dictum that biology is destiny. On the other hand, Esther confesses to being "interested" in her and believes, at some irrational level, that Dodo's activities are carried out for her express benefit. Such an idea of reference suggests that Dodo is one of the many doubles for the protagonist. She represents a split-off maternal self, publicly repudiated but unsuccessfully repressed. The maternal path represented by Dodo appears to the protagonist as both a threat and an accusation. Esther feels compelled to duck down below the window of her room in the abject position of a crouching animal so as to escape Dodo's accusatory gaze.

From a feminist perspective, Dodo embodies those patriarchal values with which most women collude in becoming mothers. Through the bodies of innumerable Dodos, society maintains the traditional institution of motherhood which Esther has good reason to perceive as a menace to

her creativity and her sanity. Alone in her determination not to become brainwashed like her female contemporaries, she is nonetheless not above feeling their reproach and a sense of ostracism from the fold. Certainly this sense of being different, even if the difference is consciously assumed, contributes to Esther's increasing state of alienation.

Her withdrawal from the world around her is summed up in the image of the bell jar—an image of being cut off from the rest of the world, shielded from outside stress but also imprisoned within one's own "sour air." The bell jar is, however, not only a metaphor for isolation and psychosis; it is closely associated with the earlier images of dead babies in glass jars, and hence linked to the heroine's infantophobia. A convergence of these two images—that of the bell jar and that of the dead baby—produces one of the most telling expressions of the narrator's anguish: "To the person in the bell jar, blank and stopped as a dead baby, the world itself is a bad dream" (p. 193). Here the narrator is no longer an outsider observing someone else's baby; she *is* the dead baby. She conjures up the dead baby as her personal emblem because she fears that she too is a stillbirth, "stopped," not yet fully born. The revulsion she has felt at babies in bottles and babies in prams and babies with or without teeth is in part the revulsion she feels towards herself; motherhood presents the most fearful of all threats, not only because of the societal implications it has for all women, but because the author at her profoundest level of being fears she has not yet given birth to herself. How then can she give birth to another?

While we should be wary of assuming that having babies is a "normal," "healthy" activity for all women, we certainly have reason to believe that annihilating oneself is an abnormal, unhealthy act. The narrator's attempted suicide can be seen only as flight from life, an unequivocal rejection of her person and potential progeny.

If one is to understand Esther's attempted suicide, it must be examined in the context of her relationship to her dead father. Just before Esther determines to take her life, she visits her father's grave—a grave she has never before seen. In a touching gesture of rapprochement with the dead father, she bemoans the tragedy of a parent's death and the cruel indifference of the universe. "I laid my face to the smooth face of the marble and howled my loss into the cold salt rain" (p. 137).

Immediately following this scene Esther almost kills herself. Up to this point the reader has been made to feel that Esther was only toying with the idea of suicide. But immediately after the graveyard scene, without any transitional passage, she says "I knew just how to go about it" (p. 137). Left unsaid is the connection between the embrace of her dead father and the ability to take her own life. Clearly the encounter with father triggers

her will toward death, but we can only speculate why. Did the suicide attempt issue from a macabre desire for union with the father, a desire that Plath herself described as the longing of "a girl with an Electra complex?"[14] Was it, as Holbrook contends, the logical consequence of a regressed ego craving a return to the original stasis of nonbeing?[15] Was it, as Judith Kroll has brilliantly argued, a quasivolitional act intended to lay the cornerstone for a personal myth of death and rebirth?[16] Was it, as Bundtzen asserts, an act of vengeance against the father stemming from her "great yearning" to pay him back "for all the years of neglect," *his* neglect of her?[17] I suggest yet another possibility: the rediscovery of her father's death may have forced upon Esther the stark discovery of her own mortality. Paradoxically, one way of denying the absolute reality of death is by taking control of it—by killing yourself before death kills you. Esther is so afraid of death that she plans to kill herself in a "calm, orderly way," thereby gaining an illusion of control. She describes the meticulous steps that led from her mother's strongbox containing a bottle of fifty sleeping pills to the cellar crevice into which she squeezed her body and where she carefully swallowed, one by one, the lethal pills. For our purpose it is important to recognize that while the reasons for her attempted suicide will always be open to speculation, the *form* of the attempt was specific and has its own meaning. To choose to die by ingesting sleeping pills is, among other things, a distinctly female form of self-destruction, an "especially female anodyne for life's hurts and ills," as one investigator of female depression recently observed.[18] The form itself implies less active physical violence than, for example, death by shooting oneself—a more prevalent form among men, as the narrator herself notes (p. 127).

This specifically female cast of her suicide is true not only of her inner space invaded by deadly drugs but also of the outer space into which Plath/ Greenwood chose to place her body. She squeezed into an "earth-bottomed crevice" in her mother's basement, "crouched at the mouth of the darkness, like a troll," and on her "knees, with bent head, crawled to the farthest wall" (p. 138).

It was completely dark.

I felt the darkness, but nothing else, and my head rose, feeling it, like the head of a worm. Someone was moaning. Then a great, hard weight smashed against my cheek like a stone wall and the moaning stopped.

The silence surged back, smoothing itself as black water smooths to its old surface calm over a dropped stone.

A cool wind rushed by. I was being transported at enormous speed down a tunnel into the earth. Then the wind stopped. There

was a rumbling, as of many voices, protesting and disagreeing in the distance. Then the voices stopped.

A chisel cracked down on my eye, and a slit of light opened, like a mouth or a wound, till the darkness clamped shut on it again. I tried to roll away from the direction of the light, but hands wrapped round my limbs like mummy bands, and I couldn't move.

I began to think I must be in an underground chamber, lit by blinding lights, and that the chamber was full of people who, for some reason, were holding me down.

Then the chisel struck again, and the light leapt into my head, and through the thick, warm, furry dark, a voice cried,

"Mother!" (p. 139)

The symbolic return to the maternal matrix becomes at the same time the conduit to a second birth. The breakthrough from complete darkness, through the "black water" and "tunnel," into the slit of light that "opened, like a mouth or wound," and finally into full light is a masterpiece of double entendre, presenting at once a realistic description of being transported from a dark enclosure and a metaphoric description of being born. If we have any doubts as to the second level of meaning, they are dispersed by the words with which the passage ends: ". . . through the thick, warm furry dark, a voice cried, 'Mother!' "

One of the little-noticed ironies of *The Bell Jar* is that it is the mother-daughter bond that represents the life force and the father-daughter bond that represents the death force—ironic because mother is the target of such venomous satire and father the recipient of daughterly nostalgia. Unlike the father who died when Esther was a child and persisted unchanged in her heart, mother became subject to adult criticism; she is filtered through the eyes of a highly judgmental daughter who does not spare her mother, just as she does not spare herself. This difference in overt attitude between mother and father may lead us astray in perceiving the underlying psychodynamics: we should not forget that it is the grave-yard encounter with father that acts as a catalyst for suicide, whereas the link with mother saves the narrator from total self-destruction. Unconsciously Esther craves life as much as death and places herself in a womb-like setting where the mother's generative powers have the possibility of being effective a second time.

Similarly, if we consider the two psychiatrists who figure most prominently in *The Bell Jar,* Dr. Gordon and Dr. Nolan, there is comparable alignment between the male doctor and destruction, and the female doctor and recovery. The first, a male, is depicted as thoroughly despicable, while the second, a female, is drawn with trust and affection; indeed, outside of

a Balzacian novel, we are hard put to find two characters who represent the absolute best and the absolute worst of the same profession. Dr. Gordon, an insensitive, inept, self-satisfied psychiatrist, inspires hatred and contempt; Dr. Nolan, the only thoroughly admirable character in the book, inspires love and respect.

Plath's portrayal of Dr. Gordon offers an early version of that psychiatric stereotype that has received its full measure of ridicule during the past two decades—the therapist whose doctrinaire smugness and one-track interpretations are of little use to the patient. Dr. Gordon's inability to understand the depths of Esther's trauma has tragic consequences. He not only is ineffectual in alleviating her presenting symptoms (severe insomnia, an inability to read or eat, and other signs of an acute depression), but it is he who helps to precipitate her suicide attempt through the first disastrous shock treatments she receives under his care.

Like almost all the other men in *The Bell Jar,* Dr. Gordon is a representative of male obtuseness and the exploitation of women. His espousal of the status quo for women is reflected in the photograph of his "beautiful dark-haired wife" and "two blond children" that sits on his desk and elicits a perfectly understandable reaction from Esther: "For some reason the photograph made me furious" (p. 136). Similarly, Dr. Gordon's repeated reference to Esther's college as the place where "they had a WAC station" during the war reinforces the picture of a shallow mentality whose concepts of normalcy are linked to appropriate sex roles. While such attitudes did indeed inform psychoanalytic theory and have not yet completely disappeared from psychiatric practice, Dr. Gordon is clearly a caricature of psychiatry at its worst. His reduction of the therapeutic process to an exchange of irrelevant banalities and his adherence to procedures that do not establish a supportive context for the patient provide ammunition for the critique that psychiatry is not only ineffectual but actively dangerous, especially to women. Twenty years later he would not be out of place in the gallery of dehumanized psychiatrists found in the works of radical feminists like Marge Piercy and Judy Grahn.[19]

By contrast, Dr. Nolan shows us the positive face of the profession. In contrast to Dr. Gordon's male conceit, she offers a paradigm of sisterly compassion, and in contrast to the images of foolish motherhood incarnated in Mrs. Greenwood, Mrs. Willard and Dodo Conway, she offers the wisdom of the mature professional. This symbolic "good mother" (or in current object relations language, the "good enough mother") receives that unambivalent adulation which a daughter can rarely preserve throughout life for her own mother. Significantly, at one of her sessions with Dr. Nolan, Esther blurts out that she hates her mother and is relieved at Dr. Nolan's understanding response. Such hate-mother tactics appear to us as

belonging to an outdated 1950s psychiatric mentality where it was fashionable to vilify the mother, although they may also reflect a genuine psychological need to "kill" the mother symbolically in order to free an emerging self from the stultifying confines of a maternal mold, as Judith Gardiner argues in her work on the development of a female sense of identity.[20] But insofar as the relationship between Esther Greenwood and Dr. Nolan is concerned, it is important to remember that the therapeutic process derives its strength from the trusting encounter between patient and therapist; in a good relationship the patient is able to express her uglier emotions, including those she feels toward the people she loves. That Esther feels free to speak ill of her mother and to tell Dr. Nolan about other anxieties, such as those surrounding sex, is indicative of the positive benefits she derives from working with this therapist.

We are told very little about the content of their sessions. Intuitively the narrator understood that it is not the "content" of their conversations that is significant but the quality of the relationship that ensues. This is made explicitly clear in a statement about Dr. Quinn, another female psychiatrist.

> I often thought if I had been assigned to Doctor Quinn I would be still in Caplan or, more probably, Wymark [more disturbed wards]. Doctor Quinn had an abstract quality that appealed to Joan, but it gave me the polar chills. . . . I never talked about Egos and Ids with Doctor Nolan. I didn't know just what I talked about really. (p. 183)

Good therapy, most practitioners agree, does not rest on the exchange of information between therapist and patient. It is not the *content* divulged but the *process* of sharing—the deep personal encounter—that ultimately heals. Plath sketches an ideal relationship between a young woman in a period of extreme life crisis and a highly effective female therapist. Although the literature of psychotherapy might have profited from a fuller account of their meetings, such amplification would have been out of place in the sparse, frequently elliptic style of *The Bell Jar*. Instead of providing us with a running description of the psychiatric sessions so as to record the process of psychotherapy and recovery, Plath turned to a more literary device. She created the character of Joan, another double for the protagonist. Consciously—perhaps too consciously—Plath followed the models of the double personality she had studied in the works of Dostoevsky—the subject of her college English honors thesis.[21]

Through a process of "projective identification," the narrator externalizes onto Joan, another hospital inmate, the qualities she most dislikes in

herself and experiences toward her both an uncanny sense of resemblance and a strong sense of repulsion. Joan is described as a "big, horsey girl in jodhpurs . . . with a broad smile" (p. 159). Like Esther, she had attempted suicide, and, even earlier, they shared similar histories as inhabitants of the same suburban town where Joan had also once been Buddy Willard's girlfriend.

Joan is the only character in the book who strains the reader's credulity. She does not exist on a convincing realistic level, nor even on the level of caricature, but she fulfills an important psychological function. She is a "mirror image" (p. 160) of the narrator's self-hatred, an outward projection of the self she wants to abandon. Here, as elsewhere, the author signposts and explicates her own text: "Joan was the beaming double of my old best self, specially designed to follow and torment me" (p. 167). She clearly represents those parts of Esther which she most despises: the ever-smiling Pollyanna who is literally *de trop* in her excessive appetite for food and sports and female friendship. Esther turns against Joan with the same kind of ferocity she has shown Buddy Willard, but in this case the cruelty seems gratuitous.

> "I like you."
> "That's tough, Joan, . . . Because I don't like you.
> You make me puke, if you want to know." (p. 180)

Why does Esther overreact so brutally to Joan? The context in which Esther repudiates her, following an interior monologue on the subject of love between women, makes it clear that what Esther dislikes and fears the most in Joan is her lesbian proclivities. Given the certainty that Joan is a double for the protagonist, one cannot avoid raising questions about Esther's own repressed homosexual feelings and her overt homophobia. Although the narrator takes care to present herself as totally unfamiliar with the nature of lesbian love and as thoroughly repulsed by the two or three women she has known whose affection for one another was open to suspicion, there is a telling interchange between Esther and Dr. Nolan that suggests a different perspective.

> "What does a woman see in a woman that she can't see in a man?"
> Doctor Nolan paused. Then she said, "Tenderness?"
> That shut me up. (p. 179)

This interchange, inserted without transition between a meditation upon Joan as the narrator's evil double ("Her thoughts were not my thoughts,

nor her feelings my feelings, but we are close enough so that her thoughts and feelings seemed a wry, black image of my own" [p. 179]) and a recollection of certain college students suspected of lesbianism, seems to derive from a different affective locus. Tenderness is the rarest emotion found in *The Bell Jar,* inspired fleetingly by memories of her father and encounters with Dr. Nolan. It is hidden and almost obliterated by the dominant strains of anger, rage, bitterness, satire, contempt, self-loathing, revulsion, and all the other negative voices that issue from the protagonist's poisoned psyche. Yet these harsh voices are stilled, momentarily, by Dr. Nolan's one word, "tenderness," pronounced in reference to the nature of love between women.

Somewhere, it seems, the narrator had glimpsed the ideal of a harmonious union between same-sex creatures, a Platonic ideal for women as well as for men, but this germ of a vision was quickly effaced by the threat of complicity with behavior tabooed by a heterosexist world.

The fear of tenderness, the fear of homosexuality, and the hatred of motherhood suggest a personality who is not yet fully separated from her own mother (which seems to have been a major problem in Plath's personal life as well). Intimacy with other women thus evokes the threat of merging and the loss of self. To deny this longing for tenderness with its threat of merging and loss of self, Esther Greenwood pursues heterosexual union despite her hatred and distrust of men. Just as suicide may be a counterphobic act in response to the fear of death, the loss of virginity may be seen as a counterphobic act against the fear of intimacy with women.

Despite her fierce aversion to marriage and motherhood, and her anger at "the thought of being under a man's thumb" (p. 181), the narrator can conceive of adult maturity only in terms of losing her virginity to a man. With Dr. Nolan's encouragement, she gets fitted with a diaphragm and sets off to find a suitable seducer. As Esther reminds us, in the 1950s, when "pureness was the great issue" (p. 66), the world was divided not between Republicans and Democrats but between girls who had and girls who had not; Esther confuses the road to sanity with the first option.

When I first read *The Bell Jar* almost twenty years ago, it was easy to dismiss Esther's sexual initiation as total fantasy; I was convinced that her near-death through hemorrhaging coupled with the emergency doctor's assertion that she was "one in a million" (p. 190) was an expression of the author's exaggerated sense of specialness. Later, however, upon discovering through Nancy Steiner's *A Closer Look at Ariel*[22] that the particulars of Esther's nearly fatal sexual initiation were true to the facts of Sylvia Plath's life, I began to recognize that vaginal bleeding is for women an emblem of their psyche as well as a fact of their physical condition. Plath/Greenwood almost bled to death after having intercourse for the

first time. A medical doctor can coolly place her on a statistical chart: "It's one in a million it happens to like this" (p. 190).

An expert in psychosomatic medicine or a psychoanalyst might also recognize the somatic content in the calamitous consequences of the narrator's first sexual experience. What basic dread of violence to body and soul conspired to produce such an outpouring of life-sustaining blood? I am reminded of Kafka in his analysis of his own tuberculosis who wrote: ". . . my brains and my lungs had come to an agreement without my knowledge."[23] Sexual initiation in *The Bell Jar* becomes a formidable rite of passage, accomplished, like everything else in the book, at the price of blood and self-destruction. In the process of casting off her virginity, which had weighed around her neck "like a millstone" (p. 186), Esther also finds it necessary to kill off Joan. The themes of heterosexuality and homosexuality are inextricably intertwined on both the underlying psychological level and on the manifest textual level.

In the penultimate chapter of the novel, chapter 19, the story of Esther's sexual initiation in the bed of a Harvard mathematics professor is framed between two short episodes concerning Joan. In the first, Joan announces that she is about to move out of the hospital to live in Cambridge with one of the nurses, and Esther, despite her envy, drinks to Joan's release.

> "Cheers." I raised my apple cider glass, and we clinked. In spite of my profound reservations, I thought I would always treasure Joan. It was as if we had been forced together by some overwhelming circumstance, like war or plague, and shared a world of our own. (p. 184)

At the end of the chapter, after Esther has had intercourse with the professor and finds herself hemorrhaging, she asks him to take her to Joan's apartment in Cambridge. It is Joan who literally saves her life by transporting her to the hospital before she bleeds to death. Then, without transition, the chapter ends with the news that Joan (not Esther) is dead— that she has hanged herself in the woods.

Esther's reaction to Joan's burial—"all during the simple funeral service I wondered what I thought I was burying" (p. 198)—raises a fundamental question: what was Esther killing off when she killed off Joan? Was it essential for the narrator's recovery that she dissociate herself from any homoerotic propensities? Was it also necessary that she experience a loveless and almost mortal heterosexual encounter? Both episodes seem to suggest a triumph of the will in manipulating experience along the lines of conventional sexuality, but they also point to Esther's failure to be able

to relate satisfactorily to either men or women, suggesting a lonely and troubled road ahead.

Up to this point, I have focused on *The Bell Jar,* distinguishing as much as possible between the novel's protagonist and its author, even though the former resembles the latter to a remarkable degree. Now it is necessary to turn directly to Plath's life for further elucidation of her psychic make-up. One crucial aspect of the Plath drama that has been alluded to, but not directly explored, is her relationship with her mother. As I suggested earlier, Plath's adult attitudes to her mother were highly ambivalent: mother was perceived as nurturer, an eternal source of sustenance, the matrix of birth and rebirth. But mother was also viewed as an inhibiting agent, an intrusive purveyor of conventional values, a self-sacrificing role model demanding cheerful obedience. As Barbara Mossberg reminds us in an article on "Sylvia Plath's Baby Book,"[24] Aurelia Plath, who secured a teaching post in secretarial studies after her husband's death, was the first to stimulate her small daughter's interest in words and writing. Throughout Sylvia's life, her mother derived vicarious satisfaction from her daughter's literary output, supporting it both morally and financially, and offering gratuitous advice on its content and tone, even when Plath was a published poet and a soon-to-be-published novelist. She admonished her mother not to tell her "about the world needing cheerful stuff!"[25] Four months before her death she wrote: "Now stop trying to get me to write about 'decent courageous people'—read the *Ladies' Home Journal* for those!"[26] But for the most part, Sylvia took care to present to Aurelia a sunny façade in keeping with the image that mother and daughter had fashioned together.

Sylvia Plath's letters, published posthumously by Aurelia Plath under the title *Letters Home,* constitute a precious example of a mother-daughter correspondence. They can even be compared with those of Madame de Sévigné in seventeenth-century France, whose maternal attachment for a distant daughter was the greatest passion of her life. In Plath's case, since it is the daughter's letters that have been preserved, we have the opportunity to observe how the daughter at a distance continues to share common ground with a mother who is ever-present in her psyche.

The birth of her daughter Frieda reinforced Plath's sense of a common identity with her mother. She wrote from England when Frieda was two: "I have the queerest feeling of having been reborn with Frieda—it's as if my real, rich, happy life only started just about then. . . . I hope I shall always be a 'young' mother like you."[27] Here the sense of female bonding and identification extends from mother to daughter to granddaughter, ignoring the existence of Sylvia's two-month-old son Nicholas.

To an extent far more than she realized, Sylvia acted out a life script authored by her mother. Only in her *Journal* (see, for example, the entries

from Boston, 1958–59, when Sylvia was in therapy with Dr. Ruth Beuscher) and in a few of her poems (such as "The Disquieting Muses" and "Medusa") did Sylvia express the depth of her anger toward her mother's controlling influence. The relationship between Sylvia and Aurelia was essentially symbiotic. Mossberg calls them "a mother and daughter team" where the daughter was obliged to produce books and babies not only for herself but for her mother as well: "When Plath miscarried, she promised to produce her mother another baby, when she wanted to commit suicide, she cried, 'let's die together!', when there was news of a grant, she announced, 'we're applying.' "[28] The symbiotic union went both ways. If Sylvia was uncertain as to where she ended and mother began, so too was Aurelia destined to live her adult life to a large extent in fusion with her daughter. The introduction to *Letters Home* written by Aurelia Plath gives us a glimpse of the vicarious emotions this mother experienced through her daughter's life. For example, of Sylvia's high school dances, Aurelia wrote: "I'd taste her enjoyment as if it had been my own."[29] Widowed early in her marriage, Aurelia devoted herself almost exclusively to the support and nurturance of her two children; it is understandable, then, that Sylvia, the closest offspring in age, gender, and literary gifts, was experienced by Aurelia as a symbolic extension of herself. Plath complained to her brother Warren in a letter written just months before her death that her mother identified with her "too much" and that she, Sylvia, had to create a new life for herself and her children separate from both mother and husband.[30]

Yet Sylvia, for her part, had such a powerful sense of identification with Aurelia that she had remained psychologically attached to and dependent on her mother long into adulthood, beyond the years when a daughter should, for the sake of her mental well-being, individuate and form a more autonomous sense of self. The negative results of this lack of individuation are seen in *The Bell Jar* in the character of Esther Greenwood, who fears intimacy with other women, despises men yet is willing to be seduced by them, is obsessed by repugnant images of maternity, breaks down on the threshold of adulthood, and tries to take her own life. Ten years after the events that had precipitated her first suicide attempt, Plath was still trying to gain mastery over them by writing *The Bell Jar*; but, despite the guarded optimism of the novel's end, it became tragically evident within weeks of its English publication that the author of *The Bell Jar,* like her fictional persona, had not developed the psychological strengths to carry her through a second period of adversity. Plath's discovery of her husband's infidelity, their impending divorce, the unrelenting English cold, her bout of sickness, and the burden of caring singly for two small children provided ample stress to a life that had been brutally seared in early childhood by

the loss of a father she had "never known." (At the age of twenty-three she was still writing in her journal, "It hurts, Father, it hurts, oh Father I have never known . . ."; at twenty-four still dreaming of the horrors and fears that began when her "father died and the bottom fell out."[31]) Surely the plethora of adverse events preceding her suicide at thirty may have downed heartier souls, and surely we have reason to believe that the fact of being born a woman was part of her "awful tragedy." Yet we also have reason to believe that the existential confrontation with paternal death at such an early age, resulting, in the words of Elaine Martin, in "a claustrophobic intensifying of the mother/daughter bond,"[32] contributed to Plath's vulnerability.

Throughout her life, "Mother" and "Father," distant or dead, would continue to exert their influence upon Plath's susceptible psyche. Father would always be associated with death, paternal absence, and the lack of a validating male authority; the raw pain of these associations was to be reactivated in the final year of Plath's life by her husband's betrayal and desertion. Mother, survivor, life-force, could never fully compensate for the loss of Sylvia's father in spite of, and, ironically, perhaps because of, her herculean efforts to do so. In her symbiotic union with Mother, Plath identified all the more with her when she too, in her early thirties, was left alone with two children. The parallel between her life situation and her mother's must have played into the psychodynamics underlying her suicide.

Given the assumptions that Sylvia both loved and hated her mother— these feelings privately expressed in her journals and publicly vented in *The Bell Jar*—and that she experienced herself as being more than ever like her mother with a future that might be very similar, what further speculation can we make about the meaning of "Mother" in Plath's final self-destructive act? Psychoanalysts often conceptualize suicide as an act of self-hatred, an attempt to kill off the hated "introject." In Sylvia's case, it would have been the bad mother introject that she wished to destroy. Such an explanation is not unreasonable if we add to it insights derived from both existential and feminist thought. From an existential perspective, it may be argued that Sylvia saw before her a life like her mother's, a life lacking possibility, a death-in-life far worse than death-in-death. Taking her own life in the tradition of romantic literary heroes may have been dimly understood as a symbolic act of defiance against entrapment in a prefabricated mothermold. The appeal of suicide existed on many levels— it was, for one thing, something her cheerfully stoic mother never would have done, effecting a wrenching disidentification with the "Old barnacled umbilicus" ("Medusa," 184). Sylvia's destiny would at least be that much different from Aurelia's. Suicide would propel her into an eternal realm

where, as two of her last poems made evident, the "perfection" of death would require suppression of the maternal mode. "The Munich Mannequins" begins with the line: "Perfection is terrible, it cannot have children" (214). "Edge" (224), written less than a week before her death, resolves the antagonism between perfection and motherhood by killing both the mother and her children, and immortalizing their tragedy in stone.

> The woman is perfected.
> Her dead
>
> Body wears the smile of accomplishment,
> The illusion of a Greek necessity
>
> Flows in the scrolls of her toga,
> Her bare
>
> Feet seem to be saying:
> We have come so far, it is over.
>
> Each dead child coiled, a white serpent,
> One at each little
>
> Pitcher of milk, now empty.
> She has folded
>
> Them back into her body as petals
> Of a rose . . .

It is a poem to make us weep, first for Sylvia, then for all women who are driven to choose nonlife over life, all women for whom becoming the Mother erodes one's sanity and one's ability to persevere.

From this end of Sylvia's life, looking back on *The Bell Jar,* we are obliged to consider the years between Plath/Greenwood's psychotic break and thwarted suicide attempt at twenty and her later successful suicide at thirty as a period of reprieve. For ten years, boosted at critical moments by the psychiatric profession, Plath survived and even prospered. Her marriage, at least in its initial stages, her children, and, most of all, her writing, are proof of the strengths defiantly eked out from suffering. Yet her final suicide speaks also of the limitations of defiance and the mysterious fragility of human life.

3
Marie Cardinal: *La Souricière*

In 1966, three years after the appearance of *The Bell Jar*, a little-known French writer named Marie Cardinal published *La Souricière*, a novel about a young mother who deteriorates into a prolonged state of physical and mental inertia and ultimately commits suicide. The book made little impact at the time of its publication, although its author had received the Prix International du Premier Roman in 1962 for her first novel, *Ecoutez la Mer,* and scattered critical acclaim for her second work, *La Mule de Corbillard*, in 1964. Cardinal was to wait another ten years before *Les Mots pour le dire* attracted widespread literary praise and established her as a leading spokeswoman for the female condition.[1]

Les Mots pour le dire was a "thundering success," selling 320,000 copies in its first two years.[2] Cardinal's readers, predominantly female, were attracted by the compelling voice of a middle-aged woman who found "the right words" to describe her seven years of psychoanalysis and whose release from debilitating forms of depression could be their own. Cardinal came to represent for her public a success story wrought by the mysteries of psychoanalysis, a form of treatment that did not become fashionable in France until the 1970s. Few have read her earlier work on madness, *La Souricière*, which presented a grimmer reality.

La Souricière and *Les Mots pour le dire* are two radically different examples of the psychiatric novel written by the same person on the basis of the same experience. The first is predominantly a work of anguish and defeat, culminating in the triumph of insanity. The second, "the book of an adventure that takes place through psychoanalysis," describes the author's rebirth into sanity.[3] Together, like the two halves of *The Bell Jar,* they constitute the story of breakdown and recovery.

La Souricière is not, however, the literary equal of *Les Mots pour le dire*. Whereas the latter work displays the hard-won authority of the mature woman and author, the earlier book exhales the tremulous and disquieting breath of adolescence. Its psychological interest derives primarily from viewing it as an early, partially successful attempt to transpose mental illness into the familiar fictive form of the novel of the individual, with the ironical twist that it entails an apprenticeship into madness. Though Cardinal would probably deny the influence of André Gide, whom she knew as a child in North Africa and instinctively hated, *La Souricière* has something of *L'Immoraliste* in reverse.[4] A young woman is removed from the South of France by marriage and installed into Parisian domesticity where instead of sensual freedom she experiences the deadening effects of three successive pregnancies. In less than five years the marriage of Camille and François—she a young Provençal who had scarcely passed her baccalauréate and he a Sorbonne professor fifteen years her senior—breaks apart. Camille closes into herself, into a terrifying world of obsession with her body and physical decay.

> Her body lives and she as well. Their lives are different and yet they are linked to one another in the closest possible way. She is afraid she will be forced to endure death with this body. She is afraid of participating in the putrefaction of her flesh, in its liquefaction, afraid of remaining locked within an iron box, with her bones and worm-infested shreds of meat. (pp. 102–3)

As Camille becomes further imprisoned in morbid images of bodily decomposition, avoiding her husband and children as much as possible, he turns to the conventional outlet for married men: other women. At twenty-nine Camille feels that she and her marriage are finished, ". . . that only death could deliver her from such a life, and she had an appalling fear of death. She felt like a prisoner caught in a sordid mousetrap" (p. 135).

The mousetrap gives to the novel its title and tone, its sense of helpless entrapment within an oppressive prison. "La souris," the mouse—in French the word is always feminine in gender and connotation—does not try to resist her captors or even rage against an unjust world that penalizes females; instead, she assumes the shame of her putrifying condition and literally rolls up to die. This is how her one remaining friend, Alain, finds her: "She is rolled up in a ball in a corner of her bed and rocks back and forth, enveloped in the rhythm, giving herself up to it completely" (p. 144). This portrait of a catatonic stupor such as one normally sees only on the most disturbed chronic wards of mental hospitals is convincing enough,

but the circumstances of Camille's treatment and miraculous recovery are not. The reader is obliged to accept, on faith, the doctor's prognosis.

> If she is willing to be treated, she will be cured in two months. . . . What she has is very common today; she must have had a postpartum shock after the birth of her first baby. Not having been treated, her depressive state has simply become aggravated by the other pregnancies. Each bout of fatigue, each setback has only pushed her further into depression. It's a classic case of melancholia. (pp. 144–45)

Despite this glib prognosis, there is a good deal of truth in the doctor's summary of the wear-and-tear on Camille's body, let alone the influence of up-and-down hormones on her mind. But whatever the author's intent in offering such a simplistic medical analysis, it is here that the choice of the name "Camille" reveals itself: what consumption was to the nineteenth century, mental illness is to the twentieth. Our modern Camille is a victim of the illness of her age in its specifically female form. While Betty Friedan in *The Feminine Mystique* was simultaneously diagnosing modern housewifery and motherhood as the problem that has no name, Camille was naming that sickness, in its most extreme manifestation, as postpartum depression and classic melancholia.[5] Having had, in real life, three children in four years, subsequent hospitalizations, and a history of psychosomatic illnesses, the author drew the clinical picture largely from her own experience.[6]

Fiction, of course, is something other than the faithful transcription of reality, and it allows for, indeed demands, that reality be transposed by both memory and imagination. In the novel, Cardinal allows herself the luxury of a fantasy of total recovery that was not realized at that point in the author's life. After the full horror of Camille's psychosis—'le point culminant" found in the third chapter of a five-part drama—the author plunges into a fantasy of complete well-being. In chapter 4, Camille and her friend Alain find themselves on a Mediterranean beach happily united in the certainty of her cure. Although the least convincing part of the book, this idyllic escape to the setting of Camille's childhood provides a temporary setback to the ravages of mental illness and a respite from what would otherwise have been a long, uninterrupted cry of anguish. However, unlike the first-chapter description of familial harmony with her mother and siblings during the golden age of childhood, the vision of happiness with Alain is peculiarly colorless and insubstantial. In contrast to the other characters in the book—Camille, her husband François, even the maid Maria—Alain has no distinct character. He seems to have issued from

Camille's need for a concerned friend and father-figure, an all-caring, all-knowing substitute for the father who had died when she was a teenager. (In *La Souricière* Camille's father frequently appears in his daughter's nostalgic reveries; we are to learn more about the reality base for Cardinal's parental images in *Les Mots pour le dire*.)

Alain does not press Camille into sexuality as had François; he is concerned exclusively with her recovery, encouraging her to become more assertive—"elle ne se laissait plus faire" (p. 155). ("Se laisser faire" is used repeatedly to describe Camille's relationship with François.) The contrast between the person she becomes in the presence of Alain and the person she had been for more than a decade with François is striking. The earlier Camille had been "formed" by François. From the moment that he had become physically attracted to her, he began to initiate her body into sexuality. "François said: 'Let yourself go' and she obeyed" (p. 41). She had allowed him to determine her adult life according to his professional and personal needs; he had fathered their three children, dismissed her illnesses as imaginary, and finally abandoned her when she became more of a liability than an asset.

But for all that, François is not simply a bastard. He comes across as a flesh and blood man, both egotistical and tender, passionately interested in his work and attached to Camille in his own way. The dialogues between Camille and François have the ring of truth that is missing from the exchanges between Alain and Camille. It is as if François were based on the model of a real person, whereas Alain is the hazy projection of the author's need for a rescuer. It is surely no accident that Camille's first meeting with Alain had taken place through the intermediary of a friend named "Sauveur" (savior).

Ultimately, the fantasy of the rescuer proves to have less substance than the reality of the husband, returning from the United States after a two-year absence. And it is in this last part of the book, the "fifth act," that Cardinal reveals a greater versatility as a novelist than one might have expected from the four earlier chapters. The reunion of Camille and François takes place within an initial context of confidence on her part and a sense that nothing has changed on his. The husband repeatedly refuses to confirm Camille in her new sense of self: his reiterated remarks that "you haven't changed" (p. 177), that "one doesn't change" (p. 180), are not the words she had hoped for.

> She wanted to hear him say that he had waited for her metamorphosis to be complete, that he had lain in wait for the day when he would know all the wealth that was in her. . . . Camille rediscovers the sensation of being delivered up to an unknown force

which makes her move according to a rhythm that does not suit her. She wants to struggle, she doesn't want to be smothered. Why doesn't she just run away? (pp. 185–86)

But instead of running away from or kicking out this man whose mere presence annihilates her precarious hold on a new identity, Camille escapes into new forms of fantasy, less morbid than the old but equally as dangerous. When François makes love to her in the old way, "elle se laisse faire" and fantasizes scenes with the Hollywood actor Gary Cooper. When François tells her that he had lived with another woman in America and that she is pregnant with his child, the shock of this news is more than Camille can take, and she begins to hallucinate the presence of "l'Américaine" in her home; along with Gary Cooper and the pregnant American, they sit down to dinner.

> The pregnant American moves into Camille's home. . . . She's going to have a baby, poor thing. You can't beat her up or throw her out. Camille has nothing against an infant, he didn't ask to be born and anyway he'll be her children's brother. (pp. 197–98)

This new form of fantasy, superficially more lighthearted, even funny, has pernicious undercurrents. Camille begins to identify more and more with the pregnant American, in the hope of vicariously becoming, once again, the mother of François's offspring.

> The further the pregnancy advances, the more active Camille becomes in her house. She has to polish the floors, scrubbing furiously so that it will be spotless for the baby's arrival. Camille's belly has become very heavy. . . .
> Camille remains alone all day with the American. . . . Her pregnancy is long and slow. It seems to Camille that this baby is taking years to be born. . . .
> Camille starts to have nose bleeds. She is getting fat. (pp. 204–6)

The fantasy of false pregnancy, technically known as *pseudocyesis,* during which a person goes through an uncanny mental identification with a pregnant woman, is not uncommon in the psychiatric literature. Camille's symptoms, including the physical component of increased weight, correspond to many reported cases, some of which are carried into false labor. Camille does not get that far; she ultimately decides it is wiser to drive the American out of the house, but from that day forth she feels that "her life no longer has any value. It's just this simple; if she hasn't been able

to keep the pregnant woman in her home, then she's not good for anything"
(pp. 207–8).

For a time the fantasied identification with her American counterpart
had given Camille a sense of identity to replace the one that had not
survived her husband's homecoming. Because her earlier sense of self as
an adult woman had been fashioned out of the roles of wife and mother,
it had been easy, all too easy, to slip into the role of mother once again,
if only in fantasy. Instead of rage at the woman who had usurped her
place—not to mention rage at the husband who had annihilated her iden-
tity—Camille had assumed a sisterly stance toward the unknown Amer-
ican, imagining a female community à deux, and ultimately turning the
guilt upon herself for evicting her pregnant double. Such are the Byzantine
psychodynamics that send the protagonist on a final downward trajectory.

In a last-ditch effort to extricate herself from total despair, Camille runs
to her friend Alain and proposes that she leave her family for him, as he
had desired earlier. Alain's refusal to play the old part of savior and the
new stance he adopts as critical judge of her conduct come as a surprise
to Camille and to the reader. His unexpected harsh statement that "she
is living a lie" (p. 214) reminds us of the astonishing ending of Kafka's
story "The Judgment" when the son receives the verdict of death by
drowning from his father and rushes from the room to carry out the
sentence.[7] So, too, Camille, upon hearing the severe judgment of her
behavior from someone who had previously shown excessive loving-
kindness, now decides to take her life.

This sudden change of set leads us to suspect for the first time that
Camille's vision of reality may be unreliable. Alain's change of face suggests
a different reality—that of the "other" who tires of being treated as a sick
person's rescuer and eventually turns against her. As in the world of Kafka,
the view of the suffering protagonist experiencing herself as innocent
victim is a distorted view to the extent that it does not take into account
the way in which the individual contributes to her own destiny.

The unexpected twist of plot and change of style that mark the end of
the novel suggest points of view different from that of the protagonist,
whose subjective reality provides the novel's central filter. There is the
point of view of the husband, returning from the United States and finding
her unchanged, subject as always to her "comédies." There is the point
of view of Alain, beginning to sound more like the husband, as he tells
her that she is "authoritarian, egotistical and . . . demanding" (p. 215).
There is the point of view of the two anonymous voices who observe
Camille stretched out dead and pronounce her "punished." And there is
the point of view of the omniscient author, who delivers an ironically
happy ending—the last sentence of the book reads: "Some months after

his wife's funeral François married the American and they, apparently, lived happily ever after" (p. 219).

The final chapter—fifth act of a strange tragedy—offers more than one interpretative possibility, including a straightforward feminist approach. A feminist reading might lead us to the conclusion that Camille commits suicide because, despite her often reiterated love for her husband, she is unable to live with him without going crazy. François is the culprit who led her into marriage, maternity, madness, and suicide. Alain's sudden about-face should then be read as universal male collusion, and Camille's suicide as brainwashed submission to male tyranny, the protagonist cast in the role of ultimate scapegoat and sacrificial victim. Such a clear-cut feminist interpretation has its merits, especially on the sequential level of plot, but it does not take into account the full spectrum of existential givens intrinsic to the female condition. The strength of Cardinal's writing, both in *La Souricière* and *Les Mots pour le dire,* lies in something larger than an indictment of men and the enterprise of patriarchy, though *La Souricière* presents ample evidence of the debilitating effects of male dominance on a young bride; elsewhere Cardinal has spoken out even more directly against the bane of sexism.[8] Her strength as a writer lies largely in her ability to render mental conditions through an evocation of feminine specificity in the flesh; both *La Souricière* and *Les Mots pour le dire* are rooted in a minute observation of the female body in all its generative and mortal potential. This focus on the female body, a quintessentially French phenomenon among contemporary women writers,[9] seems to indicate, especially in the case of Cardinal, that women have an ontologically different relationship to the universe due to their maternal potential, and that they carry the seeds of their own salvation or destruction largely in their own bodies. Madness and sanity, maternity, and death are firmly encased within the author/protagonist's skin and flesh, which in Cardinal's books become not only the focus of the narrative action but also the index of her spiritual journey. Cardinal uses the female body as a meeting ground for the themes of maternity, madness, and mortality. Although I analyze each of these themes separately, they are, of course, all interrelated in just the way that mind and body are both separate and one and the same.

Cardinal recognizes the maternal capacity as a crucial given of the female condition. It may contribute to happiness or tragedy, to psychic well-being or mental anguish, to a healthy or a threatened sense of self; but whatever its effect, the potential for maternity is a pivotal element in any woman's destiny. In her writing Cardinal evokes aspects of maternity with a force that is rare, if not unique, in literature—not that she has much competition. As Tillie Olsen reminds us in *Silences,* literary history has rarely been made by women who have had children, and therefore what

is known of maternity and motherhood through literature is generally written from the perspective of men or, less frequently, by women who were not themselves mothers. Cardinal is one of the exceptions, along with the English writer Margaret Drabble, both of whom published novels on pregnancy and childbirth in the 1960s, a decade before the work of Adrienne Rich, Jane Lazarre, and other American feminist mother-writers.[10] And given Cardinal's talent for re-creating the physical as well as the mental, she brought pregnancy and maternity into French literature with a vengeance.

Women who have known the discomforts of pregnancy and the excruciating pain of childbirth will recognize, with grim satisfaction, the authenticity of Cardinal's descriptions—for example, that of the scene where Camille is obliged to attend a Latin play directed by her husband at the Sorbonne on the very night she goes into labor. We share Camille's malaise as she is squeezed into a narrow theater seat and understand her feelings of awkwardness, shame, and fear, and her necessity to conform to public patterns of behavior when, quite literally, her insides feel as if they are about to explode. And we empathize with her unspoken anger at those around her, including her husband, who are indifferent to the turbulence within.

But it is especially in the pages describing the experience of childbirth that we share the pain and recognize the complex ambivalence women feel about the physical process of giving birth. It is necessary to quote at length a few of these pages because they will give an English-reading audience the chance of knowing Cardinal first-hand and because they spell out the interrelationship between maternity, madness, and mortality inherent in her writing.

Camille experiences childbirth as a "mighty battle" taking place on the territory of her own body: mother and foetus are pitted against one another in a physical struggle where the claims of the new life prevail. The husband, the nurse, and the doctor are seen as conspirators with the baby, each oblivious to and in some way contributing to the mother's agony. The birth process is essentially a divisive phenomenon—one that not only separates the baby from the mother but the mother from herself.

This antagonism between mother and child, between self and self, is rendered in short, staccato sentences: "her child is her enemy. She herself is her enemy." Occasionally the present tense is interrupted by the past tense (for example, "She cried like an animal"), the effect of which is to convey a further sense of rupture. Images of uncontrolled "machines," of a "mousetrap," of "chromium objects and faceless people" contribute to the overall impression of a dehumanizing ordeal imposed upon women by a ruthless biological division of labor.

In many ways, Camille's experience of childbirth resembles an experience in mental breakdown, understandable only to the person in the grip of the event and incomprehensible to persons outside. The husband, the nurse, and the doctor, representing rational thought and behavior, scold her for her inability to act according to instruction: "You're not doing it right. Pay attention." She, however, is beyond the range of reason— "Camille loses her head—she screams"—and the reader is made to feel that Camille's subjective reality is the only valid reality, that those who speak of "controlling yourself" and "taking it easy" are giving inappropriate, even foolish advice. The truth of parturition is that it defies any known standards of behavior; it projects the primagravida into a unique sphere of existential aloneness where no one other than the birthing mother can do her work for her and where she alone must choose, according to her personal capacities, how she can endure the process. In this respect, birthing is like dying—an ultimate encounter in solitude, with the crucial difference being that one generates new life while the other brings life to a close. Cardinal's harrowing description of giving birth reminds us that each new life is dearly paid for by the female parent.

By one o'clock François still isn't there. The contractions are like very powerful deep sea waves. Camille pants without stopping. Soon the sound of her breathing fills the whole room. She no longer is conscious of the noise outside. Breathe in, breathe out, ah ah ah ah ah ah! A few minutes, then once again the reminder given by her muscles: breathe in, breathe out, ah ah ah ah ah. Now she has been there more than eight hours. She feels terrible, she's hot. It's unpleasant, but she was expecting it. It's at least bearable.

All of a sudden the machines start up again at full force. These machines are her own body, but they are not subject to her orders. The rhythm, the violence, the implacable will of all her muscles are directed at expelling her child, at driving it out. A war she hadn't declared, a mighty battle she must now endure, takes place on her own territory. She wants it to stop for an instant, a single instant, but what she wants is of no importance. Labor takes place without her and yet with her. It's absurd.

François has arrived. He looks at his wife with fear.

"It's not too bad?"

She makes her head move on the pillow to tell him that she's all right, that she's too busy to be able to answer. . . .

The contractions follow quickly one after the other. Sometimes the young woman is no longer able to get her breath back in time. Her muscles tighten up, she moans softly in the midst of panting.

She is delivered up to herself, and herself is her own worst enemy. She is afraid. She murmurs:

"I am caught in the mousetrap."

François is devastated. He repeatedly comes and goes. He wants it to be over with.

The nurse arrives, this time with a table on wheels loaded with metal boxes and instruments that clink against each other. She takes out a long pincer that looks like an instrument of torture.

"I'm going to pierce the amniotic sack. That won't hurt, it will make you feel better. It won't be too long now."

The warm pleasant water runs down Camille's buttocks. She is naked on her bed with her huge stomach and her legs spread apart. She doesn't care a bit if anyone comes in. There's only one thing she wants now: to be delivered.

Her doctor is with her, he is reassuring, she knows him very well. He speaks to her as if nothing unusual were happening. She makes an effort to answer. He puts his cold hands on her stomach and percusses it skillfully.

"There's a contraction—go ahead."

She applies herself like a good student.

He examines her; the nurse examines her. The doctor announces: "They're going to take you to the delivery room. Everything's just fine."

They come to take her away and transport her to a very bright room. What time is it? François is there. He's holding her hand. She squeezes it.

The delivery room bed where she is placed is covered with a cold plastic sheet. She begins to shiver. As in a science fiction landscape inhabited by chromium objects and faceless people, she sees her thighs tremble.

"Get hold of yourself."

François' hand squeezes hers. She must appear hideous to him. How many hours has it been? Ten? Twelve? She has no idea. The doctor says:

"You're about to deliver. Do you remember what you have to do?"

She nods her head. He reminds her just the same:

"Grab hold of this bar. Breathe in deeply, then breathe out completely. Then you bear down while pushing. All right?"

"All right."

The rhythm has changed. Camille loses control. She no longer knows when it begins and when it ends. The bones of her pelvis

are pushed apart by the thrust. She pushes irregularly, she grasps onto anything.

"You're not doing it right. Pay attention. Go ahead. Go ahead. Breathe in. Breathe out. Go ahead. Bear down. Push. Again. Again."

She cried like an animal.

"You're not controlling yourself. The less you're in control, the longer it will last. There's another one. Go ahead. Bear down. Push. Down below. Push again. Again. Again. There's the skull."

She doesn't give a damn about the skull. Her child is her enemy. She herself is her enemy. The others are distant and can't do anything for her. Now she rebels. She no longer obeys. She screams.

"Put me to sleep. Put me to sleep."

She heard François' voice as if it came from, a far distance: "Take it easy, Camille."

She doesn't give a damn about François. She detests him. She'll never sleep with him again. She'll never have another child. She hates his sex organ, his and any other man's. She despises the way humanity reproduces and couples between the legs.

They put a mask over her face and tell her to breathe deeply. She breathes in greedily. Again. Again. Its odor makes her drunk. Her body slowly disappears. . . . (pp. 79–83)

Part of this passage recalls the scene in *The Bell Jar* when Esther Greenwood, taken by her medical student boyfriend into a delivery room, observes, to her horror, that the birth setting has the characteristics of a torture chamber, and that women in such a setting are completely at the mercy of male medical experts who treat childbirth as an anonymous procedure, to be endured blindly by the birthing mother. Cardinal, like Plath, recognizes the absurd discrepancy between the rational control demanded by the attendant medical professionals and the incapacity for rational control experienced by the woman in the throes of giving birth. Camille in *La Souricière* sees—as do most women—that control in the birth room is held mainly by those who do not have to experience the pain of childbirth. More than at any other time in her life, she is caught in the "mousetrap," naked and vulnerable, her legs wide open, and, to add insult to injury, subject to the ludicrous statement, "you're not doing it right!" The birth process, which for women under more fortunate circumstances can be an experience in self-empowering—a rite during which one gives birth to a new identity for oneself and one's offspring—is warped by the impersonal hospital setting and the medical mentality that blames the "victim" for her inability to perform according to a standard model of birthing behavior.

In Camille's case all of the negative aspects of childbirth prevail. Birthing is a bitter surprise forcing the discovery that the body has a will of its own and that it functions with or without one's conscious directions, even in opposition to them. Much later, after the birth of two other children, Camille is still fascinated by the same realization that she and her body are different entities.

This fundamental discovery of the separation of mind and body is intricately related to Camille's existential crisis and the massive anxiety that develops postpartum. From the period of life before her marriage and pregnancies, Camille recalls only a prelapsarian existence in which she was at one with her family, the Provençal countryside, and her body. The loss of this childhood paradise, when "her body was her best friend," translates repeatedly into the phrase that "she no longer has confidence in her body" (p. 102)—a loss of confidence that began with the changes of pregnancy. At first these changes express themselves only in fatigue, lassitude, and a lack of sexual desire. Instead of finding and enjoying physical pleasure, even on holiday in the setting of her youth, she becomes prey to weird fantasies: "a profusion of phantoms, princesses, gnomes, does, ectoplasms, heroes kept her company. They took long walks together in a trembling world where only the mad are admitted" (p. 89). Then the world of the mad becomes the only world she knows.

From maternity to madness, this is the explicit sequence of events in *La Souricière*. Other women authors—Charlotte Perkins Gilman, for example, in *The Yellow Wallpaper*—have described the sequential relationship of motherhood to mental breakdown, but none with such unambiguous clarity as Cardinal. For Camille, motherhood is not only a female form of apprehension, as in Plath's *The Bell Jar*, but a precipitating factor in the gradual process of alienation from others and from herself. Madness takes the form of an obsession with the changing body and with the spectre of death in the confines of a self-imposed prison: "Her universe became smaller: her neighborhood, then her house, then her room" (p. 95). Withdrawn within herself, she spends days, years, observing the minute changes in her flesh, her wrinkles, the puffiness of her skin. She goes to doctors who tell her there is nothing wrong with her: "nothing wrong with her heart, her lungs, her kidneys or intestines. Nothing at all. It was only nerves . . ." (p. 94).

The symptoms of excessive fatigue and hypochrondriacal preoccupation with one's body are those typically associated with neurasthenia—a diagnosis still current in Europe, especially for women. For numerous reasons, women have been more prone than men to attend to their bodies: their physical beauty has traditionally been their stock in trade; the monthly changes of menstruation and the upheavals of pregnancy can scarcely go

unnoticed; the female climacteric is also more dramatic than the male version of this life stage. Perhaps because men's bodies make fewer demands than women's, it has been easy enough for male physicians to dismiss female complaints under the general category of "nerves."

In the case of Camille, her hypochondriacal symptoms are clearly linked to something even more primary than the biological constraints of menstruation and pregnancy, and the social constraints of marriage. They are linked to an overwhelming fear of death and probably represent an unsuccessful attempt to ward off a deeply rooted, all-pervasive death anxiety. If the death anxiety were less acute, Camille's symptoms might be limited to an exclusive focus on bodily ills; perhaps she would fall prey to the many forms of medical charlatanry that provide consumer opportunities for the advanced hypochrondriac (such as optional surgery, worthless medicines, and quack treatments). Her exaggerated concern for the body, however, is accompanied by a conscious fear of death and by an awareness that the obsession with bodily decay and death is not normal.

> She shouldn't think about it. All people are made the same way and accept their death. Why shouldn't she? . . .
> People who have thoughts like hers, who live as she does with an absurd obsession, they're called crazy. (p. 103)

It is an irony of the human condition that those individuals who are most sensitive to the reality of death are sometimes considered mad, when they are, perhaps, simply closer to the truth than "normal" people. The problem is not that they are incorrect, but that the defenses they have erected against death are inadequate. For who can live, sanely, in the face of death without developing defenses? Most "normal" people build these defenses early in life and, once established, they become the most entrenched parts of our psychic armature. Later in life, forced to face our own mortality, we discover death anew as if for the first time. This is the painful message of Tolstoy's *Death of Ivan Ilych:* though we know that "all men are mortal," each of us revolts in terror when personal death becomes imminent.[11]

Camille's second discovery of death (the first having presumably occurred in childhood) is clearly related to the experience of maternity. "Before the birth of her children, death hadn't entered her mind" (p. 121). Lest we have any doubts, it is made clear that it is not the fear of her children's death that terrifies her, but her own.

Maternity had been the agent that brought to Camille's consciousness an awareness of her own mortality, and this terrifying awareness makes "normal" activities impossible. For years she is paralyzed by death anxiety

and even when she makes a cosmetic cure, she is unable to sustain her recovery because it has not been built upon a confrontation with the true sources of her illness.

A further clue to the psychodynamics at work in her suicide is found in the word *punished* overheard by Camille in her final hallucinations. Killing herself is an ultimate response to the pervasive guilt feelings that have obviously grown to unmanageable proportions in her psyche, although the complex roots of these feelings are only suggested in this novel. (An examination of *Les Mots pour le dire* in chapter 4 will show the genesis of these guilt feelings in the author's life.) Camille's debillitating sense of guilt, worthlessness, and inauthenticity, and, paradoxically, her overwhelming fear of death, are some of the overdetermined factors that lead her to take her own life. She prefers to surprise death before death surprises her. This at least gives her an illusion of control extending beyond her lifespan; she seems to derive a perverse satisfaction from the knowledge that François and his American mistress will owe their happiness to her death, and that they will undoubtedly also be obliged to experience a certain measure of remorse. This is a common enough death-fantasy among those labeled sane, as well as those labeled insane.

Mortality is, of course, a given of every human existence, male or female, and we have no reason to believe that it is any easier for males than females to accommodate themselves to that fact. Indeed, because women have the potential for bearing life, one might argue that they fear death less than men, since they may be consoled by the thought of leaving behind the fruit of their womb.

Marie Cardinal suggests a different position. *Because* women produce babies, because they learn through childbirth that the body has a will of its own, that it moves implacably toward the generation of new bodies at the expense of the old, they become tragically aware of their own impotence in the face of biology, aging and death. Some women cannot tolerate this knowledge within the bonds of sanity. Why some women experience maternity as the gateway to insanity and others as the gateway to salvation does not lend itself to easy answers.

In *La Souricière* Cardinal was trying not to understand "why" but, rather, to describe in the conventional literary form of the third-person novel what it feels like to be in the grip of madness. Despite the novel's obvious failings—its adolescent self-absorption, its lack of fully developed characters, its sometimes unconvincing plot, its uneven style—it has the merit of successfully translating the mad woman's underworld into a terrain accessible to the uninitiated. It also raises questions about the relationship between female physicality and mental derangement, which the author went on to explore further and less conventionally in *Les Mots pour le dire*.

4
Marie Cardinal: *Les Mots pour le dire*

Of the many psychiatric novels written by women during the past two decades, *Les Mots pour le dire* presents a remarkable example of female specificity. Speaking in the voice of the first person, the author recounts her history of a mental illness that took the form of an abnormality in menstruation—a menstrual period lasting for more than three years.

Initially the book focuses on details known only to women, on those furtive gestures women make to discover if they have begun to bleed, if they are still bleeding, if they have stopped bleeding. Cardinal spares us none of the shame-ridden secrets of menstrual blood, and in doing so she draws her female readers into a circle of complicity and her male readers into the position of privileged bystanders. Because menstruation is simultaneously one of the most common female experiences and one that is encrusted in ancient taboos, it has the potential for unexpected metaphoric complexity. We are told that the protagonist wished to make of her bleeding "le centre et la cause" of her illness so as to draw attention away from her mental condition.

> All of that seemed to justify my derangement, made it acceptable, less suspect. You wouldn't put a woman in an asylum because she was bleeding and that terrified her. As long as I spoke only of the blood, . . . they wouldn't see what it masked. (p. 14)

What the blood masks is the true subject of the novel: a woman living in perpetual fear, afraid of falling down, of dying, of decomposing; haunted by the sense of her inner darkness; given to the hallucination of a "living eye" that follows her about; and fearful that others will notice her psychic

warp. This is the clinical picture she presents at the onset of a psychoa-
nalysis that lasts seven years.

The problem of Cardinal the analysand, as for Cardinal the writer, is
contained in the title of the book: how does one find "the words to say
it"? For the patient vis-à-vis her doctor, the dilemma is "how to find the
words that would flow from me to him? How to construct the bridge . . ."
(p. 11). For the artist, how to find the words that will transmute interior
monologue and psychoanalytic dialogue into literature? Words, in this
context, have an extra dimension because, as Cardinal tells us, "for the
mentally ill, words and objects are as much alive as people or animals"
(p. 16). The author's mandate was to convey the emotional charge that
deranged individuals perceive in words—to convey their living quality
and their magical force. It is exactly this word-power that Cardinal acquired
in the ten years between the writing of *La Souricière* and *Les Mots pour
le dire*—two books that tell a similar story, though with distinctly different
styles and outcomes.[1]

The word designated by the author for her tortured inner condition is
"la CHOSE" (p. 11) ["the THING"], a noun that signifies both the
concrete reality of a specific object and the haunting vagueness of an
unknown menace. Moreover, "la chose," on the tongue of the narrator,
partakes of that animate character which she detected in words as well as
in sentient beings. For Cardinal's persona, "la chose" provides the central
column of her existence, separate and alive like a deep-sea creature. "It
was dense, thick, trembling with spasms and great swells and with slow
movements, like those at the bottom of the sea" (p. 11). By imaging her
anxiety in the form of underwater life, the narrator suggests the teeming
phantoms of her inner world.

In another passage, the cosmic fear she experiences is communicated
through a fixation on corporal substances named without euphemism:
sweat, pus, shit, piss. These are the forbidden words that must be con-
quered and assimilated during the confrontation with her personal demons.
Like Pascal contemplating the movements of the universe and drawing
back in horror, the narrator observes the movements of her own body and
is terrorized by the sight of life feeding on life.

> Why this life which feeds on itself? Why these pregnancies filled
> with agony? Why does my body grow old? Why does it produce
> stinking solids and liquids? Why my sweat, my shit, my piss? Why
> this dung heap? Why the war of everything that lives, of every cell
> that kills the other and feeds upon its cadaver? . . . Who watches
> over every pebble, every blade of grass, every bubble, every baby,
> leading them inevitably into the decay of death? What is stable

other than death? . . . What is this soft, enormous thing, indifferent to beauty, joy, love and peace, which lies down to sleep on me and suffocates me? (pp. 39–40)

The initial section of the book, following the chronology of the author's clinical history and deriving from her obsession with decaying matter, presents menstrual blood as her personal emblem, one which drew the attention of the medical profession to her physical condition. But when Cardinal was threatened by her gynecologist with the removal of her womb, she turned to psychoanalysis and was surprised to discover that her analyst was not at all interested in her genital flow. "These are psychosomatic disorders—they don't interest me. Talk about something else" (p. 41).

The prospective analysand received these words like a slap in the face. Heretofore she had been able to hide behind an external symbol of her abnormality; now she would be obliged to speak of other things, of the unspeakable "fear." Heretofore she had managed to convince herself that her overwhelming fear derived from the continuous bleeding; now she had to face a reversed causal sequence—"that the blood came from the thing." For the first time it became evident that she would have to confront the madwoman within, without the mask of the gynecological patient: "That evening I accepted the madwoman for the first time. I admitted that she really existed. . . . I understood that I was the madwoman" (p. 45).

Motivated by this insight, the author-protagonist embarked upon a classical analysis. Three times a week for seven years she would go to her analyst, lie down on his "divan," and speak out her secret thoughts, her profoundest fears, her inchoate fantasies, her memories of childhood and adolescence. It was, as the author came to realize later, the most orthodox of Freudian analyses. If there were to be a salvation, it would be found through words.

> Talk, talk, talk, talk.
> "Talk, say whatever comes into your head; don't try to make a choice, to reflect, or to organize your sentences. Everything is important, every word." (p. 82)

To follow these basic rules of analysis, virtually unchanged since Freud first formulated them at the turn of the century, was the patient's sole obligation. It is tempting to assume that the necessity for verbal expression provided a superior apprenticeship for the future writer, as well as a successful therapeutic experience for the patient, but such a supposition is difficult to prove. How many would-be writers, having left their mental

burdens with their analysts, are then capable of finding different combinations of words for the printed page? Fortunately for Cardinal the writer, this was the case: the book is in no respect a transcript of the thousand hours spent on her analyst's couch, where she had been admonished to reveal all that streamed through her mind. In *Les Mots pour le dire* Cardinal restructured the thrice-weekly sessions into an ordered work of literature. She selected from the raw material only the dominant psychic skeins and wove them together in a coherent and convincing fashion. For our purpose, it is important to examine four of them: Cardinal's fear of death, her relationship with her mother, the meaning of maternity in her life, and the memories of her father.

Classical psychoanalysis, such as Cardinal underwent, would normally focus upon the child's relationship to her parents, with special attention to the Oedipal period during which a girl-child supposedly changes her primary love object from Mother to Father. Freudian theory, replete with such notions currently contested among feminists, such as penis envy, castration complex, rivalry with Mother, and desire for Father, was certainly the basis upon which Cardinal's analyst had constructed his personal therapeutic system. Perhaps, too, he had been somewhat influenced by Lacan, the French neo-Freudian, for whom human beings are, above all, "speaking beings."[2]

Cardinal supplies us with little information about her analyst—indeed, she herself was never to know him other than in his ritualized professional role. Her words at the very end of the book suggest a bemused sense of frustration at his persistent impassibility: "That damned little fellow, he'll remain masked to the very end" (p. 315). All allusions to him indicate that he practiced a traditional form of analysis, encouraging the patient to free-associate, to develop a transference to him, and to relive through psychoanalysis and within a corrective context the experiences of childhood and adolescence. Certainly the book gives us ample evidence of typical Freudian concerns, such as the attempt to reconstitute the super-ego through the paternal lineage, with the concomitant need to separate from the mother, whose participation in the construction of the super-ego, according to Freudians, is fraught with complications. This classic Freudian stance, while apparently successful in the case of Cardinal as a method of therapy, leads us nonetheless to wonder to what extent its essentially phallocratic nature may have stimulated the patient's antipathy for her mother. Still, the writer of *Les Mots pour le dire* was ultimately able to transcend the limitations of the system and arrive at levels of insight and reconciliation that may not have been anticipated by Freudian doctrine.

One major example is her understanding of the crucial role played by the fear of death in the etiology of her illness. Freudian theory posits that

the fear of death is of minor significance in human development, and that it draws its energy from the more primary fears of separation and castration. Although contemporary revisionists have criticized Freud for his neglect of death as a primary source of anxiety, orthodox Freudians still place paramount stress on the primary sexual and aggressive drives, their expression and vicissitudes, and relegate the fear of death to a minor position.[3]

One of the strengths of Cardinal's work—one that distinguishes it from numerous lesser psychiatric novels—is that it never loses sight of death as THE essential source of the author/protagonist's vulnerability. In contrast to the many books and plays and films that limit themselves to the interpersonal and cultural factors associated with mental disturbances, Cardinal's work contains a vital existential dimension. It places the concept of mortality at the center of the human experience. One of her first insights as an analysand is the recognition that death had been with her as far back as she could remember. Soon after the cessation of her abnormal menstrual flow, the patient realized that her preoccupation with menstruation had been only a cover for her lifelong fear of death, and that henceforth she would be obliged to look directly at death.

"Now death took the place of blood. It stretched at ease inside my mind" (p. 80). The naked vision of death appeared even more portentous than the sight of blood. Its grim presence began to penetrate her every thought, her every fantasy, just as it inhabited every cell of her body. Cardinal evokes this mental and physical invasion in passages that recall the morbid beauty of Baudelaire's *Fleurs du Mal*.

> It was always there. At any moment it could give birth to abscesses, cancers, goiters, ulcers, cysts, breakdown, putrefactions, infections. It inhabited me completely, it was in every blink of the eye, every breath, every complete circulation of the blood, every process of digestion, of ingestion, every flutter of the gills, every drop of saliva, every millimeter of hair or fingernail. It was because of life itself that I was afraid of death. (p. 80)

Once the death fear is recognized as the primary source of her anxiety, it is, for a time, more unendurable than the fear of inexplicable bleeding, and Cardinal is led to a second bitter realization: that madness had been a means of escape from a direct confrontation with death. "I was in perpetual terror—a terror so great, so intense, so painful that only my madness made me able to bear it" (p. 82). She begins to explore the origins of this fear that had grown so monumental and incapacitating in her adult years. She sees that other human beings manage to function "normally" with the knowledge of their finitude. Why was she unable to do so? Although

it may seen ironic that mentally disturbed people are often closer to the truth of death, it is precisely because they are unable to erect denial-based defenses. To be "healthy" means that one has to develop adaptive methods of denying the full reality of death! Cardinal traces her terror of death back to her earliest years, to the spectre of tuberculosis that haunted her family.

> TUBERCULOSIS! The bogeyman of my childhood. My grand-father dead of consumption, my uncle in the sanatorium, my sister dead at eleven months of tubercular meningitis, my brother who had a bad reaction to his tuberculosis skin test, who had scoliosis . . . all of these misfortunes because of my father, because of his illness, his lungs rotted by gas during the First World War. (p. 63)

That her mother had already lost one little girl at the age of eleven months must surely have marked the author's early years; she remembers the ritual laying of flowers on her dead sister's tomb and the feeling that her mother had preferred this other child—the fruit of happier days. Indeed, when the narrator was on the verge of puberty, her mother had been unwise enough to disclose the fact that she too may not have lived even beyond the foetal stage since her mother had repeatedly tried to abort her. Recalling this confession, Cardinal gives voice to the incurable pain provoked by her mother's revelations, ostensibly intended to "prepare" Marie for puberty: she pours forth all the rage, suffering, and injury of a lifetime toward a mother who had literally tried to eliminate her before she was born.

During my discussion with Cardinal in November 1983, she spoke of the key position of her mother's confession in her later mental illness. It was as if she could date the beginning of her drift into psychosis from that moment, but as Bruno Bettelheim has written in his afterword to the English translation of Les Mots pour le dire, The Words to Say It, her mother's attempt to abort her was probably "something she must have felt without knowing since infancy," working its noxious effects upon her unconscious from the very beginnings of life.[4] Why, then, did the psychotic break not take place until Marie was in her late twenties? Bettelheim has speculated brilliantly on the answer to this question.

> The psychotic child, like a healthy one, makes the mother's wishes his own by internalizing them and acting them out, utterly destructive as this is for him, and life endangering—as the woman whose story we have been told came very close to bleeding to death. . . .

According to the story, the unwilling mother was 27 years old when she became pregnant with her second daughter; this was the age at which her daughter produced continual menstrual bleeding. Such timing, more than anything else, clinches the argument that the daughter's symptoms were the result of her identification with her mother. (That she had three children, as had her mother, also suggests an identification in this respect.)[5]

Surely, Cardinal's own experience of three successive pregnancies, like that of her mother, strengthened the identification with mother in a fashion both positive and negative. The issue of positive and negative identification with mother lies at the heart of Cardinal's book, for in the experience of the person telling the story, the mother is clearly a central figure, second only to the narrator herself. It is the mother, with her bourgeois ideals, colonial values, troubled marital history, and intrusive moral presence, who pervades the narrator's life from girlhood through young womanhood into "the slow gestation of madness" (p. 59). In psychoanalysis the daughter's excavations of her family history uncover a mother who had lost a first daughter in infancy, a Catholic martyr suffering the shame of divorce from a husband who frequented "tramps," a French colonial living in Algeria who raised Marie according to the principles and prejudices of her class, and attempted to create her in her own image—this is the mother from whose "grip" the patient must slowly separate herself during the course of psychoanalysis. "To find myself, I had to find her, to unmask her, to steep myself in the arcane secrets of my family and my class" (p. 83).

Thus, the process of psychotherapy entails the process of recreating one's mother as well as oneself, of unwinding that tangled skein of interlocking threads stretching back to the umbilical cord. The daughter defines herself in relation to her mother—first as a docile child conforming in dress and deportment to her mother's ideals; it was the mother's "inflexible gaze" (p. 63) that divided the world into good and evil—on one side, the mother and her female entourage; on the other, her father and an unknown masculine universe associated with danger. For the narrator in search of her past, the distance between mother and father is symbolically represented as two separate planets:

. . . two planets obstinately pursuing their different paths. . . . I was on the planet mother, and at regular but distant intervals, we crossed the planet father which passed by, nimbused with an unhealthy halo. (p. 73)

The child aligned herself consciously with her mother, the purveyor of orderly bourgeois morality, in a struggle against the nefarious influence of dissolute paternal ways.

Still, the positive girlhood identification with mother, with her outward beauty and superior morality, wears increasingly thin as the narrator becomes a woman. The "good mother" model has not allowed for sufficient expression of the child's less noble instincts. To use a Freudian schema, long repressed id forces, which the child associates with the father, eventually crack through the surface of a maternally imposed super-ego and assert their authority. When, in her twenties, the narrator makes love for the first time, having for many years rejected even masturbation in order to obey her mother's rules, she does so with the knowledge of having upset her entire moral cosmos: ". . . I had decided all by myself to pass beyond the principles of my class, the prejudices of my family, my mother's laws" (p. 58). In giving up her virginity to a man she did not even love, she was conscious of having crossed the infinite space that separated her mother's planet from the sphere of her father and of joining the "shameful cohort" of women he received in his bed. This defection from mother was not accomplished without enormous psychic stress: the toll was acute anxiety, and later, complete breakdown. The growing negative identification with mother, all the more tortured because it came so late in life, ultimately engulfed all tender sentiments and hardened into the choked anguish of "motherhate." Once cast down from the pedestal where she had commanded undivided loyalty, the image of mother cracked open so as to reveal the unattractive substances hidden behind her puritanical façade: the intractable prejudices of her class, the hypocrisy, the ignorance, the pettiness, and the ugliness. No longer contained within, these noxious emanations threaten to contaminate the narrator's own existence.

By the age of thirty, the narrator was in the full throes of a mental breakdown. Later, in psychotherapy, she would conceptualize her psychic turmoil as a struggle between the woman she sought to become and the synthetic being her mother had tried to fabricate: "It is between that woman whom she had tried to bring into the world and me that the 'thing' had lodged itself" (p. 84).

In order to pursue the "thing," track it down, understand it, and exorcise it, the author's persona must find "les mots pour le dire," the words that tell the story of a girl and her mother for whom symbiosis has gone awry. Intuitively, the narrator knows that the way to her psychic salvation must be found within the maze of the mother-daughter relationship: "I began to speak of my mother and that did not stop until the end of my analysis" (p. 83). To find herself, she has to find her mother as well—the mother

she had both loved and hated. The author outlines the two stages of positive and negative identification with a concision and clarity that illuminate not only her own idiosyncratic history but that of many other women. ". . . I have the memory of having loved her madly during my childhood and adolescence, then of having hated her, and finally of having deliberately abandoned her . . ." (p. 84).

Missing from this formulation is the description of a third and final stage of identification with the mother—a stage of synthesis that reconciles the early positive feelings and the later negative ones. In some instances, as in the case of Simone de Beauvoir, as recounted in *Une Mort très douce*,[6] it is only the onset of death that hastens the process of reconciliation. In the face of her mother's impending death, de Beauvoir was able to transcend the judgmental stance she had adopted in adulthood and rediscover the profound and simple attachment that bound her and her mother together. The narrator of *Les Mots pour le dire* was not able to achieve such a synthesis before her mother's death. It had been preceded instead by a heightening of anger at the view of her mother's downhill descent into alcoholism and bodily neglect. In one brutally graphic scene, Cardinal evokes the horrible picture of mother sitting on the sofa, her stomach and pubic hair uncovered, two bottles of rum at her side, and her own excrement on the floor. It is a shocking vision of utter degradation.

Whether this incident was actually experienced by the author or fantasized as an ultimate vision of maternal defilement makes little difference. It is clearly a stark and disturbing image of that paradoxical time of life when the child becomes parent to the parent. Obliged to clean her mother's excrement, as her mother had cleaned her own, and to tend to her aging body, the daughter is forced to relinquish once and for all any illusions about an all-powerful parental protector. In confronting her mother's visible disintegration and imminent mortality, she is forced to confront her own. Rage at the parent who symbolizes such a bleak reality is not an incomprehensible reaction.

Cardinal's last experiences with her mother, as described in *Les Mots pour le dire,* are equally symbolic. Her first feelings after her mother's death are of relief and freedom. Months go by before she visits her mother's tomb, but there in the cemetery, a form of reconciliation does take place. Before the grave the author retrieves from her store of memories a vision of the mother she had once adored:

> . . . How lovely you were one party evening when you came to
> show me your dress in my room. I was already in bed. You dazzled
> me! I have never seen anything more beautiful than you on that

night, in your long white dress with an immense belt at your waist, tied in the back, green like your eyes. You swirled around to show me how wide your skirt was. You were laughing.

I love you. Yes, that's it, I love you. I came here to tell you that once and for all. I'm not ashamed to talk to you. It does me good to tell you that and to repeat: I love you, I love you. (p. 312)

The scene at her mother's tomb satisfies both the narrator's personal need for the reconciliation of conflicting sentiments and the artistic need for literary resolution. *Les Mots pour le dire* ends on a note of psychological and spiritual well-being, deriving, in part, from the protagonist's mental resolution of antagonistic maternal images. Because the mother is internalized at the core of the daughter's being, making peace with the mother is tantamount to making peace with herself.

An extraordinary example of coming to terms with the mother is found in the works of one of Cardinal's compatriots, Chantal Chawal. In her first book, *Rétable. La Rêverie,*[7] published a year before *Les Mots pour le dire,* Chawal gives herself over to anxious ruminations about her mother, who was killed by enemy bombs in World War II. The author, miraculously retrieved from her dead mother's womb by means of a Caesarian section, and discovering the truth of her birth twenty-five years later, addresses in her writing her urgent need to know a parent she will never know. With explosive intensity and linguistic originality that sometimes rivals that of Cardinal, Chawal gives life to the longed-for maternal body, restores to it the experiences of sex and fecundity, and creates for herself an identity as author of her mother's existence. All of her subsequent works contribute to this imaginative enterprise and help to reconcile Chawal, now the author of seven books and the mother of two children, with the givens of her singular origins.

Reconciliation with the mother has implications that extend far beyond the obvious advantage to one's ego strengths. If the mother is the child's primary relationship and is unconsciously identified with life itself, then the unconditional acceptance of one's own mother in adulthood may lead to a fuller (and saner) acceptance of one's being-in-the-world, despite the inevitability of death. Of course, some mothers facilitate this task more than others, and some fathers share or even assume the primary role of life-force within a given family constellation. What interests us is the archetypal image of Mother, and how that image impinges upon one's mental health.

Certainly the double image Gilbert and Gubar present of Mother as angel and monster bears witness to a pre-twentieth-century literary awareness of alternately beneficial and pernicious maternal influences. Citing

the Snow White story, these critics remind us that the heroine of Grimm's tale had two mothers—the good (dead) biological mother and the evil stepmother—but they also point out that the evil "Queen and Snow White are in some sense one; while the Queen struggles to free herself from the passive Snow White in herself, Snow White must struggle to repress the assertive Queen in herself."[8] Each represents but half of the human potential—the daughter, the ideal of renunciation prescribed for women in patriarchal societies; the mother, the incarnation of warped forms of aggression that were the sole outlet for assertive women in the past.

In Cardinal's story the roles are reversed, with the mother representing the virtues of (hypocritical) renunciation against which the daughter rebels, at the expense of her own sanity. Ultimately the daughter must reintegrate the mother into her psyche if she is to achieve that kind of inner harmony that we call sanity. Gilbert and Gubar, speculating on a future for Snow White when her prince becomes a king and she a queen, can envision only a choice between the "good" mother model of passive confinement and the "bad" mother model of witchlike activity. Cardinal, writing in the second half of the twentieth century, struggles for less exclusive options. She seeks to break out of the Victorian mold, bequeathed to her by her mother, through independent acts that would bring to life a more authentic self, yet at the same time she retains the concept of maternity at the core of her being. It is in the conflict between these two selves—the self patterned on the model of her mother and the self struggling to create a new identity—that madness finds a foothold.

If Cardinal had been less attached to her mother, if the early female bonding had been less potent, if she had been less docile as a child and more overtly rebellious, if she had not followed her mother's example of marriage and motherhood, producing, like her mother, three children, if the father's life-span had been longer and his affective presence more influential, if, if, if . . . perhaps the protagonist's breakdown would have been less traumatic. The narrator of Les Mots pour le dire, like her earlier persona in La Souricière, found herself caught in the psychic squeeze between two antagonistic selves—the "should" self created in the image of the mother and a more authentic self that clamored for existence. As the analyst Karen Horney wrote in Neurosis and Human Growth, in each individual there is an idealized image of oneself often based on the kind of self one considers necessary in order to obtain the love of certain survival figures, and there is also a real image that one knows oneself to be. The wider the discrepancy between the idealized and the real selves, the greater the degree of self-hatred.[9] In Cardinal's case, the gap was very wide indeed—so wide that the "thing" was able to lodge itself and assume monstrous dimensions.

At the risk of a certain reductionism (for surely there are other factors), it is necessary to emphasize the importance of maternity in the author's history. Theorists from Freud and Helene Deutsch to Judith Bardwick and Edmée Mottini-Coulon foresee grave problems for a woman when she refuses the maternal role.[10] The problems of Cardinal's heroine are indeed related to motherhood, not because she refuses it but because she embraces it so blindly without realizing all its ramifications. Her obsession with maternity and motherhood is both an attempt to become, like her mother, the "good" mother, but also to surpass her progenitor in that her children will be conceived in love, welcomed in the womb, and projected into life and health. This interrelationship between the narrator's maternal experiences and those of her mother, centered around the mother's memories of trying to abort her daughter and the daughter's memories of perceiving her first child in the womb, provides the energy for some of Cardinal's most dynamic writing. In the remarkable passages cited below, the author weaves a verbal texture of two dramatically different strands—the one outlining the sensations of the daughter as she experiences quickening, the other tracing her mother's history (recreated in the daughter's mind) as she tries to abort her third baby.

These pages give expression to the terrible intensity of the mother-foetal relationship and to the special kind of bonding that occurs between female parent and female offspring because they share the potential for carrying life. At some point in childhood, each of us hears how we came into the world, often told by the mother, and this birth tale becomes a part of our personal mythology. Freud, in his concept of the family romance, and Rank, in his *Myth of the Birth of the Hero*, constructed theories whereby children imaginatively repudiate their biological parents and invent parents of greater distinction—hence, the legends of orphaned or illegitimate sons of great lords, kings, and even gods.[11]

Whatever the truth of these theories in their application to the life course of men in general and to certain legendary heroes (such as Moses or Jesus), there is another truth of even greater significance for girl-children. From the story of each girl's birth, handed down from mother to daughter, the daughter constructs a fantasy of how it might be for her once she too becomes a mother. "My birth was excruciatingly painful for my mother; hence, I shall give birth in pain." "My mother was never happier than when she was pregnant; I hope it will be the same for me." Or, if the negative identification with the mother is dominant, the daughter could think: "I shall *not* be like my mother, who hated having children; I shall take courses in natural childbirth and nurse my children, *unlike* my mother." Whatever the birth story, it will carry additional meaning for the girl

because she knows that giving birth may constitute an important chapter in her own life story.

Cardinal's description of the stirring foetus ("le foetus qui bouge") has all of the characteristics that Mottini-Coulon ascribes to "the ontological encounter of the other through an internal experience specific to women."[12] In this privileged experience, the pregnant woman is able to grasp, in her inner body, the reality of another being, allowing her to transcend the state of solipsism, which many philosophers claim is our common lot. Cardinal recalls the first movements of the foetus with an immediacy that leaves little doubt as to its forceful impact upon her. She apprehends the presence of the other inside her body in a manner that suggests a unique experience in the realm of intersubjectivity—one that is accessible only to pregnant women. Yet, at the same time, the foetal movements give rise to a series of visions that are undoubtedly peculiar to the author's individual sensibility.

> I felt in my belly, on the right side, an almost imperceptible contact, as if someone were looking at me whom I couldn't see. I had been pregnant for a little over four months. Some days later, once again I felt that light touch, that little caress, like a gentle finger on velvet.
>
> It was my baby moving! Larva, tadpole, fish from the deep sea. Blind and uncertain first life! Huge hydrocephalic head, bird's spine, medusa's limbs. It existed, it was living there in its warm water, secured to the fat cable of my umbilical cord. Weak, powerless, horrible. My Baby! . . .
>
> It moved! I began to make its acquaintance. It moved when it wanted to, I could not predict when it would appear. It had its own rhythm which was not my own. I was attentive, I waited for it. There it is again! I caressed the spot with my hand. What was moving? One of its stalks of transparent fingers? One of its swollen knees? One of its deformed feet? Or its monster's skull? It scarcely moved, like a bubble rising to the surface of a swamp without even the force to break through. (pp. 157–58)

In such passages, Cardinal is at her best. Here the delicate sensations of early foetal life are combined with astonishing images of underwater creatures more evocative of the evolution of the species than of one's personal progeny. As in the descriptions of menstrual bleeding, the author spares us none of the realities of the physical as filtered through her fantastic imagination. When she caresses one of her baby's protuberances, she imagines a stalk of transparent fingers, a swollen knee, a deformed foot. Once

again, as in the childbirth scene in *La Souricière*, the author realizes that the life inside her has its own compelling rhythm that is not the same as the mother's. She experiences the horror of being the vessel of evolution, and this awareness of her own passivity leads to a renewed confrontation with death. Yet, despite the frightening spawn of foetal images engendered by the pregnancy, there is present in *Les Mots pour le dire* a loving acceptance of the unknown flesh within, compared not only to monsters and Medusas but also to the poetic vision of "a bubble rising to the surface of a swamp."

These passages of tender and terrifying maternal emotions are juxtaposed with the brutal picture of Cardinal's mother when she was pregnant with the future author and preoccupied with vain abortion attempts. Imagining herself once again inside her mother's womb, the narrator creates a shocking picture of maternal hatred and disgust; she places on her mother's tongue a language of crude and abusive words addressed to the baby she tries to abort—hardly words a woman of her class and morality would have consciously used!

> So she straddled her rusty bicycle and took off for unknown territory, toward the garbage dump. I hope you're really swinging inside, my little girl, my little fish—you'll see how I'm going to break your back. Get the hell out of there. . . .
>
> You're still moving? Here's something to calm you down. Quinine, aspirin. Cuddly little thing, nap-time. Let me rock you to sleep, drink, my pretty one, drink this good, poisonous brew. You'll see what a good time you'll have in the slide of my ass when you've been rotted by drugs, bursting like a sewer rat. Death to you! Death to you! (pp. 158–59)

What an appalling vision of the myth of the birth of the heroine for Cardinal to have carried in her psychic baggage since adolescence! In projecting onto her mother these horrible words, the narrator expresses her own deep sense of what Heidegger called *Unheimlichkeit*—a sense of having no home in the world. Cardinal's adult sense of having no nest goes back retrospectively to the very beginnings of life and perseverates around the event of her mother's unsuccessful abortion. It is not surprising that she associates her mother's confession, the purpose of which was to prepare her daughter for the dangers of sexual activity after puberty, with the growth of her own postadolescent psycho-sexual difficulties.

> Menstrual blood waited until I was twenty to pay me a visit, and then very irregularly and with atrocious pains. . . . Anyhow, between

the time of my mother's admission of her failed abortion and my analysis, I have very few clear memories. On the outside, my life bathed in grays, in drab colors, in what was correct, conformist and silent; and on the inside, in what was heavy secret, shameful and increasingly terrifying. (p. 157)

Yet it was not until the narrator knew from personal experience what it was to be pregnant that she began to hate her mother consciously. The psychodynamics of this relationship between the girl-child's knowledge of the circumstances of her birth, first related by the mother and then elaborated in the child's imagination, and the later enterprise of maternity offer a rich terrain for psychological investigation. Cardinal demonstrates that it can be a subject of extreme importance, especially in cases where the mother's experience is conveyed to the child in such a way as to imply that the child was unwanted or, even worse, a failed abortion. The unwanted child, the child whose existence is intentionally or unintentionally threatened in the womb, the child born sickly or deformed may indeed carry lifelong doubts about its own validity to bring forth life. All this has special meaning for females.

It is interesting to compare these pages from *Les Mots pour le dire* with corresponding passages from Violette Leduc's autobiographical novel *La Bâtarde*.[13] Like Cardinal, Leduc projects herself back into her mother's womb and brilliantly recreates her own birth—a birth enshrouded not only with grave physical danger but also with the shame of illegitimacy. Yet despite the ignoble circumstances of her birth and the doubts she later harbored about her right to exist, Leduc does not turn against her mother as vehemently as does Cardinal. Leduc conceives of her birth as a shared fate, a "heroinic" effort for both mother and daughter, joined by the indissoluble bonds of outcast blood, to brave the affronts of a hostile world.

Leduc's later psychological problems were even more severe than Cardinal's: recurring bouts of deep anxiety, paranoid delusions, hallucinations, hospitalizations, behavior that can only be described as psychotic.[14] As a fatherless child, she too grew up in a female enclave consisting of mother and grandmother, but there the analogy ends, for Leduc's origins were in the poor peasant class of the North of France, allowing her no vision of a prelapsarian paradise, even in fiction.

Cardinal and Leduc offer two radically different examples of the paths to madness. Joined by their fierce relationships to their mothers in their childhood and adolescence, and by their later literary successes in writing about their mothers, absent fathers, and periods of insanity, they are separated by almost everything else. Early in life, Leduc found in homosexuality sources of intense happiness, as well as sources of intense unhappiness;

she never seems to have seriously considered becoming a mother. Cardinal remained in her mother's orbit long into adulthood and followed her example in the bearing of children. From a careful reading of her works, especially *La Souricière* and *Les Mots pour le dire,* we are led to believe that the overlap between maternity and madness, in the case of Cardinal as in the case of Plath, was rooted in an unhealthy symbiosis with the mother.

Although mother is primarily associated with madness in her daughter's memories, there are also substantial death-associations with her father that fed into Cardinal's unconscious turmoil. Throughout her childhood she would visit this parent, already divorced from her mother when she was scarcely born, in the company of a governess who carried out her mother's precautionary measures against the father's tuberculosis. "Don't let him kiss her too often. She should never use his handkerchiefs. . . . I've already lost one child, that's enough" (p. 64). What the narrator recalled as "the disquieting presence of germs" infected her mind, if not her body. Father took on the attributes of an alien creature from a masculine universe located beyond the pale of the female sector she inhabited with her mother, grandmother, women servants, and teacher-nuns.

At the age of fifteen she lost her father definitively. The remarkable pages in *Les Mots pour le dire* that describe his death and funeral attest to the deep association between father and death that added to her mental instability. The writer recalls, with grotesque fascination, the ritual deathwatch over her father's body, he encased in a heavy oak coffin that did not prevent the smell of decomposition from reaching her nostrils. Perhaps it is the memory of this rotting body that gave rise to the fantasies of decay that began to invade her adult life. Certainly the passage recalling her emotions as she watched over her father's bier are similar to the many other meditations on death and decay found not only in *Les Mots pour le dire* but in her earlier works, *Ecoutez la Mer* and *La Souricière.*

One of the narrator's initial enterprises in psychoanalysis had been to search out the source of her sickness in the wound created by her father's absence during her childhood and his early disappearance, in the hope of establishing a posthumous relationship. This endeavor was apparently encouraged by her analyst as a means of shoring up "la faillite paternelle." Such a "paternal bankruptcy" must have been considered catastrophic by her analyst, accounting, to a large extent, for the fact that the patient had not elaborated in childhood an adequate personality structure and that her adult constitution was characterized by more archaic, more morbid, and hence more serious levels of psychic response. The analyst seems to have assumed that an examination of what the French call *la parole paternelle* (a Lacanian term for "patriarchal language") was a necessary stage in the

reconstitution of self. Although the father had been largely absent during the patient's childhood, he was probably less absent than one might think— the child without its own father will search for another or, *faute de mieux,* be obliged to re-create the father on the analytic couch. Cardinal the patient pursued every memory of her real father: "the slightest sprig of an image, the smallest crumb of a memory" (p. 74). For example, in analyzing her childhood nightmares, she recalled one in which she was sitting on her father's shoulders while they wandered lost and helpless in a snow-covered forest. Whereas her father laughed and displayed no anxiety in the face of the coming night, the child, scarcely two or three in the dream, knew that the onset of night meant they would both perish.

It is interesting to note that in this dream the daughter is sitting on her father's shoulders and that she remembers "his warm head" between her legs. The child is in a double relationship to the father, simultaneously dependent upon and superior to him. Although on the literal level it is he who carries her, he does so with infantile disregard for the menacing forest. She, on the other hand, has an adult awareness of the threat of death. To be sitting on the father's shoulders might be interpreted by a psychoanalyst as a form of triumph over the parent, but whereas Freudian theory is often conceptualized in the terms of son pitted against father, Cardinal's vision has a distinctly maternal cast. She senses his warm head between her legs, as if she were giving birth to him, and her grave, knowing attitude contrasts with his childish insouciance. Interpreting this dream from the vantage of adulthood, the author wrote: "Thus I discovered that from my earliest childhood the thing was part of my universe and that my father could do nothing to protect me from it" (p. 75). While the investigation of the paternal legacy seems to have had its therapeutic benefits for the patient's psychic integrity, it is also obvious that the post-humous quest for a father-protector was a futile one.

Although Cardinal alludes to the fact that the desire to be loved and protected by her father had implications for her relations with other men, she does not elaborate on the tendency to form dependent relations with father figures in the form of husbands and lovers that is so apparent in *Ecoutez la Mer* and *La Souricière.* In all probability, her analyst made use of these dependency needs in the establishment of a strong transference toward him. Since the analysis is recorded as "successful," it is very likely that she was able to resolve some of her unfulfilled filial longings in the context of the transferential relationship. Ultimately she had to accept the fact that she would never know her father and that she would be obliged to carry on without him, relying solely on her own resources.

It is of no small interest that the lost father theme figures prominently in many works of literature written by women on the subject of madness.

For example, in Leduc's *La Bâtarde*, the father, also a victim of tuberculosis, left his daughter in childhood with the harrowing sense of her illegitimacy and a lifelong insecurity that the author attributed largely to his defection. In Plath's *The Bell Jar* and in many of her poems, the father's early death is presented as the crucial trauma of her life, one that is explicitly linked to her mental breakdown and suicide attempt at the age of twenty. In Margaret Atwood's *Surfacing,* the heroine, on the verge of a psychotic breakdown, returns to her childhood home in search of a missing father, presumed either dead or crazy. And in Cardinal's major work she recognizes that her childhood alienation from her father and his early death constituted "a terrible wound, a kind of deep ulcer." That this ulcer had not been fully healed by the writing of *Les Mots pour le dire* is apparent in Cardinal's most recent novel, *Le Passé empiété,* the central section of which is devoted to a re-creation of her father's life.

The death of a parent of either sex is, for a young child, a catastrophe of overwhelming proportions. It forces a confrontation with "le néant" before the child has developed sufficient psychological strengths to protect itself from feeling sucked in. It may be that the loss of a father is damaging in a special way to a child's sense of security since, in patriarchal societies, ultimate authority is invested in paternal figures. Given the fact that the paternal metaphor is so pervasive within Western culture, it is virtually impossible to grow up outside its sphere of influence. In this sense Freudian theory is probably correct in attributing significance to the symbol of the phallus in the development of the individual, though the literal interpretation of the phallus-as-penis (a trap into which Freud sometimes fell) certainly leads to questionable corollaries, such as the notion of a castration complex for women. When understood primarily as an emblem of those privileges that traditionally adhere to male status—as in the interpretation of the early analysts Karen Horney and Clara Thompson and later feminist thinkers—the phallus becomes less an object of theoretical confusion.[15]

In Western literature, the loss of the father and the subsequent search for his person, corpse, or legacy have provided the theme for some of our greatest literary works. Telemachus, Oedipus, Orestes, and Hamlet established the archetype of young males coming to manhood as seekers or avengers of fathers who had disappeared. From this exclusively male heritage, Freud fashioned a model of psycho-sexual development that placed the child-father relationship at the center of psychoanalysis. Because fathers are, in the eyes of the child, all-powerful beings, they are to be approached reverently and cautiously, as though they are distant gods. Mothers, ever-present and all-engulfing, are, on the contrary, treated as creatures to be separated out from.

The literature of madness written by women in our century demonstrates both of these cultural biases, but it also reveals a different, fundamental truth that was underplayed in Freudian theory: that the mother-child relationship is the primary one in human life. This is not to say that fathers are incapable of assuming a primary parental role, nor that mother-surrogates cannot adequately and even advantageously replace an absent blood-mother. Biological mothers are, of necessity, sometimes replaced. What is not replaceable, if a child is to develop a well-defined sense of self and basic trust in the world it inhabits, is, as the analyst Natalie Shainess phrases it, "the continuity and consistency of adequate maternal care."[16] Today most analysts agree that it is in the reciprocal interplay between child and mother (or mother surrogate) that one establishes those bonds of "love," "caring," and "empathy" (Rousseau used the word *pitié*) that form the prototype for all of life's future attachments.[17]

All of the female-authored works on madness discussed in this study, even those where the hate-mother syndrome is most obvious, bear witness to the vital nourishment transmitted from mother to daughter. Even in cases where this life-sustaining force is impeded by denial of one's love feelings or by outright hostility, positive aspects of the mother-child transaction are always in evidence.

It is here that I demur somewhat to the position taken by Dorothy Dinnerstein and certain other feminists. No matter how far we are able to progress in including fathers in the upbringing of their children—and I wholeheartedly support that aim—we are flying in the face of evidence and good sense when we seek to diminish the importance of the mother-child bond. Attachment to the mother or to a maternal surrogate, even without the presence of a father, lays the basis in early life for one's lifelong sense of worth. "Fortunately," as Bettelheim has written, "in the lives of many infants, the mother's strongest emotion is love for her baby; the baby responds to this love by building it into his budding personality as self-love, which will give him the strength to surmount many and various difficulties later in life."[18] It is indeed, as Bettelheim has said, "a tragedy" for both mother and child when this love is absent or greatly deficient. And, I repeat, a tragedy not only for the child but for the mother as well. Since female identity is so closely bound up with the idea of mothering, the woman who perceives herself as an inadequate nurturer, or who is incapable of becoming a parent, may see herself as a failure *in toto*.

Cardinal's writing bears testimony to the complex role that the maternal potential plays in a woman's life. For many women the realization of this potential contributes to a healthy sense of self; for some women, motherhood is the ultimate proving ground: she who gives birth to a normal baby is released from fears of infertility and infant deformity, and often

experiences an unparalleled sense of accomplishment. Despite the innumerable ways in which women are undermined in patriarchal societies, there is still something awesome about the creative capacity of the mother.[19] As long as men continue to feel threatened by this power and subordinate it to phallocratic structures that give primacy to male achievement, and as long as women are unable or unwilling to see in the maternal potential a symbolic paradigm of all that preserves life, we shall remain within the prison of male values that exclude a specifically female ontology.[20]

Yet the ability to produce life is by no means an unmixed blessing. For most women it has meant being limited to fulfilling a purely biological destiny; it has meant, as de Beauvoir so eloquently theorized in *The Second Sex,* being fixed in immanence;[21] and for some women, those of a particular sensibility and vulnerability, it has been the gateway to madness. "Motherhood is often a shock, a blow from which many women never recover," observed Dr. Shainess in an article that details the sense of entrapment many women feel when they discover that "the infant is here to stay, cannot be wished away, and makes imperious demands . . . from which there is no escape."[22] Postpartum depression, named as such in *La Souricière*, is a common enough phenomenon throughout the psychiatric literature.[23] Beyond that, how many unknown women suffer "prepartum" depression because they are unable to bear children and how many experience various forms of self-hatred and anxiety because they feel they should have children, even if they have valid reasons for choosing against motherhood? Of course the maternal problematic is greatly exacerbated by societal decrees that assign to women not only the rights of reproduction but also the primary or exclusive responsibility for child care. Dinnerstein, Chodorow, and others who have examined this issue in depth have concluded that motherhood as an institution would enjoy substantial benefits if it were shared more equally by husband and wife and properly buttressed by adequate public support. For the present, however, while childbearing and raising are still primarily women's responsibility, it is likely that they will continue to find in motherhood a potential source of both psychological strength and acute distress. The maternal choice will continue to be for many women the crux around which they establish a large part of their adult identity. If they choose motherhood, pregnancy will entail a special relationship with their own bodies; it will offer a unique encounter with the other in the womb; it will produce an awareness of an internal life-rhythm that may be in disharmony with one's own; and it will force the discovery that in giving birth, one comes that much closer to death. As the writer Geneviève Serreau eloquently stated in an interview shortly before her death:

Certainly I am more sensitive than a man would be to birth, to childhood, because these are realities which I have lived in my body. And every birth is an approach toward death. For us women, this is our luck and our strength, even if many of us do not recognize it as such or reject it.[24]

Or, as the playwright Martha Boesing succinctly put it: "Mothers give birth . . . to creatures who die" (*The Web,* 1981).

Cardinal's contribution to the literature of madness is to have expressed the most elemental realities of life and death as lived through the female body. Her work records not only her personal idiosyncratic history and crucial aspects of the female condition in general, especially around the nexus of maternity, but it also crosses the line of gender at the intersection of madness and mortality so as to speak to all human beings who are sensitive to the genesis of life and the obdurate fact of death.

5
Margaret Atwood: *Surfacing*

The cover of the paperback edition of Margaret Atwood's novel *Surfacing* asserts that it is "Even better than *The Bell Jar*."[1] The prospective reader is thus invited to compare two novels depicting psychological disintegration, one written by an American, the other by a Canadian woman, within a decade of one another. In many ways *The Bell Jar* and *Surfacing* do resemble each other. Each book traces the gradual breakdown of a young woman alienated from herself and from society. Each protagonist becomes increasingly distanced from her friends, each engages in self-destructive acts, each enters into a period of bizarre behavior during which she labels herself as "crazy," and each moves through that state to the brink of normality. It is clear that Atwood learned from her American predecessor certain literary techniques, such as the use of a first-person pseudojournalistic style, to convince her readers of the narrator's credibility as she leads us into the world of the irrational. Yet other aspects of the two books attest to a fundamental difference in the conception and use of madness as a literary topos.

Plath's approach to madness had derived from intimate acquaintance; hers was a confessional novel, so close to the reality of personal experience that even the distance of ten years between the breakdown and the writing of the novel scarcely altered any of the original facts. What is lacking in imagination, however, is made up for in style—by the ironic detachment she had perfected in her earlier stories and poems.

We know much less about Atwood's private life, but it would be safe to say that her use of madness is less an artifact of personal experience than a symbolic paradigm of the quest for self-knowledge. Although Atwood shares with Plath some common themes and obsessions, hers is essentially a work of the imagination, allowing for greater freedom from clinical

realism. Though one may not agree with the assertion of *Surfacing's* superiority over *The Bell Jar,* it would be difficult not to recognize its more complex mythic structure verging on the allegorical.

Initially, Atwood follows Plath's method of presenting an ostensibly "sane" young woman's revulsion before the world of the Philistines, now reincarnated in the narrator's "Americans." Like Esther Greenwood in *The Bell Jar,* the heroine of *Surfacing* has recently embarked upon a journey outside of her hometown, but her course leads in an opposite direction: into the Canadian hinterlands rather than the Big City. In the company of three other Canadians—her boyfriend Joe and a couple called David and Anna—she returns to the Northern Canadian outpost where she had spent large portions of her childhood. Her mother has since died, her brother is now far away, and she does not know whether her father is dead or alive.

The journey has all of the hallmarks of what Atwood calls "the exploration story" in her book on Canadian literature, *Survival,* published the same year as *Surfacing.* Like many other Canadian writers before her, as well as writers of various nationalities, Atwood is concerned with that voyage into the past which unearths "ancestral figures" for the purpose of exploring one's own identity. As she writes in *Survival,* "If you aren't too sure where you are, or if you're sure but you don't like it, there's a tendency, both in psycho-therapy and in literature, to retrace your history to see how you got there."[2]

As a psychologically conscious artist, Atwood conceives of the journey back, in time and place, as a journey inward. With the model of Conrad's *Heart of Darkness* before her, she too embarks upon an exploration that takes on "overtones of another kind of journey . . . the journey into the unknown regions of the self, the unconscious, and the confrontation with whatever dangers and splendours lurk there. . . . The explorer must leave rational order behind."[3] Far from civilization, which corresponds to "the everyday ego or the order of the rational mind," the Canadian wilderness in *Surfacing,* like Conrad's jungle, represents "the chaos of the unconscious." Return to the distant region of one's origins thus becomes a metaphor for psychological regression—for a reversion to prerational thought processes and irrational acts that, in an adult person, may constitute a form of madness.

In the first chapter of *Surfacing,* as the protagonist drives along the country roads to the French-speaking village she had known as a child, her growing sense of dismay at the desecration wrought by technology and "Americanization" does not surprise us, but almost imperceptibly we begin to sense certain alarming psychological signs. An early indication of her malaise occurs when she eats an ice cream cone.

I bite down into the cone and I can't feel anything for a minute
but the knife-hard pain up the side of my face. Anesthesia, that's
one technique: if it hurts invent a different pain. I'm all right. (p. 15)

Here the icy numbness produced by ice cream is a familiar enough
sensation, yet it seems to suggest mental as well as physical anesthesia.
Note how the narrator is quick to reassure herself that she's "all right."
Much later she recognizes that this early stage of local anesthesia had led
to a more pervasive lack of affect.

I didn't feel awful; I realized I didn't feel much of anything, I hadn't
for a long time. . . . At some point my neck must have closed over,
pond freezing or a wound, shutting me into my head; since then
everything had been glancing off me, it was like being in a vase. . . .
Bottles distort for the observer too: frogs in the jam jar stretched
wide, to them watching I must have appeared grotesque. (p. 126)

By now the sensation of numbness has spread from the oral cavity to
the whole head, and the head seems as if it is sealed off from the rest of
the body. The neck, no longer a bridge between head and shoulders, is
transformed, like everything else, into an agent of disjuncture. Images pile
up to reinforce the feeling of isolation—the pond freezing over, enclosure
inside the vase, frogs in bottles—all of which recall the title and central
images of *The Bell Jar*. In both books, the glass jar symbolizes alienation
from the external world and imprisonment within a noxious inner space.
The narrator of *Surfacing* moves slowly from these first stages of psychic
numbness, alienation, and isolation to the dramatic regressive acts that
signal a full-blown psychosis.

Esther Greenwood's breakdown occurs in the middle of *The Bell Jar,*
leaving ample space for descriptions of her inner chaos, suicide attempts,
hospitalizations, therapies, and slow recovery. The heroine of *Surfacing*
does not fully disintegrate until the last pages of the book, and it is there
that Atwood departs most radically from Plath's model and stakes out
new territory in the literature of madness.

Certain major themes lead up to and converge in the novel's cataclysmic
ending. Those which command our attention are: the search for parents,
the relationship of female to male, the confrontation with the existential
reality of nonbeing, and the opposition between death and life as sym-
bolized in the experiences of abortion and childbirth. All of these concerns
are embedded within a central topos, which is the search for self, or rather,
the destruction of a fabricated self in order to allow a more authentic self
to "surface."

The search for a more authentic self begins with a return to origins. The protagonist's trip to the Canadian back country is ostensibly motivated by a search for her missing father. She had received news of his disappearance from Paul, a French-Canadian living in her childhood village and incarnating the "ideal of the simple life" (p. 27) that her father had admired and consciously pursued. This other search in the novel, the search for the father, has many of the characteristics of a mystery story, moving the plot along from clue to clue as the protagonist doggedly attempts to discover her father's whereabouts. Refusing to be satisfied with the investigation already undertaken by the police, and unwilling to accept Paul's naive explanation that "He is just gone" (p. 27), she presses out to his island retreat, dragging her friends in tow.

The mystery of the father's disappearance is not solved until the end of the book, with the discovery of his body in the lake. Until that point the protagonist had found ingenious means of denying the likelihood of his death—she had traced his preoccupation with a secret archaeological project and preferred to imagine him mad in the bush rather than dead. The confrontation with her father's body underwater strips away these mechanisms of denial and also releases a series of other cruel revelations. Once denial is eroded, the protagonist is inundated with the return of long-exiled memories, some too painful for her to assimilate immediately. Although the circumstances of Plath's and Atwood's novels are very different, it is noteworthy that in both instances the confrontation with a dead father acts as a catalyst to set in motion the heroine's most radical departure from sanity—a near-fatal suicide in *The Bell Jar* and acts of symbolic self-destruction in *Surfacing*.

If, on the level of plot, the quest for father entails a literal search for the father's person, then on a psychological level this same quest constitutes an investigation of the paternal legacy. As the child of a professional naturalist, an amateur archaeologist, a rationalist, an ecologist before it became fashionable to be one, the daughter had inherited her father's disparaging view of industrial societies and his self-sufficiency in nature. One of the most impressive features of the heroine's make-up—one that contrasts dramatically with the other members of her party—is her ability to negotiate life in the wilderness, relying solely on her own resources. It is she who shows the others how to paddle a canoe, bring in fish, make fires, and prepare meals. As a child she had "memorized survival manuals, *How to Stay Alive in the Bush, Animal Tracks and Signs, The Woods in Winter*" (p. 56). Survival, as she tells us in her book of that title, is for Atwood "the central symbol" of Canadian literature.[4] In keeping with this tradition, the heroine of *Surfacing* must undergo her spiritual odyssey in a setting where sheer physical survival cannot be taken for granted. The

strategies of "staying alive" at all cost, of "hanging on" in the face of elemental obstacles, of winning against nature had been learned in childhood from her father.[5]

In *Madness and Politics in the Feminist Novel* Barbara Hill Rigney writes that the father in *Surfacing* "represents human reason and its limitation."[6] Comparing him to Virgil leading Dante to the edge of paradise, where he must relinquish his charge to the superior wisdom of Beatrice, Rigney argues that Atwood's protagonist "must go beyond the father, beyond the world of logic which he represents." It is in the mother's legacy that she will find her more vital half.

Going home to the place of one's childhood inevitably represents a quest for both parents. Atwood's protagonist admits as much when, in the early pages of the book, she compares her own filial attitudes to those of her friends: "my reason for being here embarrasses them, they don't understand it. They all disowned their parents long ago, the way you are supposed to: Joe never mentions his mother and father, Anna says hers were nothing people and David calls his The Pigs" (pp. 19–20). These lines— an ironic commentary on the ethos of the times—offer early clues as to the relative moral worth of the four central characters, with David at the bottom and the narrator at the top of the scale.

The heroine's relationship to her mother appears to have been more ambivalent than her relationship to her father. Throughout the book Mother is presented as a nature figure, in close harmony with her husband's ecological views and with the birds and flowers of their island sanctuary. Mother is remembered by Madame (Paul's wife) as a "good woman" (p. 25) and by the protagonist as the coauthor of her own "good childhood" (p. 21). But Mother is also a distant and mysterious figure; her silent union with nature, her inwardness, and her flights into self are experienced by the daughter as emotional absence, and the younger woman's own difficulties in communication seem to have been rooted in this affective gap. The distance between daughter and mother had increased during the years following her departure from home, postcards of a marriage, of a baby, and of a divorce doomed to be misunderstood. And with the mother's death several years before the events of novel, the protagonist seems to have lost touch with her maternal heritage. The memory of visiting her mother in the hospital right before she died leaves behind a haunting maternal vision, more birdlike and remote than ever, now transformed into a distant symbol of the passing seasons, and eternally incapable of responding to the daughter's need for a more personal parent.

> She was very thin, much older than I'd ever thought possible, skin tight over her curved beak nose, hands on the sheet curled like

bird claws clinging to a perch. She peered at me with bright blank eyes. She may not have known who I was: she didn't ask me why I left or where I'd been, though she might not have asked anyway, feeling as she always had that personal questions were rude. . . .

On the bedside table with the flowers, chrysanthemums, I saw her diary; she kept one every year. All she put in it was a record of the weather and the work done on that day: no reflections, no emotions. . . . I waited till her eyes were closed and slipped it into my shoulder bag. When I got outside I leafed through it, I thought there might be something about me, but except for the dates the pages were blank. . . . (pp. 25–26)

It is noteworthy that the daughter had hoped, in vain, to find in her mother's diary some reference to herself. Similarly, later in life when she returns to her childhood home, she looks for a message from her absent parents. She interprets her father's sketches of prehistoric rock drawings as a "talisman" intentionally left behind for her benefit, and tries to ferret out a similar legacy from her mother, which would teach her "Not only how to see but how to act" (p. 179). In a state of visionary frenzy, she takes up a scrapbook of her own childhood drawings and lets it fall open.

My mother's gift was there for me. . . . the gift itself was a loose page, the edge torn, the figures drawn in crayon. On the left was a woman with a round moon stomach: the baby was sitting up inside her gazing out. . . . The picture was mine, I had made it. The baby was myself before I was born. (p. 185)

It matters not to the vatic heroine that she herself had drawn the picture. She receives it as a message from her mother to assume her maternal heritage by bearing a child. In Rigney's succinct words, "now she must *become* the mother."[7]

The decision to act immediately upon her mother's gift by conceiving a child with Joe is clearly a life-affirming move intended to counteract the abortion she had undergone several years earlier. The memory of that abortion, skillfully alluded to but sufficiently concealed throughout the greater part of the novel, also "surfaces" right after the confrontation with her dead father's body. Until this point the protagonist had constructed a fabric of lies about a mythical husband, a child, a divorce, so as to seal over the painful ugliness of a truth rejected by her psyche. "I couldn't accept it, that mutilation, ruin I'd made, I needed a different version" (p. 169). As the circumstances of the abortion unravel, the art of the mystery story and the psychological novel intersect. We learn that the

narrator, following the abortion, had invented the story of a marriage, communicated to her parents on a postcard, as an explanation for her sudden departure. The abortion had left her with such a sense of defilement that she had been unable to return to their garden paradise, nor could she bring herself to contaminate their innocence by sending a true report of her misfortune. "They didn't teach us about evil, they didn't understand about it, how could I describe it to them?" (p. 169). In time she herself had come to believe the fantasy of a female adulthood constructed for her parents' benefit and had repressed the real story.

Why does the discovery of her father's body in the lake force her to confront the repressed memory of her abortion? The sight of his body, "a dark oval trailing limbs" (p. 167), triggers other images of ghoulish forms immersed in water—the drowned brother who had not really drowned, the creature "in a bottle curled up, staring out . . . like a cat pickled" (p. 168). The rush of associations leads from the drowned father through the two screen memories to the final, unmasked version of the aborted foetus.

> That was wrong, I never saw it. They scraped it into a bucket and threw it wherever they throw them, it was traveling through the sewers by the time I woke, back to the sea, . . . (p. 168)

Water imagery links the baby's death to the father's death through the subterranean mental system signified by the sewers. Yet the water imagery suggests life as well as death in the fluids of the amniotic sac, the seas teeming with life, and the lake from which the narrator emerges after discovering her father's body as a prelude to a new life. Descent into the death-filled waters, like Dante's descent into the inferno, is the preliminary stage of a psychological baptism, where a kind of grace will propel the heroine toward truth.

With father drowned and mother long since gone, there is no one left to lie to, no one who represents the claims of innocence. The "should" self begins to dissolve with the realization that she is now accountable only to herself. The death of a parent, of both parents, leaves her ultimately alone facing the gratuitousness of her own existence. All defense mechanisms are swept away, social constructs no longer have meaning, and the protagonist begins to act in such a way as to reduce living to its most elemental nature.

The weird events of the book's final section (part 3) are certainly to be understood, from a psychological perspective, as an experience in madness. For a period of five days, the protagonist retreats into a primitive, animal-like state governed by a number of mysterious injunctions. First, she

follows her mother's command by dragging Joe outside into the cold night and compelling him to couple with her on a bed of leaves. This act of love is presented as the copulation of two nocturnal creatures, the male with his "furry" body and lack of comprehension, the female with her guiding knowledge of the need to act in harmony with nature and herself. She immediately feels the benefits of sex in something more significant than pleasure: "pleasure is redundant, the animals don't have pleasure. . . . He trembles and then I can feel my lost child surfacing within me, forgiving me, rising from the lake where it has been prisoned for so long, . . ." (pp. 190–91). Once again water imagery suggests death, life, and the unconscious regions of the mind. The lost baby, whose fantasied remains had been washed out to the seas, surfaces from the lake, surfaces from the unconscious where it had been imprisoned. Conception of a new creature symbolically gives life to the aborted foetus.

The narrator's ensuing actions depart from all standards of rational behavior, yet they have their own internal logic, leading from breakdown and disintegration to rebirth at a superior level of sanity. Psychiatrists would call this "regression in the service of the ego." The principle of psychotherapy presented by the European analyst Marguerite Sechehaye in her introduction to the *Autobiography of a Schizophrenic Girl* would also be applicable to the narrator of *Surfacing*: ". . . the therapy outlined the evolution of a psyche from its regression to complete infantilism back to independent adulthood."[8]

The story of Atwood's heroine, however, is more than a clinical case. Her experience suggests those liminal preparations undertaken by initiates in primitive cults. In the course of her "madness," she undergoes a series of carefully structured ordeals, takes on some of the attributes of plants and animals, becomes empowered with the ability to communicate with dead spirits, and ultimately incorporates their mana into a transcendent consciousness. This is the domain of the truly visionary, encompassing, but not limited to, psychological reality, and expanding outward—as Carol P. Christ demonstrates in *Diving Deep and Surfacing*—into the mysteries of religion.[9]

The prerequisites for such an experience are total isolation and a willingness to divorce oneself from all preconceived rational notions: "this is what I wanted, to stay here alone. From any rational point of view I am absurd; but there are no longer any rational points of view" (p. 199). Having tricked her companions into leaving the island without her, the protagonist follows the course of the power that ebbs and flows within her. First it directs her back into her own house in a sing-song language suggesting regression into childhood: "Breaking into my own house, go in and out the window, they used to sing, holding their arms up like

bridges; as we have done before" (p. 200). It leads her to the turbulent emotions of grief and rage inspired by the death of her parents:

> I'm crying finally, it's the first time, . . . But I'm not mourning, I'm accusing them, *Why did you?* They chose it, they had control over their death, they decided it was time to leave and they left, they set up this barrier. They didn't consider how I would feel, who would take care of me. I'm furious because they let it happen. (p. 202)

Reverting to a stage of life when crying came naturally, she reexperiences primitive emotions and childish thinking, which make it possible for her to break through the affective paralysis that had characterized her earlier adult behavior. Like a child who mistakes wish for reality, she endows her parents with godlike control over life and death. Irrationally, she berates them for abandoning her and calls out for their response. "Here I am, . . . I'm here! . . . If I will it, if I pray, I can bring them back" (p. 202). But will and prayer and an infantile belief in her own omnipotence are not enough. Sensing the necessity for an unknown ritual, she concludes that a sacrifice of great material destruction will be required to bring forth their spirits. She must destroy all her possessions, all reminders of the past—the wedding ring from her nonhusband, the scrapbook filled with her drawings, her father's map, her mother's jacket, cooking utensils, clothes, books, photographs—are slashed and sent into the fire, and she too is symbolically destroyed in photographs.

The ritual sacrifice observed as a part of the ceremony of conjuring up the dead has a long literary tradition stretching back to *The Odyssey*. Atwood merges this tradition with the ritual of symbolic self-destruction found in *The Bell Jar* when Esther Greenwood, on the brink of breakdown, tears up all her New York finery. In *Surfacing* the slashing of belongings and the subsequent conflagration signal a further stage in the heroine's psychological disintegration: as a human creature she has regressed to the point of symbolic nonbeing. The protagonist understands her regression as a necessary metamorphosis into a nonhuman form, which is the prerequisite for communication with the spirits she had recognized in the maternal and paternal talismans. "The gods, their likenesses: to see them in their true shape is fatal. While you are human; but after the transformation they could be reached" (p. 185). Thus she regresses still further, descending along the evolutionary scale from the order of the humans to that of the animals. Animal-like, she strips off her clothes, leaves her "dung, droppings, on the ground" (p. 209), eschews man-made shelter and prepared foods, and finds her way outdoors among the elements, first in the

garden, then beyond all enclosures, and finally even beyond the path that bears the mark of a human tool. She survives on mushrooms, plants, and berries. She merges with the forest, descending even further along the phylogenetic scale to the level of plants. When she loses all sense of a personal identity and reaches a point of total oneness with nature ("I am a tree leaning" [p. 212]), the "transformation" is complete and the parental visions are vouchsafed her. First that of the mother, perceived feeding the jays:

> . . . in front of the cabin, her hands stretched out, she is wearing her gray leather jacket; her hair is long, down to her shoulders in the style of thirty years ago, before I was born; she is turned half away from me, I can see only the side of her face. She doesn't move, she is feeding them: one perches on her wrist, another on her shoulder. (p. 213)

Then the vision of the father:

> He is standing near the fence with his back to me, looking in at the garden. . . .
> I say Father.
> He turns toward me and it's not my father. It is what my father saw, the thing you meet when you've stayed here too long alone. . . .
> . . . it gazes at me for a time with its yellow eyes, wolf's eyes, depthless but lambent as the eyes of animals seen at night in the car headlights. . . .
> I see now that although it isn't my father it is what my father has become. I knew he wasn't dead.
> From the lake a fish jumps
> An idea of a fish jumps
> A fish jumps, carved wooden fish with dots painted on the sides, no, antlered fish thing drawn in red on cliffstone, protecting spirit. It hangs in the air suspended, fish turned to icon, he has changed again, returned to the water. How many shapes can he take. (pp. 218–19)

What is the meaning of these visions? Mother will be remembered for all eternity feeding jays in her gray leather jacket, her face only half-visible, symbolizing the parent only half-known. The realization that she can never know the other half of her mother's face, like the other half of the moon, is one of the most devastating aspects of the loss of a parent. The dead mother represents uttermost loss. Father, however, transformed into a

werewolf, into a fish, into a unknown number of forms, is not dead in an ultimate sense. He tells us that parents continue to live as spirits of the "earth, the air, the water" (p. 219), alive as long as children are alive to call up their memories.

The metamorphosis of mother into jay, of father into werewolf, and the final vision of the sacred fish with its association to Indian lore constitute a turning point in the narrator's spiritual odyssey. The ceremony of madness has come to an end. "The rules are over. I can go anywhere now, into the cabin, into the garden, I can walk on the paths. . . . To prefer life, I owe them that" (pp. 219–20). In a moment of supreme illumination, she acknowledges the parental spirits as beneficent, life-sustaining forces. Accepting the parents, their loss and their reintegration into the cosmos, the protagonist is now prepared to accept herself. She knows that henceforth she cannot permit herself further experiments in disintegration, visionary or otherwise. That would lead only to "the hospital or the zoo" (p. 222). As Rigney points out in *Lilith's Daughters: Women and Religion in Contemporary Fiction,* "the protagonist's return to sanity and to human existence is marked by her recognition that she must have food and shelter to survive, that she is neither animal nor primitive god and is therefore incapable of living alone in the wilderness. To live, she decides, is a responsibility to her parents, to society, to herself."[10]

Her mission will be to bring into life "the first true human; it must be born, allowed" (p. 223). The baby is necessary not only to her personal psychic salvation, but also to the salvation of the world. It is hardly accidental that its father is named Joe; it would have been too obvious for the unnamed protagonist to have been called Mary. It is not accidental either that the name of Jesus is introduced at the end of the book immediately before a pastiche of the Lord's prayer. "Our father, Our mother, I pray, Reach down for me, . . ." (p. 221). Even Paul, who comes back in his boat with Joe to fetch her, has a biblical reference—that of Saint Paul, whose iconography traditionally includes a boat in memory of the shipwreck at Malta and his miraculous salvation. Clearly the implications are that the modern world, improperly civilized and bent upon destroying itself, is in need of a new savior. However, despite numerous biblical associations (many of whch are explored by Rigney in her second book), Atwood revises the gospel to attain non-Christian ends.[11] Her vision of salvation, inspired by a decidedly female will, posits the need for a return to nature, as the first stage in a process of personal and social rebirth. Drawing upon the philosophy of Rousseau as well as traditional Christian sources, Atwood remythologizes the concept of salvation within the framework and with the yardage of New Age ecological and feminist concerns. The new savior, "the primeval one" (p. 223), will be the offspring of a

"natural woman" (p. 222) and a father who is "only half formed" (p. 224). Because neither progenitor is fully developed, neither is fully corrupted. The protagonist says that Joe "isn't an American, . . . he isn't anything, . . . and for that reason I can trust him" (p. 224).

If "Americans" (some of whom are actually Canadians) represent for Atwood pollutors, desecrators, and victimizers, hope for man/womankind lies in the hands of those who, like Joe, have retained an infantile simplicity or who, like the protagonist, have regressed to a stage of childlike innocence where it is possible to become a born-again non-Christian. In the hope of seeding a mutant species of nonvictimizers, the narrator links her destiny with that of her child: "if I die, it dies, if I starve it starves with me" (p. 223). The reverse is also true: if she is to survive, the baby must be born, a new race of humans must come into being. By reclaiming her maternal rights and joining forces with the future of the species, the protagonist transforms herself from passive victim to active mover, triumphing over the powerless role women are often forced to play. "This above all, to refuse to be a victim. Unless I can do that I can do nothing. I have to recant, give up the old belief that I am powerless . . ." (p. 222).

Hearkening to the promise incarnated in every baby, each a potential messiah, the narrator takes up the grandiose project of bringing into the world the herald of a new age, and the less grandiose project of forming a couple with the baby's father, though she suspects such a project will "probably fail" (p. 224). She is all too well aware of the problematic nature of male-female relationships. Her earlier relationship with a married man had led to the devastating abortion. The marriages she sees around her, like that of David and Anna, are notable for their worst qualities—male sadism, female victimization, mutual deceit, and treachery. She knows too that she cannot aspire to the innocence of "another age, prehistoric, when everyone got married and had a family, children growing in the yard like sunflowers" (p. 169). That ideal, symbolized by the figures of husband and wife in separate spheres on Paul's wooden barometer, went out with her parents' generation. Still she clings to the idea of the family, perhaps because her own childhood in a nuclear family had left her with an idealized vision of a golden age, and though she suspects that the family has been permanently undermined by the society in which it tries to be a family, she envisions her future as Joe's mate with a limited measure of trust. Like *The Bell Jar, Surfacing* ends on a tenuous note of hope, with the protagonist anticipating a return to normal reality.

That "normal" reality must be different from the psychological state of the narrator at the very beginning of the book. At that time she seems to have been in a phase of emotional paralysis. To break out from that state, she was obliged to take the long route—the trip downward into the unconscious where primitive emotions and prerational thoughts predom-

inate. Exploring this domain, she reentered the affective realm of childhood and then, through an animistic identification with animals and plants, achieved an ecstatic union with nature, which is the privileged experience of madwomen and mystics. Her trancelike visions of mother and father, while beyond the province of the purely psychological, are to be seen as a culminating point in the narrator's regression, both end and beginning. From this point on, she can move toward reconciliation with herself and the outside world.

Integral to the tale of psychological recovery is the existential discovery of nonbeing. The recognition of the death of her parents, the acceptance of their mortality, the ability to give them up as godlike protectors and to separate from them, yet at the same time to incorporate their strengths, are crucial aspects of her psychic transformation. Only when the separation from parents is complete can the heroine effectively assume the next task in her own life cycle, the task of providing offspring for the future.

The idea of the baby-to-be bears a direct relationship to the protagonist's newly recovered self capable of feeling and creating, just as the image of the aborted foetus had issued from and corresponded to her earlier stunted self. (A similar correspondence between the dead foetus or stillbirth and the author's immature persona was explored in the chapter on Sylvia Plath.) Clearly, Atwood conceives of the act of procreation, like the act of creation, as possessing redemptive attributes, yet she has sufficient ironic detachment from her own literary creations to be able to write in *Survival*: "The great Canadian Baby is a literary institution; it could be termed the Baby Ex Machina since it is lowered at the end of the book to solve problems for the characters which they can't solve for themselves."[12] As a fictional device, the idea of the baby supplies the novel's "happy end," which can no longer be provided by the dubious institution of marriage.

The baby-to-be might well have been only a conventional psycho-literary trope were it not for Atwood's obvious knowledge and skillful use of maternity rituals in primitive societies. The entire madness episode, including the narrator's conception and pregnancy, is structured so as to suggest a unified magico-religious ceremony marking the prospective mother's passage from one life stage to another. Unlike Plath and Cardinal, Atwood removes the drama of maternity and madness from the clinic and situates it in a region that is both geographically and ancestrally primitive, thus imparting an aura of primeval mystery into the story of psychological regression. This overlap of psychological and anthropological intents gives the book's final section a uniquely rich resonance and societal implications beyond the purely personal.

As Solon T. Kimball writes in his introduction to the English edition of Arnold Van Gennep's classic *The Rites of Passage,* the ceremonies accompanying the rites of betrothal, marriage, pregnancy, and childbirth

"are directly related to the devices which society offers the individual to help him achieve the new adjustments." In societies with few communal rituals, "individuals are forced to accomplish their transitions alone and with private symbols." Today in the Western world "ritual has become so completely individualistic that it is now found for many only in the privacy of the psychoanalyst's couch."[13]

On one level, then, the crises experienced by Plath, Cardinal, Atwood, and the countless others who come into adulthood through the perilous gates of madness may be seen as periods of transition between one life stage and another—transitions which, in former times and different cultures, might have been more easily achieved with the aid of established *rites de passages*. The breakdown into madness, into private symbols meaningful only to their inventors and, at best, communicable to psychiatrists, has become in the twentieth century a common signifier of early adult crisis for an age lacking adequate collective forms of expression.

What rituals accompany such personal milestones as conception, pregnancy, and childbirth in our time? The trip to the laboratory to ascertain if one has conceived? Increasingly, as in the case of Atwood's protagonist with her first conception, pregnancy is terminated by the "ritual" of abortion. Childbirth, as shown by Cardinal, is performed in sterile settings where the process of giving birth is treated as a medical intervention. Atwood evokes, instead, the sense of the sacred that once accompanied the creation of human life and empowers the female creator with magico-religious strengths that help facilitate her tasks.

Thus, what we have understood as a sequence of events constituting regression—regression in the service of the ego, to be sure—may also be seen as a complex ceremony designed to enable the future mother to achieve her new status. In this connection, Van Gennep's *Rites of Passage* offers useful insights: "The ceremonies of pregnancy and childbirth together generally constitute a whole. Often the first rites performed separate the pregnant woman from society. . . . They are followed by rites pertaining to pregnancy itself, which is a transitional period. Finally come the rites of childbirth intended to re-integrate the woman into the groups to which she previously belonged, or to establish her new position in society as a mother. . . ."[14] Following Van Gennep's three-fold division of these rites into those of separation, transition, and incorporation, it is possible to make anthropological sense out of literary madness. The narrator's withdrawal to her wilderness cabin may be seen as a rite of separation, not unlike those practiced in primitive societies by pregnant women who were commonly sequestered in special huts or other segregated locales. The self-imposed interdiction against eating prepared foods and the ablutions in the lake may be seen, respectively, as dietary taboos and purification

rituals—rituals intended to protect the mother and foetus, in their vulnerable interdependent state, against evil forces. According to this schema, the narrator's parents, like the animal emblems with which they are associated, may be identified as protective spirits. When Atwood's heroine exclaims that "the rules are over" and that she "can go anywhere now," she signals the lifting of taboos. It is not surprising that the removal of barriers occurs only after she has taken leave of mother and father; it is necessary to separate conclusively from the parental family before embarking upon the final rite of childbirth. Maternity will project the narrator into a new social realm where mother and child, and mate and mate henceforth constitute her primary loyalties. At the end of the novel the narrator cautiously declares herself ready for motherhood and for reintegration into society.

Note that the decision to bear a child precedes the decision to rejoin her mate and the social world from which they have come. This sequence of priorities, reversing the more typical order of marriage and childbirth, has become increasingly frequent in the last decade; couples throughout the Western world have begun to live with each other outside the official bond of marriage and, to a large extent, without societal reproach. Often it is the decision to have a child or the onset of pregnancy that convinces the couple it is time to wed. While Atwood's narrator may be simply following the mores of her time and set, she may also be recalling certain cultures in which marriage is not valid until a child has been born.[15] Whatever the reasons for adopting this sequence in her novel, the author seems to be making a statement about the priority of the mother-child bond over the spousal bond and questioning the validity or at least the durability of marriage without a child. In the world to which the narrator will return, a world devoid of meaningful ritual, something as elemental as the ties of blood may be necessary to bind woman to man within the social order.

Many of Atwood's short stories written during the 1970s and recently collected under the title *Dancing Girls and Other Stories*[16] bear witness to the same fascination with mental derangement, babies, and the uncommitted heterosexual couple found in *Surfacing*. "The Man from Mars," "Polarities," "When It Happens," "Lives of the Poets," and "Giving Birth" are fictive accounts of actual or potential breakdown written in that understated yet disquieting style Atwood has perfected for conveying human estrangement. "Betty," "Under Glass," "The Resplendent Quetzal," and "Giving Birth" express the conscious and unconscious worry over babies or the lack of babies that we have come to recognize as an archetypal female form of apprehension. "Betty," "Under Glass," "The Grave of the Famous Poet," "Hair Jewellery," and "The Resplendent Quetzal" are also

all exercises in miscommunication between members of a male-female dyad. Together these stories constitute a compendium of concerns drawn from Atwood's understanding of what it is to be a nubile woman in our time—traditional concerns about "marriage" and "family" in their contemporary nontraditional forms—and the fear of mental disintegration that has become almost epidemic in the modern world.

In the three novels Atwood has written since *Surfacing*, the heroines have clearly moved beyond the individualistic experience of madness and the dualistic experience of maternity into a larger social arena. *Lady Oracle*, her third novel, while still conceived of as a search for identity, is more of a Gothic thriller than an artistically and psychologically satisfying work of literature. *Bodily Harm*, her last novel, is a potboiler that treats grave human and political matters with facile superficiality. Fortunately, these criticisms cannot be made of her penultimate work, *Life Before Man*, which reconsiders some of *Surfacing*'s major themes within the framework of a fully mature work. In this book, Atwood distances herself from the problem of female identity by writing in the third person (rather than in the first person) and by creating two female protagonists, Elizabeth and Lesje. The issue of male-female relationships has moved to center stage, as both of these women lay claim to Elizabeth's husband, Nate. Both Lesje, a paleontologist, and Nate, a former lawyer turned craftsman, articulate Atwood's continued concerns for a world that has become increasingly inhuman. Taking its title from the apocalyptic ending of *Surfacing*, *Life Before Man* implies that humankind, in the best sense of the word *human*, has not yet begun to evolve.

Surfacing leaves us with a vision of madness that is meaningful for the individual and symbolic for the species. As a narrative about psychic disintegration and reintegration, it is a noteworthy example of the modern psychiatric novel. Its central character can be classed with Esther Greenwood, Holden Caulfield, the heroine in Cardinal's *Les Mots pour le dire*, and numerous other post-World War II protagonists for whom mental breakdown has become an almost exemplary response to overwhelming internal and external stress. As a visionary figure exquisitely sensitive to the ills of her age, Atwood's heroine also joins the ranks of Lessing's Martha Quest in *The Four-Gated City*[17] and Piercy's protagonist in *Woman on the Edge of Time* in their passionate condemnation of a world that passes for sane. However, unlike Lessing and Piercy, who envision no possible personal or racial survival in a world gone mad, Atwood, as Lillian Feder notes, "make a kind of peace" with herself.[18] Through the rediscovery of her personal maternal heritage and the reunion with a primeval past, she is reborn into hope for herself and for the human race.

The message of hope promulgated by Atwood in *Surfacing* springs from a belief that there are still a few noncorrupted souls, a few pristine islands outside the mainstream of pollution. For late twentieth-century Americans who constitute a large portion of Atwood's readership, the Canadian hinterlands still offer the possibility of a primitive retreat; not so very long ago the American wilderness possessed this same symbolic value in the eyes of Europeans. In such a state of nature, one must depend entirely upon one's own resources, becoming one's own guide, parent, psychiatrist, reinventing religion. The monumental project of the rebirth of self and civilization will call primarily upon female rather than male power because men have traditionally directed their force against each other, as well as animals, in games of war and the hunt. Atwood's narrator comments on the "Americans' " wanton killing of the wildlife: "Senseless killing, it was a game; after the war they'd be bored" (p. 144). The words of Adrienne Rich seem to parallel Atwood's position: "men—insofar as they are embodiments of the patriarchal idea—have become dangerous to children and to other living things, themselves included; . . . we can no longer afford to keep the female Principle enclosed within the confines of the tight little post-industrial family."[19]

In Atwood's utopian vision, woman leads the way, but she does not go it alone.[20] The male too is necessary, if only as progenitor. (Having coupled with Joe, the protagonist says: "I'm grateful to him, he's given me the part of himself I needed" [p. 191].) Atwood conceives of a "soft primitivism" where the male element would be subordinated to the female, where a female alignment with the life force in nature would constitute a moral bulwark against male-authored destructive forces. Ultimately, however, Atwood does not present her spokeswoman as totally innocent; she was at least an accomplice to acts of violence, such as those perpetrated by her brother in childhood upon animals and later by her lover upon herself when she consented to an unwanted abortion; she calls herself "accessory, accomplice" (p. 143) when she takes her friends fishing for sport rather than necessity, and concedes that it is not men alone but "the Americans, the human beings, men and women both" (p. 180) who have aligned themselves with death. In the confrontation between the destroyers and "the gods," the narrator recognizes her obligation "to choose sides" (p. 180), and then traces the rough path that leads away from a sense of victimization toward responsibility and beneficent action. Powerless no longer, Atwood's heroine takes a first willed step: she conceives a child. Some would see this as a step backwards into a hopelessly outdated promaternalism, into the immanence of the madonna figure who can only recapitulate but never initiate. This is surely not Atwood's intent.

In *Surfacing,* the choice of motherhood represents a fusion of the personal and mythic, but it is not to be seen as a categorical imperative. The narrator chooses motherhood as a consciously determined act designed to efface the festering memory of abortion and to assist in the reintegration of previously fragmenting parts of the self. These are drawn back into a magic circle presided over by benign parental and natural spirits. At the heart of the circle sits the figure of the "woman with a round moon stomach" (p. 185), bearing a girl child. This graven image gives the protagonist power to go forth out of the world of madness into a better place.

The icon of mother and daughter, recast from the traditional image of mother and son, offers a radical feminist revision of the Christian myth. By reversing the sex of the baby, it subverts the legendary relationship of mother to male offspring, which has been conceived of by men, from the Gospel writers to Freud, as the epitome of familial bonds.[21] It concerns itself instead with "female-female relationships" and with a matrilineal heritage passed down from mother to daughter.[22] The moon stomach also suggests prehistoric goddess cults whose lunar emblem presided over gynocentric cultures.[23]

By placing the baby within the mother's womb, instead of in the mother's arms, it evokes the iconography of primitive cultures and mad artists who often rendered fertility with a graphic vividness rare in Western art. In this respect, the drawings of Emma Santos are classic examples of the female artist-cum-madwoman; her expressionistic visions of self frequently include a baby in the womb or babies emerging from her mouth.[24]

In Atwood's iconography the narrator is not depicted as the mother, but as the baby looking out from the womb. In addition, it is she, the narrator as child, who had made the drawing in the first place. These interlocking images of mother-daughter-artist suggest levels of creativity beyond the solely biological. As potential mother, the narrator offers a symbolic paradigm of the female prerogative to bear life, perhaps even the legendary savior. As daughter, offspring of the madonna-goddess, she may *herself* direct the establishment of an ecological utopia where humankind is no longer synonymous with "man-unkind" (e.e. cummings). As artist, the narrator may imagine an infinite number of alternate visions for herself and her species. She can no longer look to parents or lovers or gods for self-justification, but must take full responsibility for her own existence. Ultimately, if she is to survive, she must give birth to herself and become midwife to a life-oriented human community.

6
Mother to Herself:
The Writer's Quest for Sanity

The words "Mother to myself" found in Sylvia Plath's poem "Face Lift" encode the desire for rebirth that is implicit in almost every literary account of mental breakdown.[1] Going mad is rarely presented as an end in itself, no matter how exalted its hallucinatory or visionary power. Madness is a tragic necessity, a boundary experience through which the sufferer passes, clutching the hope that a new life will be found on the other side. This new life is not simply granted like first life; it must be attained through an act of re-creation. Plath's metaphor "Mother to myself" suggests the difficult labor of creating oneself anew, which can occur only when one is both biologically and psychologically capable of assuming responsibility and direction for one's life. The metaphor is maternal and the content existential.

Fifteen years after Plath's death a young American painter named Pamela Djerassi Bush chose the words "Mother to myself" as the title for a poem in which she described the experience of having her tubes tied voluntarily when she was in her mid-twenties and not yet a mother.[2] The decision to take such a radical step was wrung from the irreconcilable conflict she perceived between the immediate demands of her art and the potential claims of motherhood. The poem ends on an affirmative note: henceforth the artist will be mother only to herself, mother to her paintings rather than to living children. That life, however, ended tragically. Pamela Djerassi killed herself at the age of twenty-eight.

It is not my intent to analyze the particular case of Pamela Djerassi nor to draw any lesson from her history. What interests me is the representative nature of her life situation. As a woman, she knew that she had the power to bear life. But as a woman, she also knew that the creation of life would be bought at the expense of other human rights: it would constrict her

personal liberty and impinge upon her performance in other than maternal spheres. The process of producing life might even threaten her own or, at the least, her sanity. For the female artist, whether she is Pamela Djerassi, Sylvia Plath, or Anne Sexton, the conflicting pressures of art and maternity can be of such intensity as to add overpowering stress to any fissure that already exists in the psychic structure.

Margaret Atwood's short story "Giving Birth,"[3] written after the author had become a mother (unlike *Surfacing*), further explores the hidden connections between maternity, madness, and the reborn self. The author, now the mother of a toddler-daughter, sits down to write the story of a primagravida, Jeanie. Despite the author's disclaimer that "This story about giving birth is not about me" (p. 226), it is made clear through a series of parentheses that the character of Jeanie emerges from Atwood's recollection of a former self and that writing is a means of "bringing her back to life" (p. 229). Jeanie goes through pregnancy enthusiastically, knowledgeably, with the requisite sympathetic mate, prenatal classes, and all the rational accoutrements of baby-making in the 1970s. She is pursued, however, by an uncanny double, another pregnant woman "who did not wish to become pregnant, who did not choose to divide herself like this, who did not choose any of these ordeals, these initiations" (p. 230). The nameless woman with "the haggard face, the bloated torso"—clearly the obverse of a "vitaminized, conscientious, well-read Jeanie"—prompts Jeanie to ask herself why she is being followed "by this other" (p. 231). Their shadow relationship becomes even closer in the hospital when Jeanie, carefully observing the program laid out in her prenatal classes, gives birth with a good measure of lucidity and control, while her alter ego lies in the next room "screaming and crying . . . saying, over and over, 'It hurts. It hurts' " (p. 236).

When the dual deliveries are over, Jeanie wonders if the other woman or her baby has died, or if she will be "one of those casualties . . . who will go into postpartum depression and never come out" (p. 239). All the bad feelings one experiences during the long months of pregnancy and the seemingly endless hours of labor—the horror at one's distorted body, the ongoing discomforts and ultimate physical agony, the threats of losing one's mind and of dying—these are disowned and projected onto the unknown woman, thus allowing Jeanie to preserve only the positive residue of her maternal self-image.

Now that "her job is done," the mysterious woman leaves the hospital "carrying her paper bag" (p. 240). The bag suggests those other nameless "bag women" found in urban centers who are living incarnations of our worst fears about mental and social disintegration. Jeanie's double, however, performs a valuable function stated explicitly in the text: "She has

seen Jeanie safely through, she must go now to hunt through the streets of the city for her next case" (p. 240). As the vessel into which Jeanie has poured her deepest terrors, the suffering woman is more than a conventional doppelgänger (like Joan, for example, in *The Bell Jar*); she is a female Christ figure who searches out expectant mothers, accepting their fulsome fantasies and assuming their intolerable pain—an anonymous partner in the eternal drama of childbirth. This is the mythic helpmate Atwood invents for prospective mothers to see them through a rite of passage that has the potential for dividing them against themselves.

Before her personal experience of childbirth, Atwood had imagined maternity as a visionary experience—one capable of bridging madness and mysticism and of transforming the heroine of *Surfacing* from a stunted human being into a fully realized one. "Giving Birth" recalls that hope: in labor, Jeanie "is, secretly, hoping for a mystery. Something more than this, something else, a vision. After all, she is risking her life, . . . She deserves a vision, she deserves to be allowed to bring something back with her from this dark place" (p. 235). After the baby has been born, the narrator is more sober: "As for the vision, there wasn't one. Jeanie is conscious of no special knowledge; already she's forgetting what it was like" (p. 239).

What, then, is the unique effect of childbirth on the mother, if it can no longer be seen as a mystical experience? "Giving Birth" acknowledges the very real dangers to the mother's health and sanity that lurk in pregnancy and parturition; but while childbirth may not lead to a visionary moment, it can effect long-term renewal. This belief is conveyed in linguistic observations on the words *delivery* and *giving birth*, as in the story's first two sentences, which, referring to the title, ask: "But who gives it? And to whom is it given?" (p. 225). These questions are answered near the end in a parenthesis that blurs the distinction between Jeanie, a fictional character (albeit an autobiographical one), and the author who is writing her story: "(It was to me, after all, that the birth was given. Jeanie gave it, I am the result.)" (p. 239). Jeanie, Atwood's persona for her pregnant self, gave birth not only to a baby but to the baby's mother. The primary referent for "giving birth," Atwood suggests, is the mother—it is her act, producing both a new person and a renewed person. As in Plath's image, the mother is mother to herself. The story concludes with Jeanie's metamorphosis into "someone else" (p. 240), presumably the person writing the story, for whom parenthood has provided an emotionally rich and "calm and orderly" life (p. 227).

Paradoxically, then, while maternity may lead to breakdown, it can also serve as a grounding experience. Atwood embraces the idea of motherhood as a means of projecting the heroine of *Surfacing* (initially an arrested

human being and artist) into a more auspicious future, and she foresees for Jeanie the sense of accomplishment and joy in producing offspring that the author seems to have experienced in her own life. A case can also be made for the fruitful effects of motherhood on Sylvia Plath, who, for all of her terrible ambivalence about motherhood, produced her best work after she had become a mother. Alvarez reminds us that "The *real* poems began . . . after the birth of her daughter, Frieda. It is as though the child were proof of her identity, as though it liberated her into her real self."[4] Susan Van Dyne goes even further in establishing a direct connection in Plath's mind between the experience of childbirth and the birth of poetry: "she hoped the violent naturalness of her home deliveries of both Frieda and Nicholas might free the emergence of the poems."[5] Bundtzen also contends that "babies were . . . crucial to Plath's sense that she was creative, evidence that she was not a barren intellectual. . . ."[6] In Cardinal's works, too, the various personae, while often severely damaged by the negative aspects of motherhood (especially in *La Souricière* and *Les Mots pour le dire*), also reveal its humanizing benefits, most notably in *La Clé sur la porte* and *Le Passé empiété*.

In this study I have explored the question of why some women experience maternity primarily as a psychic threat and others as a contribution to a healthy sense of self, by examining the responses to certain existential realities—responses which become pathological under certain circumstances. These circumstances derive largely from experiences in early life: from insufficient or warped forms of parent-daughter attachment, from the discovery of death in childhood, and the defense mechanisms that are inadequately erected at that time. Although we must be careful not to ascribe sole responsibility to parents for the etiology of their children's mental diseases—as is often the case when psychiatrists consider their patients' mothers,[7] and as we also find in the "blame-the-mother" school of feminist scholars[8]—parents *do* play a major role in helping the child overcome the menace of mortality and develop satisfying, life-affirming capacities.

Sylvia Plath, Marie Cardinal, and Margaret Atwood have left remarkable testimonies to the role played by the death of a parent in the genesis of madness. Other writers who have gone mad—Violette Leduc, Virginia Woolf, and Anne Sexton, for example—have contributed further evidence of the relationship between parental death and psychological impairment for the daughter who lives through that death.

In the case of Virginia Woolf, both the death of her mother in 1895 when Virginia was only thirteen years old and that of her father in 1904 when she was twenty-two triggered severe mental breakdowns, the latter accompanied by her first suicide attempt. Evidently it was the earlier death

that made the deepest and most enduring insult to Woolf's fragile psyche, inaugurating the "horrible voices" that were to be heard intermittently in periods of insanity throughout her life until they led her to suicide in 1941. Her biographer Quentin Bell wrote that "The shock [of her mother's death] drove Virginia out of her mind,"[9] and her later recurrent breakdowns were, by her own admission, bound up in the obsessive presence of her dead mother. Woolf wrote in "A Sketch of the Past": "It is perfectly true that she obsessed me, in spite of the fact that she died when I was thirteen, until I was forty-four."[10] Literary attempts to come to terms with the loss of her mother began with the writing of *The Voyage Out* in 1915 and culminated in her masterpiece *To the Lighthouse* in 1927, in which the portrait of Mrs. Ramsay paid consummate tribute to Julia Stephens and established an unrivaled mythopoetic maternal figure in modern fiction. Twelve years later, recognizing the therapeutic benefits derived from writing *To the Lighthouse*, Woolf reflected:

> I wrote the book very quickly; and when it was written, I ceased to be obsessed by my mother. . . . I suppose I did for myself what psychoanalysts do for their patients. I expressed some very long felt and deeply felt emotion. And in expressing it I explained it and then laid it to rest.[11]

As Woolf recognized, writing is one of the most available artistic forms for dealing with personal loss; for finding release from grief, sorrow, pain, fear, or terror; for exorcising those nighttime ghosts who seem less potent in the day when controlled by the pen or typewriter.

The connection between mortality, maternity, and madness, as well as the therapeutic benefits obtained from writing, are nowhere more evident than in the life and works of Anne Sexton. Throughout her adult years until her death by suicide one month before her forty-seventh birthday, she was subject to bouts of severe depression requiring numerous hospitalizations. She was first institutionalized for attempted suicide following the birth of her first baby, and again two years later after the birth of her second. Childbirth and the care of infants seem to have been intolerable experiences for Sexton. The editors of her letters—one of whom was her daughter Linda—write bluntly: "Motherhood was overwhelming. Anne had found childbirth horrifying and later avoided discussing it."[12] The years following the birth of her two daughters "were nightmares for everyone,"[13] with Sexton intermittently institutionalized and unable to care for her children. Joy, the second daughter, remained with her paternal grandmother for three years, while Sexton struggled to keep Linda at home

and to build a firmer sense of self with the help of her psychiatrist and through her developing commitment to writing poetry.

Sexton's biographer Diane Middlebrook has traced her metamorphosis from "housewife into poet" during those turbulent years in the 1950s when Sexton became a mother of two, a chronic mental patient, a fledgling poet, and an orphan.[14] She documents Sexton's wild determination to birth herself as poet—an identity more consciously assumed and more ego-enhancing than those of wife, daughter, mother, and madwoman. Poetry offered the possibility of integrating disparate and often conflicting parts of the self—daughter and mother, crazy lady and artist, wife and seduc-tress. In poetry she would find her best self.

Like many who had gone before her into spiritual darkness, Sexton grasped the opportunity of madness for spiritual rebirth. "Not til we are lost . . . do we begin to find ourselves" is the quote from Thoreau she used as epigraph for the second poem in her first published collection, *To Bedlam and Part-Way Back,* based upon the experiences of insanity and institutionalization.[15] Despite the scorn for the insane that she perceived from society, and even the admonition from her mentor John Holmes that the life of a mental patient is hardly fit subject for poetry,[16] she persisted in acknowledging that she and the madwoman were one.

> I have gone out, a possessed witch,
> haunting the black air, braver at night;
> dreaming evil, I have done my hitch
> over the plain houses, light by light:
> lonely thing, twelve-fingered, out of mind.
> A woman like that is not a woman, quite.
> I have been her kind.[17]

Rebirth as witch—evil, mad, unwomanly—the self-image prefigures Plath in the *Ariel* poems. Sometimes the tone is defiantly gleeful: "And this is the way they ring / the bells in Bedlam."[18] More often it is wistful, ironic, attesting to the fear and pain that self-scrutiny entails.

> And opening my eyes, I am afraid of course
> to look—this inward look that society scorns—
> Still, I search in these woods and find nothing worse
> than myself, caught between the grapes and the thorns.[19]

Much of Sexton's poetry issued from the need to restrain a terrifying array of inner ghosts. Two years after *To Bedlam and Part-Way Back,* she

published a second volume entitled *All My Pretty Ones,* which was dedicated to her recently deceased parents. In it she wrote:

> Some ghosts are women,
> neither abstract nor pale,
> their breasts as limp as killed fish.
> .
>
> Not all ghosts are women,
> I have seen others;
> fat, white-bellied men,
> wearing their genitals like old rags.
> .
>
> But that isn't all.
> Some ghosts are children.
> Not angels, but ghosts;
> curling like pink tea cups
> on any pillow, or kicking,
> showing their innocent bottoms, wailing
> for Lucifer.[20]

The ghosts of women and men, of mothers and fathers, are devastating enough, yet there is probably nothing worse for a person to contemplate or experience than the death of his or her own child. All my pretty ones?—Macduff's tragic cry when he learns of the slaughter of his family—is the ultimate howl of despair. Sexton, both daughter and mother, composes her confessional elegies from the births and deaths that constitute key chapters in her own life story. Her mother's cancer is imaged as an organic growth, similar to the natural presence of Sexton herself when, as a foetus, she inhabited her mother's womb.

> It grew in her
> as simply as a child would grow
> as simply as she housed me once, fat and female.[21]

In another poem where Sexton, the mother, lies down next to her baby daughter, the poet aches with the knowledge that her baby will die someday, and that her baby's baby will also share that same unthinkable fate.

> Darling, life is not in my hands;
> life with its terrible changes
> will take you, bombs or glands,
> your own child at
> your breast, your own house on your own land.[22]

Whether the end come from "natural" or external causes, the mother-writer is hard put to ignore the omnipresence of death. "Fact: death too is in the egg."[23]

Like Sexton, all the writers discussed in this study make manifest the interrelationship between life and death that exists in the female psyche and that frequently finds literary expression in obsessive maternal images. Procreation activates memories of the death of parents, siblings, and significant relatives, and begets fears of the death of one's offspring, not to mention the root fear of one's own death.

It is instructive to find these same themes played out in the work of Maxine Hong Kingston, whose ghosts derive from a different cultural source. In *The Woman Warrior: Memoirs of a Girlhood among Ghosts,* Kingston recreates the Chinese-American heritage that provided the tissue for her adult fantasies.[24] Stories from a mythical China, where females were traditionally denigrated and girl babies often murdered at birth, prey upon her psyche and weave their shapes into phantasmagoric fables. Like the obsessive images of babies in *The Bell Jar,* Kingston's inner turmoil finds its objective correlatives in "nightmare babies" (p. 101) who proliferate among a host of ghosts and crazywomen. There are the Mainland China ghosts carried to America by her mother; the brother and sister "who died while they were still cuddly" (p. 96), defective babies left to die in outhouses, girl babies smothered in boxes of ashes, "the ghosts, the were-people, the apes, . . . the nagging once-people. . . . My mother saw them come out of cervixes" (p. 98). Most of these phantasms are transmitted to Maxine through her mother's midwifery tales, thus establishing a ghoulish connection in the daughter's mind between the mysteries of birth and death.

America has its own forms of "Kuei," ghosts recognized as such only by the Chinese: "—Taxi Ghosts, Bus Ghosts, Police Ghosts, Fire Ghosts, Meter Reader Ghosts, Tree Trimming Ghosts, Five-and-Dime Ghosts" (p. 113). These visible ghosts add to the young girl's store of fears and, unlike the effect they have on her mother, Brave Orchid, a bold Ghost Chaser, they maim and paralyze her. "Once upon a time the world was so thick with ghosts, I could hardly breath; I could hardly walk, limping my way around the White Ghosts and their cars" (p. 113).

It is not surprising to find in Kingston's world blatant images of crazy women coexisting alongside ubiquitous ghost forms. There is the crazy lady stoned to death by the villagers for trying to signal Japanese planes with her mirrored headdress; Crazy Mary left behind in China for twenty years and forever beyond the pale of sanity when she arrives in America; the witchwoman Pee-A-Nah, "the village idiot, the public one" (p. 219); Aunt Moon Orchid, who goes insane in California after her arrival from

Mainland China; the speechless girl who refuses to be pinched into speech—
all are alter egos for the author herself, who lived her girlhood on the edge
between the threat of ghosts and the temptation of madness. "I thought
every house had to have its crazy woman or crazy girl, every village its
idiot. Who would be It at our house? Probably me" (p. 220).

Kingston structures her autobiography around the figures of five central
women who incarnate various negative and positive possibilities leading
either to craziness and/or suicide, or to escape into more fortuitous forms
of self-expression. The first, a cautionary tale told by her mother when
Maxine began to menstruate, concerns the "No Name Woman," an aunt
in China who killed herself and her illegitimate baby following humiliation
at the hands of the villagers. The nameless aunt speaks for the author's
most deep-rooted fears: cruelty and injustice inflicted upon women; terror
in the face of pregnancy and childbirth, especially out of wedlock; the
intermingling of birth, death, and potential madness. Kingston closes the
episode by telling us: "My aunt haunts me—her ghost drawn to me because
now, after fifty years of neglect, I alone devote pages of paper to her . . ."
(p. 19). She feels implicated in the life and afterlife of this ancestor, the
chief ghost in a hierarchy of spectral beings. The aunt whose name cannot
even be pronounced by surviving relatives because of the shame she has
brought to the family becomes incorporated into her niece's sense of iden-
tity as a negative role model who must, nonetheless, be placated and
vindicated. Kingston assumes responsibility for restoring her aunt's mem-
ory, for giving her symbolically the descent line she will never have;
starting from this obligation to feed a "forever hungry" (p. 19) ghost, she
proceeds to evoke other mythic figures who represent alternative images
for self-definition.

The major antagonist to the No Name Woman is Fa Mu Lan, the
Woman Warrior, a legendary character in Chinese literature, whose story
was also transmitted to Maxine Hong Kingston by her mother. In the
original ballad, Fa Mu Lan goes off to fight for the Khan as a replacement
for her father; the motive for martial involvement is daughterly piety.[25]
After briefly passing over the ten years spent in battle, the ballad focuses
on the daughter's traditional life at home before and after her bravery as
a soldier. Kingston turns this feminine figure into a modern, militant
heroine—a strong and dangerous swordswoman, a visionary sensitive to
ecological concerns, an athlete unaffected by her menstrual days, a feminist
wife and mother, a female avenger, the fierce enemy of sexism, racism,
and all other forms of injustice. She is essentially a creation of Kingston's
imagination, though she shares with her literary ancestor the act of replac-
ing her father as conscript. One of the most original aspects of Kingston's
revision of the woman warrior is found in the combination of maternity

and soldiering. No virginal Joan of Arc, she rides into battle big with child at the side of her husband, and retires from the field only once—to give birth. Then, in a clear-cut reversal of roles, she gives the baby to her husband and tells him to take it to his family. In many ways the woman warrior presented in chapter 2 offers a contemporary American wish-fulfillment fantasy designed to counter the image of the victimized Chinese aunt.

Chapter 3 of *The Woman Warrior* focuses on the figure of the author's mother, clearly the source of the daughter's contradictory self-images: "She said I would grow up a wife and a slave, but she taught me the song of the woman warrior, Fa Mu Lan. I would have to grow up a warrior woman" (p. 24). Like the mother in Marie Cardinal's autobiographical novel, Kingston's mother is the overarching female presence of the book, planting in her daughter the seeds of confusion that could spring into full-grown madness. Mother is the link between Chinese and American culture, the transmitter of myth, the storyteller, the shuttle between dream and reality. "Night after night my mother would talk-story until we fell asleep. I couldn't tell where the stories left off and the dreams began" (p. 24). From her tales of a prewar China, Mother assumes in her daughter's mind the larger-than-life dimensions of a shrewd and dignified doctoress whose patients all get well. But how is the daughter to merge that vision with the reality of her mother as laundryworker in Stockton, California? And how can she combine her mother's stories and proverbs conveying female worthlessness ("Better to raise geese than girls" [p. 54]) with the legends of female power and the awesome life force she perceives in her own mother? ("At last I saw that I too had been in the presence of great power, my mother talking-story" [p. 24].)

From the contradiction between female worth and worthlessness, the confusion between dream and reality, and a plethora of other conflicts issuing from Hong Kingston's Chinese-American heritage arise the alarming figures of female madness who abound in her imagination and proliferate in the last two chapters of the memoirs. Chapter 4 is devoted to Moon Orchid, Brave Orchid's delicate sister from Hong Kong who loses her sanity in California. Hers is one of the funniest and most pathetic stories in the book. Unlike Brave Orchid, the tough and fearless, Moon Orchid is a complete misfit in America, ineffectual even in her attempts to communicate with her sister's children or to fold towels in the family laundry. She is pushed over the border into madness by Brave Orchid's insistance that she try to recoup the wayward husband who had abandoned her decades earlier although he had continued to send support payments from Los Angeles. Moon Orchid's symptoms are a paranoid fear of the

"Mexican ghosts" (p. 180) and a monotonous form of speech that ultimately defeats even Brave Orchid's determined ministrations.

> Brave Orchid saw that all variety had gone from her sister. She was indeed mad. "The difference between mad people and sane people," Brave Orchid explained to the children, "is that sane people have variety when they talk-story. Mad people have only one story that they talk over and over." (p. 184)

Speech is also the core issue in the story of the "sissy-girl" (p. 204), the closest childhood double for the author herself. While Maxine and other Chinese-American girls learn to whisper so as to make themselves "American-feminine" (p. 200), this little girl refuses to talk at all. The irrational hatred Maxine experiences for her is a form of projective identification—one hates in the other exactly that which one hates in oneself—and her violent efforts to pinch the girl into speech in the lower depths of the lavatory reflect the narrator's self-flagellation over her own shyness and "pressed duck voice."

When asked in an interview about the relationship between herself and the speechless girl in her book, Kingston conceded that the speechless girl was in some ways a double for herself. "The question has to do with fantasy life and the so-called real life. I feel that everyone has a blurred area, which is a border between their imagination and what actually happens, and I am very interested in that border. Yes, I went through a time when I did not talk to people. It's still happening to me but not so severely. I'm all right now but I do know people who never came out of it."[26]

Recovering one's speech is, for Kingston, synonymous with finding the path away from madness. This is the central concern of the last chapter, "A Song for a Barbarian Reed Pipe," inspired by the poetess Ts'ai Yen born in A.D. 175. The captive poetess who sings of China to her barbarian captors, transcending differences in language, sex, and station, becomes for Kingston a model of self-realization. She points the way for Kingston's own mode of translating an alien culture to Americans and provides the medium through which the author is able to end her memoirs on a note of reconciliation with her mother. The final strategy, like much of the book, is nothing less than brilliant. "Here is a story my mother told me, not when I was young, but recently, when I told her I also talk-story. The beginning is hers, the ending, mine" (p. 240). Resolution takes place between the mother's oral tradition and the daughter's written craft, between the Chinese and the American, and ultimately between mother and daughter. Maxine Hong Kingston, American offspring of a foreign-born mother

who does not speak or read English, finds her voice by taking up where her mother's leaves off. By consciously situating herself within the heritage of maternal "talk-story," she learns to loosen her own tongue, which will be the guarantor of her sanity. Like Cardinal, Kingston offers the model of a writer who talked her way out of madness.

All the authors in this book dramatize by their lives and works the problematic of literary creation for highly gifted women. Invariably, creation conflicts with procreation, forcing the writer to come to terms, as best she can, with the existential claims of maternity and the societal demands of motherhood. The writer attempts to mediate this conflict in a variety of ways, some of which prove to be more effective than others. Woolf, like most women writers in the past, chose not to have children (or did Leonard Woolf and the medical profession choose for her?).[27] Plath and Sexton, each the mother of two children and each ultimately a suicide, strove throughout their adult lives to carve identities for themselves as poets over and above their roles as wives and mothers. Cardinal, whose three successive pregnancies contributed to her mental breakdown in her late twenties, finds the way out of madness through the psychoanalytic process and by writing her personal story in fictional and autobiographical forms. Atwood and Kingston, each the mother of one child, appropriate the maternal metaphor for psycho-literary ends and offer imaginative visions of modern women accepting motherhood as a desirable, if difficult, component of balanced lives.

Each writer struggles with the dialectic between creation and procreation within an orbit inhabited by personal ghosts—the ghosts of parents long since dead, the wraiths of aunts, uncles, brothers, sisters, and dead babies. Ghosts continue to live in the artist's psyche, influencing her daily choices, attitudes, commitments, successes, and failures. The extent to which the ghosts of childhood, especially those of dead parents, persevere into adulthood has been a continuous theme of this book.

If in the dialectic between art and life women writers more often than not swim against the current of a maternal imperative, they are also frequently able to derive strength from their work as writers. Plath and Sexton through their poetry, Cardinal and Kingston through their autobiographies, Woolf through her fiction, each buoyed up her sense of self so as to stay afloat long enough to make substantial contributions to literature. When we think of the tragic ends of Woolf, Plath, and Sexton, we must also remember the books they *did* leave behind. But for their writing, they may have committed suicide even earlier. Without advancing the claim that writing in and of itself possesses curative virtues, and in the absence of critical studies which substantiate or disprove this claim, I have nonetheless been impressed by the number of authors who share the

belief that the medium of language can be the medium of salvation. Through their chosen craft, these writers, highly gifted, neurotic, sometimes psychotic, found the will and the way to tell the stories that helped to maintain a precious hold on sanity.

The relationship between artistic creation and the quest for sanity is a fascinating, complex topic that has commanded the attention of numerous members of the healing profession. A large psychiatric literature exists on the subject espousing various and sometimes conflicting theoretical positions, some favoring the view that the artist creates largely out of the suffering engendered by neurotic conflict, others arguing that he or she creates in spite of neurosis and would be a better artist without it.[28] There are those who understand art in terms of the sublimation of unsatisfied psycho-sexual drives and needs (Freud's analyses of art and literature often took this approach); those who extol the therapeutic properties of the creative process (Hemingway called his Corona his psychiatrist); those who grant to writing fiction the power of transforming an obsession into something that the reader, rather than the author, will then have to cope with (Nabokov wittily articulates this view in his memoirs).[29] Conversely, others convey the agony of artistic labor (Mallarmé's blank page, Flaubert's *affres du style* ["the anguish of style"]), and certain poets demonstrate how poetry itself may further the awesome flight from experiential reality that is the dubious privilege of madmen and visionaries (for example, Trakl and Rimbaud). All of these examples drawn from male theoretical and creative writers may, indeed, apply to individual female writers as well.

What seems to differentiate women as a "class" from their male counterparts, in this regard, is their propensity for seeing their literary production as conflicting with or substituting for biological offspring. The conflictual nature of creation and procreation is found throughout women's writing, as in a recent *New York Times Book Review* article entitled "On Mothership and Authorhood," in which the novelist Mary Gordon states candidly: ". . . it is impossible for me to believe that anything I write could have a fraction of the importance of the child growing inside me, or of the child who lies now, her head on my belly . . ." (10 Feb. 1985).

Consider the work of Emma Santos, whose long history of psychotic episodes, hospitalizations, electroshock treatments, sleep cures, medications, and suicide attempts was bound up with an entrenched desire to have a child—a desire that was frustrated by forced abortions, the growth and removal of a huge goiter, and several miscarriages. While pregnant, Santos associates the birth of the hoped-for child with the birth of language.[30] She makes little distinction between the book she is writing and the baby she is carrying: "A book is going to be published. A book is

going to be born. I have a swollen belly. I'm waiting for a baby. The book and the baby." But the baby is stillborn at five months, constituting a form of "payment" for the book she has just completed. ". . . I finish the second book in a burst of fury. I go into labor the same day. The baby is stillborn. The price of words."[31] As in her drawings that depict babies in the womb and babies emerging from her mouth like words in a cartoon, children and literature are connected in the deepest recesses of the author's mind. Even when Santos, in her sixth book, writes that her longstanding obsession with maternity has disappeared (replaced by her obsession with her ex-husband), her writing is presented as a substitute for the unrealized child. "I have published. I don't want to have a child."

Similar associations are manifest in Plath's writing. For example, in the poem "Stillborn" she transfers her obsession with dead babies to her unsuccessful poems, devoid of life despite their perfect form.

> These poems do not live; it's a sad diagnosis.
> They grew their toes and fingers well enough,
> Their little foreheads bulged with concentration.
> .
> They sit so nicely in the pickling fluid!
> They smile and smile and smile at me.
> And still the lungs won't fill and the heart won't start.[33]

Even so accomplished a writer as Virginia Woolf is wont to compare her literary talents unfavorably with her sister Vanessa's family life. Having received a generally encouraging letter from Macmillan's about *The Voyage Out,* she writes in her diary on September 13, 1919: ". . . I don't think Macmillan had much to do with my depression. Do I envy Nessa her overflowing household? Perhaps at moments."[34] Seven years later she is still weighing her gifts against Nessa's and berating herself for her lack of children: "My own gifts and shares seemed so moderate in comparison; my own fault too—a little more self control on my part, & we might have had a boy of 12, a girl of 10: This always makes me wretched in the early hours."[35] Woolf's biographer, Quentin Bell, recognizing that his subject (who was also his aunt) had "a perennial and incurable regret that she had no children" and "a natural jealousy of Vanessa in this respect," cites this cruelly lucid diary entry that marked the beginning of 1923: ". . . never pretend that the things you haven't got are not worth having. . . . Never pretend that children, for instance, can be replaced by other things."[36]

Clearly, the "child" is the standard by which the woman author often evaluates her literary output. Even when one is not a mother and has no realistic expectation of becoming one, as in the case of Woolf, one has to

measure up to the mother; and when one is a mother, as in the case of Plath who wrote "Stillborn" after the birth of her first child, the lingering fear of producing defective babies bleeds over into her literary work. Mother and child—these are the twin angels that even the proven female writer has to wrestle with. Her struggle to create literary offspring is simultaneously a struggle to equal or, better yet, to surpass herself as biological mother. In the process, if she is an artist with a history of mental illness, she may be able to write herself out of neurotic and psychotic prisons. Words offer the possibility of reconstituting the world, of gaining mastery over one's phobias, of redefining oneself. "I see myself in my (hand)writing," wrote Emma Santos from her hospital room when they had taken her mirror away.[37] However unstable the starting point, the act of writing can be seen as an effort to reclaim one's life, as a labor through which one may become mother to oneself as well as to literary progeny.

7
Conclusions

Throughout the writing of this book a certain question has constantly nagged at me. Each time I confront a text and find what I am looking for, I ask myself: have you found that particular bit of evidence because it is truly salient or because you have been selectively inattending to other equally salient issues? Each time, I convince myself that the core concerns of maternity and motherhood, the existential realities of aging and death, the crucial influence of mothers and fathers, and the perennial conflict between creation and procreation constitute the dominant chords in the fugue to madness that commands my attention. Perhaps I cannot hear the other notes.

Surely there are other strains: the "dischords" of poverty and deprivation, the wounds of class and race, the brutalities of war and violence. Women are raped into madness, as in Gloria Naylor's too-terrible *Women of Brewster Place*.[1] And women are shocked into madness, as in the world of Doris Lessing, by social disintegration and global holocaust. However true and however horrible, these are not the dominant chords one hears when listening to the combined voices of women writing about madness in the second half of the twentieth century.

This literature of madness, represented largely though not exclusively by the psychiatric novel, has at its core an inner quest as old as Augustine's and Dante's. It adds to the traditional autobiographical odyssey, where mortal sin or near-death were the conventional turning points in a narrative of conversion, a conception of madness as the ultimate modern experience through which the protagonist passes in search of her authentic self. (This psychological voyage of self-discovery is similarly romanticized in the work of the British analyst R. D. Laing and his followers.) Encrusted around this core are scathing critiques of the world in which we live, visionary

insights into worlds that could be. Implicit in all of these works is a belief that the mad person sees truths which "sane" people refuse to acknowledge, and that women in particular are hypersensitive to the realities of impending doom, not only because they are less able than men to act with impunity in a world dominated by male power, but because they are endowed with a unique capacity to bear life.

The maternal possibility forces upon each woman an anguishing confrontation with the most elemental aspects of existence, even if one chooses not to exercise the power of reproduction or if one is physically unable to reproduce. Motherhood, as reality, possibility, or impossibility, raises questions about the meaning of life, the value of projecting oneself into the future through one's progeny, the eventuality of replacing one's parents, the inevitability of death. These existential concerns, common to all human beings, are intensified in the case of women, before, during, and after the experience of childbirth. For some women—those whose adaptation to life is already shaky—the anguish surrounding pregnancy and motherhood is too much to bear, and they deconstitute under the strain. Of course, motherhood, actual or imagined, does not always make women vulnerable to psychosis; it is simply one of the major factors that impinges upon the female destiny, yet, from my reading of women's literature and psychiatric studies, it is one that has not been sufficiently appreciated as a causal factor in the etiology of mental illness.

Where is the woman who could say that she has never been awed by the thought of herself as a mother, never worried about the pains of childbirth, never wondered whether children would prove to be unbearable or, conversely, confer a privileged status? Where is the mother who has not applauded herself for having survived parturition, not feared for the life of her child, not mourned the loss of her prematernal self? Women's sense of self, derived from a myriad of biological, existential, interpersonal, and social factors such as one's gender, family, class, and race, is so fundamentally bound up with the idea of motherhood that any theory of mental health or mental illness that does not take it into account must be seen as a defective theory.

From the moment of one's birth the potential for maternity sets in motion a biological clock that ticks incessantly within the female form. Women hear it whether they attend to it consciously or not. Like the church bell calling one to early mass, occasionally the bell breaks through even the most tenacious sleep. This is the case for the girl experiencing her first menses, accompanied by the admonition "Now you can have babies," and, like Kingston and Cardinal, made to feel guilty for that very potential; for the twenty-year-old who knows that her best childbearing years lie in the decade before her and, like Plath, feels compelled to have babies at the very time when career demands are equally pressing; for the woman of

thirty who is warned that she had better hurry up; for the woman of thirty-five advised to have an amniocentesis; for the woman of forty reminded by her doctor that she is at the outer limit; and for the woman of fifty who knows that the making of children is no longer possible—just when someone close to her, a male contemporary or ex-lover or even her husband, decides it is time for him to start again, invariably with a younger woman. The older woman who has not yet reproduced wonders what she has missed, or, if she has, what she might have accomplished in life had she not made motherhood her career.

Little wonder that some women finding themselves caught in the vise of a maternal imperative—all the more potent because it is compressed into a third of one's expected lifespan—shatter in the wake of childbirth or under the pressures of childraising. But why some women and not others?

Of course, it is pretentious even to ask such a question, much less to try to answer it. Undoubtedly there is an infinite number of possible explanations for why people go mad, ranging from concrete biochemical to abstruse psychoanalytic systems. I shall focus only on those factors that have become apparent from a reading of the writers discussed in this book, against the backdrop of certain existential and psychological theories.

To begin, we must recall the assumption that madness is both a pan-human and a gender-specific experience, that both men and women are subject to certain inexorable existential realities including aging and death, isolation and freedom. These existential givens produce stresses that occur to all human beings, though they obviously affect some people more than others. One of the major variables affecting the experience of existentially produced stress is one's sex; for example, freedom is often encountered in radically different situations depending upon whether one is male or female. Sylvia Plath and Marie Cardinal, exceptional women—headstrong, daring, and gifted—still experienced their freedom, to a large extent, within the narrowly circumscribed arena of what was considered appropriately feminine. The choice of "giving up one's virginity," of marrying or not marrying, of having or not having children, of accepting or rejecting prevailing forms of childbirth, and of assuming the sole responsibility for childcare without a live-in father constituted traditionally female choices. Their decisions, however, to persevere as writers and to use the written word to reconstitute their lives were part of an exercise of freedom in a broader human (read, traditionally male) arena. Like many other women writers, they fashioned their lives and their literature from the dialectic between art and motherhood.

Plath and Cardinal shed light upon the manner in which one's early life experience does or does not lay the groundwork for dealing with the stresses inherent in this dialectic. Each writer in her own way draws

attention to the importance of parental influences, each emphasizing the overattachment to mother and the loss of father. Both experienced at an early age the sickness and death of their fathers; both attest to ambivalent attitudes of love and hate for their mothers that colored their own self-identities. While their experiences are not paradigmatic of all women, nor even of all women who have gone mad, they do suggest certain problem areas for all who find themselves unable to negotiate the various rites of passage into full adulthood.

A pervasive fear of death is present in all the works considered at length in this book, those of Atwood and Kingston as well as Plath and Cardinal. This paralyzing fear seems to have derived from exposure to death—that of fathers, mothers, siblings, and aunts—before the authors in question were able to build a normal denial system against it. The idea or experience of motherhood reactivated the fear of death, both for themselves and for their offspring, and provided powerful ontological instruction in the relationship between maternity and mortality: to become a mother is to replace one's own mother, to assume responsibility for the next generation, to accept the inescapable chain of life and death.

The guidelines women have for assimilating these existential truths are provided, for the most part, by their own mothers, who best prepare their daughters for this confrontation by being good mothers themselves. Of course, no one can formulate a conclusive program for the good mother, or even the "good enough" mother; writers recalling their histories in madness tell us only what the mother should *not* do. She should not die too early, like Virginia Woolf's mother; she should not reveal to her daughter that she was a failed abortion, as in the case of Marie Cardinal; she should not wrap double binds of female worth and worthlessness around her daughter's psyche, as did Maxine Hong Kingston's mother; she should not withdraw into silence that may be construed as emotional absence, like the mother of Margaret Atwood's protagonist; she should be wary of living vicariously through her female offspring in an unhealthy symbiosis, as happened with the Plath duo. The story of each maternal figure reads like a cautionary tale of how not to raise a daughter, yet each attests to the transmission of positive attributes as well. The attachment to mother in early life, the reciprocal love that clearly existed before and alongside the emergence of outright hostile feelings, undoubtedly contributed to each author's sense of self-worth and provided the strength for surmounting many, if not all, of their later problems in living.

And where are the fathers in all these stories? Dead, absent, insignificant, or, even worse, magnified into larger-than-life ghosts by their very deaths. Plath, both in her poems and also in *The Bell Jar,* Cardinal in *Les Mots pour le dire* and *Le Passé empiété,* Atwood in *Surfacing,* and Leduc

in *La Bâtarde* leave behind records of longing for fathers who were lost too soon or barely known. The death of Woolf's father occasioned an early suicide attempt, although Woolf admitted much later that had he lived, she probably would never have become a writer, so intimidating was the paternal aura. Kingston's father is but a wafer-thin figure behind her mother's massive form; Sexton's father was similarly overpowered by her mother's pervasive presence. What correctives might these fathers have brought to the unbalanced juggling act performed by mothers who tried to be both mother and father, or, as Plath poetically put it, "a man and a woman in one sweet ulcerous ball"?[2]

In this connection, a passage from *La Bâtarde* encapsulates the mental set of the single mother's daughter. When the author as a girl is taunted about her absent father, she retorts, "My mother is my father. . . . We haven't got a father in our house. There's just my mother. Can't you understand what I tell you? My mother's all that by herself."[3] For the child whose father is nonexistent, mother takes on the meanings of both parents, often becoming the recipient of a double set of expectations. All children grow up with "the fantasy of the perfect mother," as Chodorow and Contratto argue in an article of that name;[4] how much more potent and confusing must that fantasy be when it contains a fantasy of the perfect father as well!

Let us not fall into a blame-the-mother mode, even while we acknowledge the crucial influence of mothers on their daughters' psychic lives. All mothers have a formidable task, and many operate with little help from husbands or lovers or any other outside support. Perhaps the mother most to be pitied is Aurelia Plath. Sylvia recognized, with characteristic ambivalence, that her mother had done her utmost to provide for her children what she conceived of as the best possible upbringing within her limited means. "She pinched. Scraped. Wore the same old coat. But the children had new school clothes and shoes that fit. Piano lessons, viola lessons, French horn lessons. They went to summer camp and learned to sail. . . . In all honesty and with her whole unhappy heart she worked to give those innocent little children the world of joy she'd never had."[5] In the process, she also conveyed to Sylvia the expectation that she would become both a successful writer and a successful wife and mother. But how could Aurelia have prepared her daughter for the one fate that they had never anticipated for Sylvia—the fate of a single parent? Although Aurelia had bravely assumed that role, offering Sylvia the model of the good-mother-in-spite-of-everything, it was exactly that role which Sylvia could not accept for herself. Of all the fates she did not want to have, that of her mother as a joyless woman raising two small children alone was the one she found intolerable.

The experience of sharing the fate of other women is noticeably absent in the literature of madness written by white women. Plath, Cardinal, and Atwood exemplify the alienation of women from each other, both inside and outside the family. Only in the writing of women of color—to some extent in the world of Maxine Hong Kingston and to an even greater extent in the work of black authors like Gloria Naylor, Toni Cade Bambara, Paule Marshall, and Alice Walker[6]—do we find a female community providing a potential bulwark against breakdown. In these works women band together against the madness brought into their lives by men and racist societies, poverty, violence, and death. They succeed in attenuating existential and even pathological forms of isolation, by caring for and nursing each other.

In one of the stories from *The Women of Brewster Place,* Naylor draws an unforgettable portrait of a black woman who falls apart after the accidental death of her only child, which is linked in her mind to her husband's repeated cruelties. This pathetic figure is snatched from the edge of permanent despair by an understanding older woman who undresses and bathes her like a baby in a symbolic cleansing ritual destined to wash away unbearable memories and rebirth her into sanity. At such a moment only the most elemental ministrations performed by knowing female hands have restorative power. In a world where there are precious few valid rituals and where men cannot be trusted, the mother-baby paradigm reasserts itself as the original symbol of charity and healing.

The madness of a Plath or a Cardinal must be related, at least in part, to the failure of a community beyond the nuclear family to help mediate existential givens and parental influences. While not produced by society in the first place, mental instability is certainly exacerbated by a lack of communal rituals and supports, once found in religions, neighborhoods, extended kinship systems, and friendship groups—formal and informal institutions that may still be capable of promoting a "therapeutic community."

Perhaps the escape from madness of an Atwood or a Kingston can be understood as the result of their ability to integrate into their lives some bits of shared wisdom inherited from a female tradition. In the last analysis, the protagonists of *Surfacing* and *The Woman Warrior* find themselves by recognizing their place in that tradition, and if they do not go so far as their black counterparts in extending kinship horizontally to a sisterly community, they do at least situate themselves vertically along a chain or continuum of the human race, whose most immediate predecessor or link is the mother. The protagonist of *Surfacing* takes up her maternal heritage by becoming a mother, the protagonist of *The Woman Warrior* by becoming a storyteller. They both find their authentic selves, and their sanity,

through a process that requires, as Woolf put it, thinking back through their mothers—in one case, as far back as prehistoric goddesses and the Virgin Mary, and in the other, as far back as a second-century Chinese poetess.

One of the clearest messages found in a reading of the works discussed in this book is that the path away from madness, like the path into it, has a specifically female lane. The mad heroine in search of sanity is her mother's daughter—a reality she must grasp and accept if she is to come to terms with herself. It is perhaps cruelly comforting to know that the process of reconciliation can occur even after the mother's death. Cardinal and Kingston, as they present themselves in their autobiographical works, and Atwood's protagonist in *Surfacing* were able to complete that psychic process; Plath ended her life in the absence of such resolution.

The laborious struggle to shed pathology is a mysterious process for even the seasoned psychotherapist. As interested observers we look to women writing about madness not only for accounts of their seasons in hell, but also for signposts leading to a more desirable location. One that has a central position in both psychotherapy and autobiography points toward the role of language as the essential medium through which the wounded narrator conveys the story of her life and gives it meaning. Just as psychoanalysis encourages the patient to reconstruct his life story with the aid of "narrative structures"—the term is used by Roy Schafer in an interesting article on "Psychoanalytic Dialogue"[7]—so too the autobiographical writer remakes her life from the standpoint of present concerns in order to understand the past, unravel confused emotions, resolve persistent conflicts, and give to life a coherence that life does not intrinsically have. Plath said that writing was "a way of ordering and reordering the chaos of experience."[8]

The authoring of oneself through the written word is a form of creating one's existence anew, of reconceiving oneself. By the end of each autobiographical account of breakdown and recovery, there is always the implicit understanding that the author, as in a conversion narrative, has been born again, and that the new self that she has mothered is sane.

Kingston is even more explicit in connecting autobiographical narrative to the search for sanity: "You have to be able to tell your story . . . or you go mad."[9] She suggests that sanity is predicated upon the ability and the opportunity to communicate one's personal history, through speech or writing, to a receptive audience. The attempt to convey one's particular life story in the fullness of one's feelings, flaws, feats, and aspirations is propelled by the hope, however dim, that one's life is worth the telling and that someone out there is listening. To tell one's story implies, as Carol Gilligan indicated recently, a willingness to take a risk and to engage with others, be it a friend, a therapist, or even a reader.[10]

For those of us who concern ourselves with the destiny of women, there is much to be gleaned from this literature of madness. We must grapple with autobiographical personae *as if* they were living people, interpreting what is only inferred and supplying what is missing; in short, we are obliged to respond to literary characters *as if* we had met them in the privileged space of a therapeutic encounter. Like a therapist, we serve a function for the author: we are the audience for whom the writer ventilates. Like a good therapist, we listen attentively, empathically, respectfully. But unlike the therapist, we make no direct impact on the speaker; it is the author/narrator/patient who influences us, extending our vision of mental illness beyond the limits of personal experience and into a realm of communal knowledge. Whether this illusion of intimacy with fictional characters can lead to shared wisdom is a question that each reader can answer only for herself. Without denying the distinction that exists between life and art, I have chosen to focus on their psychological similarities and to look to literature for insights into the female condition that may not yet exist in any other written form.

Notes

Chapter 1

1. Lillian Feder, *Madness in Literature* (Princeton: Princeton Univ. Press, 1980).
2. Sigmund Freud, *Interpretation of Dreams*, vol. 5 in Standard Edition (1900 orig. pub.; London: Hogarth, 1953); Ernest Jones, *Hamlet and Oedipus* (New York: Norton, 1949); Theodore Lidz, *Hamlet's Enemy* (New York: Basic, 1975); Norman H. Holland, *Psychoanalysis and Shakespeare* (New York: McGraw-Hill, 1966).
3. Sandra Gilbert and Susan Gubar, *The Madwoman in the Attic* (New Haven: Yale Univ. Press, 1979).
4. Marie Cardinal, *Les Mots pour le dire* (Paris: Grasset, 1975). All translations are my own. The recently published American edition, *The Words to Say It*, trans. Pat Goodheart (Cambridge, Mass.: Van Vactor and Goodheart, 1983), while an excellent adaptation of the original, is frequently abridged.
5. Margaret Atwood, *Surfacing* (New York: Popular Library, 1976).
6. Sylvia Plath, *The Bell Jar* (London: Faber and Faber, 1963; New York: Harper and Row, 1971).
7. Judith Kroll, *Chapters in a Mythology: The Poetry of Sylvia Plath* (New York: Harper Colophon, 1976).
8. Marge Piercy, *Woman on the Edge of Time* (New York: Knopf, 1976).
9. Charlotte Perkins Gilman, *The Yellow Wallpaper* (Old Westbury, N.Y.: Feminist Press, 1973).
10. Helen Cixous, *Portrait de Dora* (Paris: Editions des femmes, 1976).
11. Emma Santos, *La Malcastrée* (Paris: Maspéro, 1973; Editions des femmes, 1976); *J'ai tué Emma S.* (Paris: Editions des femmes, 1976); *L'Itinéraire psychiatrique* (Paris: Editions des femmes, 1977); *La Loméchuse* (Paris: Editions des femmes, 1978).
12. Joanne Greenberg (Hannah Green), *I Never Promised You a Rose Garden* (New York: Holt, Rinehart and Winston, 1964).
13. Elaine Martin, "Mothers, Madness, and the Middle Class in *The Bell Jar* and *Les Mots pour le dire*," *French-American Review* 5, no. 1 (Spring 1981): 24.
14. Leo Bersani, *A Future for Astyanax* (Boston: Little, Brown, 1976); Shoshana Felman, *La Folie et la Chose littéraire* (Paris: Editions du Seuil, 1978);

Meredith Anne Skura, *The Literary Uses of the Psychoanalytic Process* (New Haven: Yale Univ. Press, 1981).

15. Gilbert and Gubar, *Madwoman,* p. 53.

16. Annis Pratt, *Archetypal Patterns in Women's Fiction* (Brighton, Sussex: Harvester Press, 1982), pp. 142–43.

17. Phyllis Chesler, *Woman and Madness* (New York: Doubleday, 1972).

18. Ibid., p. 56.

19. Nancy Chodorow, *The Reproduction of Mothering: Psychoanalysis and the Sociology of Gender* (Berkeley: Univ. of California Press, 1978); Dorothy Dinnerstein, *The Mermaid and the Minotaur: Sexual Arrangements and Human Malaise* (New York: Harper Colophon, 1976); Adrienne Rich, *Of Woman Born* (New York: Norton, 1976).

20. Herzl R. Spiro, "Prevention in Psychiatry: Primary, Secondary and Tertiary," *Comprehensive Textbook of Psychiatry,* 3d ed., ed. Harold I. Kaplan, Alfred M. Freedman, and Benjamin J. Sadock (Baltimore and London: Williams & Wilkins), 3:2858–74.

21. The relationship between creativity and madness has been the subject of numerous psychiatric studies, including the recent work of Dr. Kay Jamison, professor of psychiatry at the University of California at Los Angeles, who reports that artists, writers, and poets are thirty-five times more likely to seek treatment for serious mood disorders than the average person. Based on a study done in Britain in 1982–83, where the subjects were 87% male, Dr. Jamison concludes that there is a strong statistical link between creative genius and madness, and that poets in particular suffer the highest incidence of manic-depressive illness. Dr. Jamison's work, reported in the *New York Times,* 23 Sept. 1984, will be published in book form by Oxford University Press in 1985.

22. See, for example, Linda Wolfe, "Mommy's 39, Daddy's 57—and Baby was Just Born," *New York,* 5 Apr. 1982, pp. 26–33.

23. Marilyn Fabe and Norma Wikler, *Up Against the Clock: Career Women Speak on the New Choice of Motherhood* (New York: Random House, 1979); Pamela Koehler Daniels and Kathy Weingarten, *Sooner or Later: The Timing of Parenthood in Adult Lives* (New York: Norton, 1982).

24. R. May, E. Angel, and H. Ellenberger, *Existence* (New York: Basic, 1958); Ernest Becker, *The Denial of Death* (New York: Free Press, 1973); Irvin D. Yalom, *Existential Psychotherapy* (New York: Basic, 1980).

25. Adrienne Rich, *On Lies, Secrets and Silences* (New York: Norton, 1979); Elaine Showalter, *A Literature of Their Own* (Princeton: Princeton Univ. Press, 1977); Ellen Moers, *Literary Women* (Garden City, N.Y.: Anchor, 1977); Tillie Olsen, *Silences* (New York: Delacorte, 1978); Gilbert and Gubar, *Madwoman.*

26. Vineta Colby, *The Singular Anomaly: Women Novelists of the Nineteenth Century* (New York: New York Univ. Press, 1970). Although Colby's book on English women authors takes its title from a provocative phrase in Gilbert and Sullivan's *Mikado* ("And that singular anomaly, the lady novelist . . ."), she fails to pursue the implications of her title by treating gender as a serious variable.

27. René Girard, *Mensonge romantique et Vérité romanesque* (Paris: Grasset, 1961), p. 260.

28. A useful, comprehensive examination of the problem of authorial presence in the novel is found in a special issue of the French journal *Confluences* entitled "Problèmes du Roman" (3, nos. 21–24 [1943]), edited by Jean Prévost.

29. Paul de Man, *The Rhetoric of Romanticism* (New Haven, Conn.: Yale Univ. Press, 1984), p. 72.
30. Jean-Michel Rey, "Freud's Writing on Writing" in *Literature and Psychoanalysis,* ed. Shoshana Felman (Baltimore and London: Johns Hopkins Univ. Press, 1982), p. 311.
31. Ibid., p. 310.
32. A. Alvarez, *The Savage God: A Study of Suicide* (New York: Random House, 1970), p. 40.

CHAPTER 2

1. Sylvia Plath, *The Bell Jar* (London: Faber and Faber, 1963; New York: Harper and Row, 1971; New York: Bantam Books, 1971). All subsequent citations are to the Bantam Books paperback edition.
2. David Holbrook, *Sylvia Plath: Poetry and Existence* (London: Athlone, 1976), p. 89.
3. A. R. Jones, "On 'Daddy,' " in *The Art of Sylvia Plath: A Symposium,* ed. Charles Newman (Bloomington and London: Indiana Univ. Press, 1970), p. 236.
4. *The Journals of Sylvia Plath* (New York: Dial, 1982), p. 30.
5. Lynda K. Bundtzen, *Plath's Incarnations: Woman and the Creative Process* (Ann Arbor: Univ. of Michigan Press, 1983), p. 113.
6. Each poem is identified according to its number in *The Collected Poems of Sylvia Plath,* ed. Ted Hughes (New York: Harper and Row, 1981).
7. In the fall of 1958, while living in Boston with her husband, Ted Hughes, Plath was in therapy with Dr. Ruth Beuscher and especially prone to a Freudian analysis of her life situation. See Plath, *Journals,* pp. 278–84.
8. I am grateful to Laurel Brodsley for her unpublished manuscript "Sylvia Plath's Experience of her Daddy's Disease and Its Implications for Her Poetry and Her Life," which documents Otto Plath's illness and death. The loss of Plath's father was not a single traumatic event occurring suddenly when Sylvia was eight years old (changed to nine in *The Bell Jar* so as to be closer to Plath's personal mythology of cyclical catastrophe occurring every ten years); his sickness dated from her earliest years. When Sylvia was only three and a half, her father became extremely ill for the first time, and for the rest of his life, convinced that he had a terminal cancer and mistrustful of doctors, he refused to do anything about his condition. Surely, as Brodsley writes, life in a home "ruled by the needs of a dying man, must have had a profound influence on members of this household." We know, too, that Otto Plath did not die from cancer, but from the terminal complications of untreated diabetes, including pneumonia, a leg amputation, and finally an embolus in the lung. During this period, Sylvia, barely eight, occasionally waited upon her father in the hospital and later received the news of his death from her mother, who decided that neither Sylvia nor her younger brother should attend the funeral and who also chose to hide her own tears from them. Thus, Otto Plath's illness and death constituted a central force in Sylvia's childhood, shaping her conscious and unconscious attitudes toward death and disease, and generating underground currents of stress that were to erupt in periods of crisis.
9. Bundtzen, *Plath's Incarnations,* pp. 139–47.
10. I. Yalom, *Existential Psychotherapy,* p. 168.

11. I. Yalom, *Existential Psychotherapy*, p. 171.

12. Bruno Bettelheim, "Growing Up Female," *Harper's* 225 (Oct. 1962): 120–28.

13. Linda Gray Sexton, *Between Two Worlds: Young Women in Crisis* (New York: Morrow, 1979).

14. A. Alvarez, "Sylvia Plath," in *The Art of Sylvia Plath*, p. 65.

15. Holbrook, *Sylvia Plath: Poetry and Existence*, p. 89.

16. Judith Kroll, *Chapters in a Mythology: The Poetry of Sylvia Plath* (New York: Harper and Row, 1976).

17. Bundtzen, *Plath's Incarnations*, p. 134.

18. Maggie Scarf, *Unfinished Business: Pressure Points in the Lives of Women* (Garden City, N.Y.: Doubleday, 1980), p. 107.

19. Marge Piercy, *Woman on the Edge of Time* and Judy Grahn, "The Psychoanalysis of Edward the Dyke," in *The Work of a Common Woman* (New York: St. Martin's, 1978).

20. Judith Kegan Gardiner, "The Heroine As Her Author's Daughter," in *Feminist Criticism*, ed. Cheryl Brown and Karen Olson (Metuchen, N.J.: Scarecrow, 1978), pp. 244–53.

21. Plath's senior honors thesis at Smith College was "A Study of the Double in Two of Dostoevsky's Novels." According to her thesis advisor, she read voraciously on the subject from literary, psychoanalytic, and anthropological sources. See Edward Butscher, *Sylvia Plath: Method and Madness* (New York: Seabury Press, 1976), pp. 165–67.

22. Nancy Hunter Steiner, *A Closer Look at Ariel: A Memory of Sylvia Plath* (New York: Harper's Magazine Press, 1973).

23. Franz Kafka, *Briefe: 1902–1924*, ed. Max Brod (New York: Schocken, 1958), p. 161.

24. For a discussion of the mutually dependent relationship between Plath and her mother, see Barbara Mossberg, "Back, Back, Back: Sylvia Plath's Baby Book," in *Coming to Light: Women Poets in the Twentieth Century*, ed. Diane Middlebrook and Marilyn Yalom (Ann Arbor: Univ. of Michigan Press, in press).

25. Sylvia Plath, *Letters Home* (New York: Harper and Row, 1975), pp. 559–60.

26. Ibid., p. 564.

27. Ibid., p. 530.

28. Mossberg, *Coming to Light*.

29. A. Plath, Introduction to *Letters Home*, p. 35.

30. Plath, *Letters Home*, p. 472.

31. Plath, *Journals*, p. 162.

32. Martin, "Mothers, Madness, and the Middle Class in *The Bell Jar* and *Les Mots pour le dire*," p. 28.

CHAPTER 3

1. Marie Cardinal, *Ecoutez la Mer* (Paris: René Julliard, 1962); idem, *La Mule de Corbillard* (Paris: René Julliard, 1964); idem, *La Souricière* (Paris: René Julliard, 1966); idem, *Les Mots pour le dire*. Cardinal's other books are *La Clé sur la Porte* (Paris: Grasset, 1972), *Autrement dit* (Paris: Grasset, 1977), *Une Vie pour deux* (Paris: Grasset, 1978), *Cet Été-là* (Paris: Nouvelles éditions Oswald, 1979),

Au Pays de mes Racines (Paris: Grasset, 1980), and *Le Passé empiété* (Paris: Grasset, 1982). All translations are my own.
All references in the following discussion of *La Souricière* are to this edition.
2. Pascal Werner, "Marie Cardinal et le sexe des mots," *Politique hebdomadaire* 262, 21–27 Mar. 1977, p. 39.
3. Cardinal, *Autrement dit*, p. 85.
4. André Gide, *L'Immoraliste* (Paris: Mercure de France, 1921).
5. Betty Friedan, *The Feminine Mystique* (New York: Norton, 1963).
6. After *La Souricière*, all of Cardinal's works are written in the first person; her last six books contain considerable information about the author's historical reality and constitute, in Cardinal's own words, "a single book"—*Au Pays de mes Racines*, p. 194.
7. Franz Kafka, "The Judgment," in *The Penal Colony* (New York: Schocken, 1948).
8. "Le trône percé," *Le Matin*, 6 Dec. 1977.
9. French literary critics who have drawn attention to the interrelationship of the female body and 'l'écriture féminine" include Yannick Resch, *Corps Féminin, Corps Textuel: Essai sur le Personnage féminin dans l'Oeuvre de Colette* (Paris: Librairie C. Klincksieck, 1973) and Irma Garcia, *Promenade fémmillière* (Paris: Editions des femmes, 1981). Among modern French women authors who best exemplify this phenomenon, the names of Colette, Hélène Cixous, Monique Wittig, Violette Leduc, Marie Cardinal, Chantal Chawaf, and Viviane Forrester come immediately to mind. In American literature, contemporary women writers have explored the female body predominantly in poetry. For an analysis of this phenomenon, see Alicia Ostriker, "Body Language: Imagery of the Body in Women's Poetry," in *The State of the Language*, ed. Leonard Michaels and Christopher Ricks (Berkeley: Univ. of California Press, 1980), pp. 247–63.
10. Margaret Drabble, *The Millstone* (London: Weidenfeld and Nicolson, 1965); Adrienne Rich, *Of Woman Born* (New York: Norton, 1976); Jane Lazarre, *The Mother Knot* (New York: Dell, 1977). For other examples of the birthing experience in literature, see Carol H. Poston, "Childbirth in Literature," *Feminist Studies* 4, no. 2 (June 1978): 18–31.
11. Leo Tolstoy, *The Death of Ivan Ilych and Other Stories* (New York: Signet Classics, 1960).

CHAPTER 4

1. At a personal interview with Cardinal in San Francisco in November 1983, she told me how surprised she was to realize only recently, from the observation of one of her readers, that *La Souricière* and *Les Mots pour le dire* related essentially the same story. The first book was written when Cardinal had just begun psychoanalysis; the second, after her analysis had ended and her mother had died.
2. Personal communication with Cardinal's analyst, Michel de M'Uzan, member of la Société psychoanalytique de Paris and author of *De l'Art à la Mort* (Paris: Gallimard, 1972); I am grateful to Dr. M'Uzan for his kindness in discussing with me certain analytic theories without, of course, referring to Cardinal's specific case.
3. Melanie Klein, perhaps the most influential analyst of the Freudian revisionists, has insisted that the fear of death is at the origin of all anxiety. See also

Ernest Becker, *The Denial of Death* (New York: Free Press, 1963), and I. Yalom, *Existential Psychotherapy.*

4. *The Words to Say It,* trans. Pat Goodheart (Cambridge, Mass.: Van Vactor and Goodheart, 1983), p. 301. Although I recommend this translation to the English reader for its accuracy and ease, as well as for Bettelheim's remarkable introduction and afterword, I have decided to use my own translations in this book since Goodheart has often cut the very passage I need to quote.

5. Ibid., pp. 301–4.

6. Simone de Beauvoir, *Une Mort très douce* (Paris: Gallimard, 1964).

7. Chantal Chawal, *Rétable. La Rêverie* (Paris: Editions des femmes, 1974). See also *Maternité* (Paris: Stock, 1979).

8. Gilbert and Gubar, *Madwoman,* p. 41.

9. Karen Horney, *Neurosis and Human Growth* (New York: Norton, 1940).

10. Sigmund Freud, "Some Psychological Consequences of the Anatomical Distinction between the Sexes," *Collected Papers,* vol. 5 (London: Hogarth, 1956); Helene Deutsch, *Psychology of Women,* vols. 1 and 2 (New York: Grune and Stratton, 1944, 1945); Judith Bardwick, *Psychology of Women: A Bio-cultural Conflict* (New York: Harper and Row, 1971); Edmée Mottini-Coulon, *Essai d'Ontologie spécifiquement féminine* (Paris: Librairie Philosophique J. Vrin, 1978).

11. Otto Rank, *The Myth of the Birth of the Hero* (New York: Vintage, 1959); first published in 1914 in *Nervous and Mental Disease Monographs,* no. 8.

12. Mottini-Coulon, *Essai d'Ontologie spécifiquement féminine,* p. 51.

13. Violette Leduc, *La Bâtarde* (Paris: Gallimard, 1964). For a fuller discussion of Leduc's birth and relationship to her mother, see M. Yalom, "They remember 'maman,' " *Essays in Literature* 8, no. 1 (Spring 1981): 73–90.

14. See Leduc's autobiographical novels (*La Bâtarde, L'Asphyxie, L'Affamée, Trésors à prendre, La Folie en Tête, Ravages, Thérèse et Isabelle,* and *La Chasse à l'Amour*) and Simone de Beauvoir's *Tout Compte fait,* (Paris: Gallimard, 1972), pp. 57–63.

15. Karen Horney, "The Flight from Womanhood: The Masculinity-Complex in Women as Viewed by Men and by Women," *International Journal of Psychoanalysis* (1926): 324–39; and Clara Thompson, "Penis Envy in Women," *Psychiatry* (1943): 123–31. Horney's and Thompson's pioneering critiques of Freudian theory pertaining to women have been greatly expanded in the past decade by French, English, and American feminists who, for the most part, are not themselves analysts. Influential contributions to this new corpus of feminist psychoanalytic theory are Juliet Mitchell, *Psychoanalysis and Feminism* (New York: Random House, 1974); Luce Irigaray, *Speculum de l'autre Femme* (Paris: Les Editions de Minuit, 1974); idem; *Ce Sexe qui n'en est pas un* (Paris: Les Editions de Minuit, 1977); Sarah Kofman, *L'Enigme de la Femme. La Femme dans les Textes de Freud* (Paris: Galilée, 1980); and Nancy Chodorow, *The Reproduction of Mothering* (Berkeley: Univ. of California Press, 1978).

The loss of a mother during one's childhood has been reported as a significant factor in two contemporary studies of adult women's depression: G. W. Brown and Tirril Harris, *The Social Origins of Depression* (New York: Free Press, 1978) and D. M. Schaffer, "The mental health of single mothers" (unpub. presentation, Center for Research on Women, Stanford University, January 1985).

16. Natalie Shainess, M.D., "Mother-child Relationships: An Overview," *Science and Psychoanalysis* 14 (1969): 67.

17. Much post-Freudian analytic work has centered on the significance of the mother-child relationship, beginning with the early work of Otto Rank, who broke with Freud on this and other theoretical points. Rank criticized Freud for making the father a figure of godlike power and presenting woman only as a negative of male attributes. Among those psychiatrists most prominent in their examination of the ties that bind the infant to its mother are the British analysts Melanie Klein, John Bowlby, and D. W. Winnecott, and Americans M. S. Mahler, Margaret Mead, and Theodore Lidz.

18. Bettelheim, Afterword to *The Words to Say It,* p. 302.

19. It was Margaret Mead who coined the term *womb envy* on the basis of her study of males in the Pacific island cultures. If, however, he "who can never bear a child must seek achievement in other ways," this has generally worked to the disadvantage of women, for what men do "in all cultures, without any known exception, . . . is seen as achievement," and "what women do—including mothering—is valued less." Margaret Mead, "On Freud's View of Female Psychology," in *Women and Analysis,* ed. Jean Strouse (New York: Dell, 1974), p. 121.

20. For a comprehensive discussion of feminist views on motherhood, see Nancy Chodorow and Susan Contratto, "The Fantasy of the Perfect Mother," in *Rethinking the Family: Some Feminist Questions,* ed. Barrie Thorne with Marilyn Yalom (New York and London: Longman, 1982), pp. 54–71.

21. Simone de Beauvoir, *Le deuxième sexe,* vols. 1 and 2 (Paris: Gallimard, 1949) [*The Second Sex,* trans. H. M. Parshley (New York: Knopf, 1952)].

22. Natalie Shainess, "Feminine Identity and Mothering," *Science and Psychoanalysis,* vol. 7 (New York: Grune & Stratton, 1964), pp. 237–49.

23. Statistics indicate that new mothers are at a risk four or five times greater than usual of developing a psychological illness in the first three months after delivery. Scarf, *Unfinished Business,* p. 277.

24. "Entretien avec Geneviève Serreau," *Des Femmes en mouvement hebdo* 62, 16–23 Oct. 1981, p. 28.

CHAPTER 5

1. Margaret Atwood, *Surfacing* (New York: Popular Library, 1976) was originally published in 1972 (New York: Simon and Schuster). All subsequent citations are from the Popular Library edition. Atwood's other novels are *The Edible Woman* (Boston: Little, Brown, 1969), *Lady Oracle* (New York: Simon and Schuster, 1976), *Life Before Man* (New York: Simon and Schuster, 1980), and *Bodily Harm* (New York: Simon and Schuster, 1982).

2. Margaret Atwood, *Survival: A Thematic Guide to Canadian Literature* (Toronto: Anansi, 1971), p. 112.

3. Ibid., p. 113.

4. Ibid., p. 32.

5. Ibid., p. 33.

6. Barbara Hill Rigney, *Madness and Sexual Politics in the Feminist Novel* (Madison: Univ. of Wisconsin Press, 1978), pp. 107–9.

7. Ibid., p. 110.

8. "Renée," *Autobiography of a Schizophrenic Girl,* ed. Marguerite Sechahaye, trans. from 1950 French ed. (New York: American Library, 1970), p. xiii.

9. Christ presents an insightful feminist interpretation of the religious experience in *Surfacing* in *Diving Deep and Surfacing: Women Writers on Spiritual Quest* (Boston: Beacon Press, 1980).

10. Barbara Hill Rigney, *Lilith's Daughters: Women and Religion in Contemporary Fiction* (Madison: Univ. of Wisconsin Press, 1982), p. 89.

11. Ibid.

12. Atwood, *Survival*, p. 207.

13. Solon T. Kimball, Introduction to Arnold Van Gennep, *The Rites of Passage*, trans. Monika B. Vizedom and Gabrielle L. Caffe (Chicago: Univ. of Chicago Press, 1960), pp. xvii–xviii.

14. Arnold Van Gennep, *The Rites of Passage*, p. 41.

15. Ibid., p. 48.

16. Atwood, *Dancing Girls and Other Stories* (New York: Simon and Schuster, 1982).

17. Doris Lessing, *The Four-Gated City* (New York: Alfred A. Knopf, 1969).

18. Lillian Feder, *Madness in Literature*, p. 285.

19. Adrienne Rich, "The Anti-feminist Woman," in *On Lies, Secrets and Silences*, pp. 83–84.

20. Compare certain feminist utopias where men have simply been eliminated, where women live separately from men, where both men and women have the possibility of changing their sex, or where they have become thoroughly androgynous. Charlotte Perkins Gilman, *Herland* (1915 orig. pub.; New York: Pantheon, 1979); Monique Wittig, *Les Guerrières* (Paris: Les Editions de Minuit, 1969); Marge Piercy, *Woman on the Edge of Time*; Ursula LeGuin, *The Left Hand of Darkness* (New York: Ace, 1969; rpr. 1977); and Sally Miller Gearhart, *The Wanderground* (Watertown, Mass.: Persephone Press, 1978). See also Anne K. Mellor, "On feminist utopias" (*Women's Studies* 9 [1982]: 241–62) for a valuable analysis of feminist utopian writers working within the science-fiction genre.

21. In his essay entitled "Femininity" that was part of the 1932–33 *New Introductory Lectures on Psychoanalysis*, Freud wrote: "A mother is only brought unlimited satisfaction by her relation to a son; this is altogether the most perfect, the most free from ambivalence of all human relationships." Sigmund Freud, *The Complete Psychological Works* (London: Hogarth, 1964), p. 133.

22. Alicia Ostriker, "The Thieves of Language: Women Poets and Revisionist Mythmaking," *Signs: A Journal of Women, Culture and Society* 8, no. 1 (Autumn 1982): 68–90. I am grateful to Ostriker for valuable insights into the process by which contemporary women writers have appropriated traditional myths and revised them for specifically female ends.

23. For a complex discussion of prepatriarchal gynocentric cultures, see Adrienne Rich, "The Primacy of the Mother," in *Of Woman Born*, pp. 84–109.

24. Four of these amazing drawings, in color, are found in *J'ai tué Emma S.* (Paris: Editions des femmes, 1976).

Chapter 6

1. Sylvia Plath, "Face Lift," in *The Collected Poems*, p. 156.

2. Pami Djerassi Bush, *Mother to Myself* (Wilbur Springs, Calif.: John Daniel, 1980).

3. Margaret Atwood, "Giving Birth" in *Dancing Girls*, pp. 225–40.

4. A. Alvarez, "Sylvia Plath," *The Art of Sylvia Plath*, p. 58.

5. Susan R. Van Dyne, " 'More Trouble Than Ever She Was': The Manuscripts of Sylvia Plath's Bee Poems," Northampton, Mass., Smith College Library Rare Book Room, 1982, p. 11.

6. Bundtzen, *Plath's Incarnations*, p. 89.

7. For an analysis of the psychiatric penchant for attributing blame to the "castrating" or "schizophrenogenic" mother, see David Spiegel, "Mothering, Fathering, and Mental Illness," in *Rethinking the Family*.

8. The most popular proponent of the "blame-the-mother" group is Nancy Friday in *My Mother/Myself* (New York: Delacorte, 1978); in addition, this optic also colors the work of feminist scholars like Phyllis Chesler, Elaine Martin, and Judith Gardiner, who focus on the mother's role as socializing agent within a patriarchal tradition.

9. Quentin Bell, Introduction to *The Diary of Virginia Woolf*, ed. Anne Oliver Bell (New York and London: Harcourt Brace Jovanovich, 1977), 1:xv.

10. Virginia Woolf, "A Sketch of the Past," in *Moments of Being* (New York and London: Harcourt, Brace, Jovanovich, 1976), p. 81.

11. Ibid.

12. Anne Sexton, *A Self-Portrait in Letters*, ed. Linda Gray Sexton and Lois Ames (Boston: Houghton Mifflin, 1977), p. 22.

13. Ibid., p. 23.

14. Diane Middlebrook, "Housewife into Poet: The Apprenticeship of Anne Sexton," *New England Quarterly*, Dec. 1983:483–503.

15. Anne Sexton, *To Bedlam and Part-Way Back* (Boston: Houghton Mifflin, 1960), p. 5.

16. Middlebrook, "Housewife into Poet."

17. Sexton, "Her Kind," *To Bedlam*, p. 21.

18. Sexton, "Ringing the Bells," *To Bedlam*, p. 40.

19. Sexton, "Kind Sir: These Woods," *To Bedlam*, p. 5.

20. Anne Sexton, "Ghosts," *All My Pretty Ones* (Boston: Houghton Mifflin, 1961), p. 27.

21. Sexton, "The Operation," *All My Pretty Ones*, p. 12.

22. Sexton, "The Fortress," *All My Pretty Ones*, p. 32.

23. Sexton, "The Operation," *All My Pretty Ones*, p. 13.

24. Maxine Hong Kingston, *The Woman Warrior: Memoirs of a Girlhood Among Ghosts* (New York: Random House, 1976).

25. For an English translation of the original version of "The Ballad of Mulan," see J. D. Frodsham and Ch'eng Hsi, *An Anthology of Chinese Verse* (London: Oxford Univ. Press, 1967), pp. 104–6.

26. Maxine Hong Kingston, interview by Arturo Islas, Berkeley, Calif., 1 Oct. 1980. Part of this interview is reproduced in *Women Writers of the West Coast*, ed. Marilyn Yalom (Santa Barbara: Capra Press, 1983), pp. 11–19.

27. This is the position taken by Stephen Twombley in *All That Summer She Was Mad, Virginia Woolf: Female Victim of Male Medicine* (New York: Continuum, 1982).

28. Lawrence Kubie, taking issue with the mainstream psychoanalytic position that creation is a product of the neurosis, advanced an opposing view in the late 1950s, when he wrote: "What men succeed in creating is in spite of their struggles

to overcome their neurosis, and not in any sense the fruit of these struggles" (*Neurotic Distortion of the Creative Process,* Porter Lectures, series 22 [Lawrence, Kansas: Univ. of Kansas Press, 1958], p. 6).

29. Vladimir Nabokov, *Speak, Memory* (New York: Putnam, 1947).
30. Santos, *La Malcastrée*, p. 113.
31. Santos, *J'ai tué Emma S.,* pp. 21–22.
32. Santos, *L'Intinéraire psychiatrique,* p. 92.
33. Plath, "Stillborn" in *The Collected Poems,* p. 142.
34. Virginia Woolf, *The Diary of Virginia Woolf,* 1:298.
35. Woolf, *The Diary of Virginia Woolf* (1980), 3:107.
36. Quentin Bell, *Virginia Woolf: A Biography* (New York: Harcourt Brace Jovanovich, 1972), 2:89.
37. Santos, *La Malcastrée*, p. 96.

CHAPTER 7

1. Gloria Naylor, *The Women of Brewster Place* (New York: Penguin, 1983).
2. Plath, *Journals,* p. 267.
3. Leduc, *La Bâtarde,* trans. Derek Coltman, (New York: Farrar, Straus and Giroux, 1965), pp. 37–38.
4. Chodorow and Contratto, "The Fantasy of the Perfect Mother," *Rethinking the Family,* pp. 54 ff.
5. Plath, *Journals,* p. 267.
6. See Naylor, *The Women of Brewster Place;* Toni Cade Bambara, "The Johnson Girls," in *Guerilla, My Love,* (New York: Random House Pocket Books, 1973), pp. 144–59; Paule Marshall, *Brown Girl, Brownstones* (Old Westbury, N.J.: Feminist Press, 1981); and Alice Walker, *The Color Purple* (New York: Harcourt, Brace, Jovanovich, 1982).
7. Roy Schafer, "Narration in the Psychoanalytic Dialogue," *Critical Inquiry* 7, no. 1 (Autumn 1980): 29–53.
8. Plath, *Journals,* p. 281.
9. Maxine Hong Kingston interview, in *Women Writers of the West Coast,* p. 17.
10. Carol Gilligan, speech at Stanford University, Feb. 1984.

Bibliography

I. SELECTED BIBLIOGRAPHY OF AUTOBIOGRAPHY, FICTION, AND POETRY

Atwood, Margaret. *Surfacing.* 1972. New York: Popular Library, 1976.
———. *Dancing Girls and Other Stories.* New York: Simon and Schuster, 1977, 1982.
———. *Life Before Man.* New York: Simon and Schuster, 1979.
Barry, Anne. *Bellevue is a State of Mind.* New York: Harcourt, Brace, Jovanovich, 1971.
Beauvoir, Simone de. *Mémoires d'une Fille rangée.* Paris: Gallimard, 1958.
———. *Une Mort très douce.* Paris: Gallimard, 1964.
Bush, Pami Djerassi. *Mother to Myself.* Wilbur Springs, Calif.: John Daniel, 1980.
Cardinal, Marie. *Ecoutez la Mer.* Paris: René Julliard, 1962.
———. *La Mule de Corbillard.* Paris: René Julliard, 1964.
———. *La Souricière.* Paris: René Julliard, 1966.
———. *Les Mots pour le dire.* Paris: Grasset, 1975.
———. *Le passé empiété.* Paris: Gallimard, 1982.
Chawal, Chantal. *Rétable. La Rêverie.* Paris: Editions des femmes, 1974.
Cixous, Hélène. *Portrait de Dora.* Paris: Edition des femmes, 1976.
Drabble, Margaret. *The Millstone.* London: Weidenfeld and Nicolson, 1965.
———. *The Waterfall.* New York: Knopf, 1969.
Duras, Marguerite. *Le Ravissement de Lol V. Stein.* Paris: Gallimard, 1964.
Epstein, Sandra. *A Place like Dairy-Anne.* New York: Avon, 1979.
Ferguson, Sara. *A Guard Within.* London: Chatto and Windus, 1973.
Fitzgerald, Zelda. *Save me the Waltz.* New York: Scribners, 1932.
Frame, Janet. *Faces in the Water.* New York: Avon, 1971.
Gilman, Charlotte Perkins. *The Yellow Wallpaper.* Old Westbury, N.Y.: Feminist Press, 1973.

Gordon, Barbara. *I'm Dancing as Fast as I Can*. New York: Harper and Row, 1979.

Grahn, Judy. "The Psychoanalysis of Edward the Dyke," in *The Work of a Common Woman*. New York: St. Martin's, 1978.

Greenberg, Joanne [Hannah Green]. *I Never Promised You a Rose Garden*. New York: Holt, Rinehart and Winston, 1964.

Howland, Bette. *W–3*. New York: Viking, 1974.

Hyvrard, Jeanne. *Mère la Mort*. Paris: Editions de Minuit, 1975.

Kingston, Maxine Hong. *The Woman Warrior: Memoirs of a Girlhood among Ghosts*. New York: Vintage, 1977.

Larkin, Joy. *Strangers No More—Diary of a Schizo*. New York: Vintage, 1979.

Leduc, Violette. *L'Asphyxie*. Paris: Gallimard, 1946.

———. *La Bâtarde*. Paris: Gallimard, 1964.

———. *La Folie en Tête*. Paris: Gallimard, 1970.

Lee, Judy. *Save Me!* New York: Doubleday, 1980.

Lessing, Doris. *The Golden Notebook*. London: M. Joseph, 1962.

———. *The Four-Gated City*. New York: Knopf, 1969.

———. *Briefing for a Descent into Hell*. London: Jonathan Cape Limited, 1971.

———. *The Summer Before the Dark*. New York: Knopf, 1973.

———. *The Memoirs of a Survivor*. New York: Knopf, 1975.

McLaughlin, Anne. *Margo's Room*. Unpublished manuscript.

Millett, Kate. *The Basement*. New York: Simon and Schuster, 1979.

Morrison, Toni. *The Bluest Eye*. London: Chatto and Windus, 1979.

Naylor, Gloria. *The Women of Brewster Place*. New York: Penguin, 1983.

Nin, Anaïs. *Under a Glass Bell*. Chicago: The Swallow Press, 1948.

———. *House of Incest*. Chicago: The Swallow Press, 1958.

———. *Ladders to Fire*. Chicago: The Swallow Press, 1959.

Olsen, Tillie. *Yonnondio from the Thirties*. New York: Dell, 1974.

———. *Tell Me a Riddle*. New York: Dell, 1976.

Peterson, Dale, ed. *A Mad People's History of Madness* (anthology). Pittsburgh: Univ. of Pittsburgh Press, 1982.

Piercy, Marge. *Woman on the Edge of Time*. New York: Knopf, 1976.

Plath, Sylvia. *The Bell Jar*. London: Faber and Faber, 1963.

———. *Letters Home*. New York: Harper and Row, 1975.

———. *The Collected Poems*. New York: Harper and Row, 1981.

———. *The Journals of Sylvia Plath*. New York: Dial, 1982.

Renée [pseud.]. *Autobiography of a Schizophrenic Girl*. Edited by Marguerite Sechahaye. Translated from the 1950 French edition. New York: American Library, 1970.

Rossner, Judith. *August*. New York: Warner, 1983.

Santos, Emma. *La Malcastreé*. Paris: Maspéro, 1973; Editions des femmes, 1976.

———. *J'ai tué Emma S*. Paris: Editions des femmes, 1976.

———. *L'Itinéraire psychiatrique*. Paris: Editions des femmes, 1977.

———. *La Loméchuse*. Paris: Editions des femmes, 1978.

Savage, Mary. *Addicted to Suicide—A Woman Struggling to Live.* Santa Barbara: Capra, 1975.

Sexton, Anne. *To Bedlam and Part Way Back.* Boston: Houghton Mifflin, 1960.

——. *All My Pretty Ones.* Boston: Houghton Mifflin, 1961.

——. *Live or Die.* Boston: Houghton Mifflin, 1966.

——. *The Book of Folly.* Boston: Houghton Mifflin, 1972.

——. *The Death Notebooks.* Boston: Houghton Mifflin, 1974.

——. *Words for Dr. Y.* Boston: Houghton Mifflin, 1978.

Ward, Mary Jane. *The Snake Pit.* 1946. New American Library, 1973.

Wolfe, Ellen. *Aftershock: The Story of a Psychotic Episode.* New York: Putnam, 1969.

Woolf, Virginia. *The Voyage Out.* 1915. New York: Harcourt Brace Jovanovich, 1948.

——. *To the Lighthouse.* New York: Harcourt Brace and Co., 1927.

——. *Moments of Being.* New York: Harcourt Brace Jovanovich, 1976.

——. *The Diary of Virginia Woolf.* Vols. 1–4. New York: Harcourt Brace Jovanovich, 1977.

II. SELECTED BIBLIOGRAPHY OF SECONDARY SOURCES

Abel, Elizabeth, Marianne Hirsch, and Elizabeth Langland, eds., *Fictions of Female Development.* Hanover and London: Univ. Press of New England, 1983.

Alvarez, A. *The Savage God: A Study of Suicide.* New York: Random House, 1970.

Atwood, Margaret. *Survival: A Thematic Guide to Canadian Literature.* Toronto: Anansi, 1972.

Bardwick, Judith M. *Psychology of Women: A Bio-cultural Conflict.* New York: Harper & Row, 1971.

Beauvoir, Simone de. *Le deuxième Sexe.* Vols. 1 and 2. Paris: Gallimard, 1949.

Becker, Ernest. *The Denial of Death.* New York: Free Press, 1973.

Benedek, Therese, and Anthony James, eds. *Depression and Human Existence.* Boston: Little, Brown, 1975.

Bersani, Leo. *A Future for Astyanax.* Boston: Little Brown, 1976.

Bowlby, John. *Attachment.* Vol. 1 of *Attachment and Loss.* London: Hogarth, 1969.

——. *Separation, Anxiety and Anger.* Vol. 2 of *Attachment and Loss.* New York: Basic, 1973.

——. *Loss, Sadness and Depression.* Vol. 3 of *Attachment and Loss.* New York: Basic, 1980.

Chesler, Phyllis. *Women and Madness.* New York: Doubleday, 1972.

Chodorow, Nancy. *The Reproduction of Mothering: Psychoanalysis and the Sociology of Gender.* Berkeley: Univ. of California Press, 1978.

Christ, Carol. *Diving Deep and Surfacing: Women Writers on Spiritual Quest.* Boston: Beacon Press, 1980.

Dinnerstein, Dorothy. *The Mermaid and the Minotaur: Sexual Arrangements and Human Malaise.* New York: Harper Colophon, 1976.
Erikson, Erik. *Childhood and Society.* 2d Ed. New York: Norton, 1963.
———. *Identity, Youth and Crisis.* New York: Norton, 1968.
Feder, Lillian. *Madness in Literature.* Princeton: Princeton Univ. Press, 1980.
Felman, Shoshana. *La Folie et la Chose littéraire.* Paris: Editions du Seuil, 1978.
———, ed. *Literature and Psychoanalysis: The Question of Reading: Otherwise.* Baltimore and London: Johns Hopkins Univ. Press, 1982.
Freud, Sigmund. *The Complete Psychological Works.* London: Hogarth, 1964.
Gilbert, Sandra, and Susan Gubar. *The Madwoman in the Attic.* New Haven: Yale Univ. Press, 1979.
Gilligan, Carol. *In a Different Voice.* Cambridge, Mass.: Harvard Univ. Press, 1982.
Girard, René. *Mensonge romantique et Vérité romanesque.* Paris: Grasset, 1961.
Hartman, Geoffrey, ed. *Psychoanalysis and the Question of the Text.* Baltimore: Johns Hopkins Univ. Press, 1968.
Holbrook, David. *Sylvia Plath: Poetry and Existence.* London: Athlone, 1976.
Horney, Karen. *New Ways in Psychoanalysis.* New York: Norton, 1939.
———. *Neurosis and Human Growth.* New York: Norton, 1940.
Irigaray, Luce. *Speculum de l'autre Femme.* Paris: Les Editions de Minuit, 1974.
———. *Ce sexe qui n'en est pas un.* Paris: Les Editions de Minuit, 1977.
Kristéva, Julia. *Desire in Language: A Semiotic Approach to Literature and Art.* Translated by Tomas Gora, Alice Jardine, and Leon Roudiez. Oxford: Basil Blackwell, 1980.
Kroll, Judith. *Chapters in a Mythology: The Poetry of Sylvia Plath.* New York: Harper Colophon, 1976.
Leonard, Linda Schierse. *The Wounded Woman: Healing the Father-Daughter Relationship.* Boulder and London: Shambhala, 1983.
Lidz, Theodore. *The Person: His and Her Development Throughout the Life Cycle.* New York: Basic, 1976.
May, R., E. Angel, and H. Ellenberger. *Existence.* New York: Basic, 1958.
Miller, Jean Baker, ed. *Psychoanalysis and Women.* Baltimore: Penguin, 1973.
Mitchell, Juliet. *Psychoanalysis and Feminism.* New York: Pantheon, 1974.
Moers, Ellen. *Literary Women.* Garden City, N.Y.: Anchor, 1977.
Mottini-Coulon, Edmée. *Essai d'Ontologie spécifiquement féminin.* Paris: Librairie philosophique J. Vrin, 1978.
M'Uzan, Michel de. *De l'Art à la Mort: Itinéraire psychiatrique.* Paris: Gallimard, 1977.
Olsen, Tillie. *Silences.* New York: Delacorte, 1978.
Pratt, Annis, with Barbara White, Andrea Loewenstein, and Mary Wyer. *Archetypal Patterns in Women's Fiction.* Brighton, Sussex: Harvester Press, 1982.
Rich, Adrienne. *Of Woman Born.* New York: Norton, 1976.
Rigney, Barbara Hill. *Madness and Sexual Politics in the Feminist Novel.* Madison: Univ. of Wisconsin Press, 1978.

———. *Lilith's Daughters: Women and Religion in Contemporary Fiction*. Madison: Univ. of Wisconsin Press, 1982.

Roland, Alan, ed. *Psychoanalysis, Creativity and Literature*. New York: Columbia Univ. Press, 1978.

Scarf, Maggie. *Unfinished Business: Pressure Points in the Lives of Women*. Garden City, N.Y.: Doubleday, 1980.

Shainess, Natalie. *Sweet Suffering: Woman as Victim*. New York: Bobbs-Merrill, 1984.

Showalter, Elaine. *A Literature of Their Own*. Princeton: Princeton Univ. Press, 1977.

Skura, Meredith Anne. *The Literary Use of the Psychoanalytic Process*. New Haven: Yale Univ. Press, 1981.

Spacks, Patricia Meyer. *The Female Imagination*. New York: Knopf, 1972, 1975.

Strouse, Jean, ed. *Women and Analysis*. New York: Dell, 1974.

Sullivan, Harry Stack. *The Interpersonal Theory of Psychiatry*. New York: Norton, 1953.

Thorne, Barrie, and Marilyn Yalom, eds. *Rethinking the Family: Some Feminist Questions*. New York and London: Longman, 1982.

Yalom, Irvin D. *Existential Psychotherapy*. New York: Basic, 1980.

Index

"Psychoanalytic Dialogue," 111
Psychoanalytic theory. *See* Freudian
 theory
Psychotherapy, 2–3, 78, 111. *See also*
 Cardinal; Plath, Sylvia; Psycho-
 analysis

Rank, Otto, 60, 118 n. 18
Religion. *See* Atwood
Rétable, 58
Rey, Jean-Michel, 11
Rhys, Jean, 1
Rich, Adrienne, 4, 9, 42, 87
Rigney, Barbara Hill, 75, 76, 81
Rimbaud, Arthur, 1, 101
Rites of Passage, 83–84
Rituals, 83–85

Santos, Emma, 1, 3, 88, 101–2, 103;
 and madness, 1, 3, 101, 103; and
 maternity 101–2; and writing,
 101–2
Sartre, Jean-Paul, 5
Schafer, Roy, 111
Sechehaye, Marguerite, 78
Second Sex, The, 68
Serreau, Geneviève, 68–69
Sexism, 3–4, 6–7, 41
Sexton, Anne, 1, 10, 92, 93–96, 100,
 109; and childbirth, 93; and death
 of children, 95–96; and madness, 1,
 10, 92, 93–94; and mortality, 95–
 96; and motherhood, 93–100; and
 suicide, 93, 100; and writing, 93,
 100
Sexual initiation. *See* Cardinal; Plath,
 Sylvia
Sexual relationships. *See* Lesbianism;
 Male-female relationships
Shainess, Natalie, 67, 68
Shelley, Mary, 2
Showalter, Elaine, 9
Silences, 41–42
Singular Anomaly, The, 114 n. 26
"Sketch of the Past, A," 93

Skura, Meredith Anne, 3
Souricière, La, 35–48, 50, 64, 65, 92,
 117 n. 1 (chap. 4)
Speech. *See* Kingston; Writing
Steiner, Nancy, 28
"Stillborn," 102
Suicide. *See* Cardinal; Plath, Sylvia;
 Sexton; Woolf
Surfacing, 2, 10, 66, 71–88, 91,
 108–9, 110–11
Survival, 72, 74, 83
"Sylvia Plath's Baby Book," 30

Thompson, Clara, 66
To Bedlam and Part-Way Back, 94
Tolstoy, Leo, 47
To the Lighthouse, 93
Trakl, Georg, 1, 101
Ts'ai Yen, 99

Van Dyne, Susan, 92
Van Gennep, Arnold, 83–85
Voyage Out, The, 93, 102

Walker, Alice, 110
Winnecott, D.W., 119 n. 18
Woman on the Edge of Time, 2, 86
Woman Warrior, The, 96–99, 110–11
Women and Madness, 3
Women of Brewster Place, The, 105,
 110
Woolf, Virginia, 1, 92–93, 100, 102,
 111; and father's death, 92–93,
 109; and madness, 1, 10, 92–93;
 and maternity, 100, 102; and
 mother, 92–93, 108, 111; and sui-
 cide, 92–93, 100, 109; and writing,
 93, 100, 102, 109
Writing, 6, 9, 11, 100–103, 111. *See
 also* Atwood; Cardinal; Kingston;
 Plath, Sylvia; Santos; Sexton; Woolf

Yalom, Irvin, 9, 18
Yellow Wallpaper, The, 3, 46